Millie Marotta's

Wildlife Wonders

Favorite Illustrations
from Coloring Adventures

LARK

New York

An Imprint of Sterling Publishing Co., Inc.
1166 Avenue of the Americas
New York, NY 10036

Distributed in Canada by Sterling Publishing Co., Inc.
c/o Canadian Manda Group, 664 Annette Street
Toronto, Ontario, Canada M6S 2C8

For information about custom editions, special sales, and premium and corporate purchases, please
contact Sterling Special Sales at 800-805-5489 or specialsales@sterlingpublishing.com.

Manufactured in Singapore

2 4 6 8 10 9 7 5 3 1

sterlingpublishing.com
larkcrafts.com

Millie Marotta's

Wildlife Wonders

Favorite Illustrations
from Coloring Adventures

LARK

New York

Introduction

Step into a world of wildlife wonders—which celebrates the incredible natural world with a bumper selection of favorite illustrations highlighted by the astonishing talents of the worldwide coloring community. To sit at my desk every day and disappear into my own world of drawing and exploring new creatures, habitats, and landscapes is, for me, just the best thing. I get to indulge both my love of illustration and my passion for wildlife. Better still is that I get to share my illustrations with the most fantastic, collaborative audience I could ever wish for. As colorists from all walks of life and all corners of the globe share their colored artworks over social media and in my coloring gallery, I find myself endlessly astounded and inspired by their extraordinary creativity. I see my illustrations brought to life with dazzling color palettes, inventive techniques, and unique creative ideas, with each colorist turning the illustrations into masterpieces of their very own.

There are some illustrations that pop up more than others, sometimes even appearing multiple times, in different colorways—all colored by the same person. And so the idea came to me that I should create a book that brings together a collection of those favorite illustrations, which have inspired the coloring community to create the most flabbergasting, eye-popping, outstanding artworks. Seeing such a huge audience interacting with one another, sharing ideas, inspiration, and work makes me endlessly happy. Together, we have created something of which I am immensely proud. And what better way to celebrate than to curate a collection of those very illustrations, cherry-picking the favorites, the most popular, the ones that time and again are enjoyed and shared the world over?

Selecting images to include in *Wildlife Wonders* was a thoroughly enjoyable task; spending hours poring over beautifully colored images from across all five

of my books was a pleasure in itself. From revisiting the earliest colored pages to emerge after *Animal Kingdom* was first published, to exploring the fabulous work of recent newcomers to the coloring scene, it's always a thrill to see how differently you all work. I have my socks knocked off on a regular basis. If you haven't yet delved into the pages of *Animal Kingdom*, *Tropical World*, *Wild Savannah*, *Curious Creatures,* or *Beautiful Birds and Treetop Treasures*, you will get a taste of each here in *Wildlife Wonders*.

There is no better source of inspiration than the marvels of our natural world. Mother Nature never fails to amaze or impress with shapes, textures, forms, patterns, and colors, presenting an endless array of creative possibilities. With a host of animals from habitats across the globe—tropical rainforests, coral reefs, African savannahs, Australian deserts, ocean depths, and mountaintops—a world of color awaits in *Wildlife Wonders*.

Whatever your reason for coloring, be it to get your creative juices flowing or simply as a great excuse to disappear into your own world for a while, I hope you will enjoy flooding these pages with a kaleidoscope of colors. From the mighty African elephant to the tiny field mouse, the flamboyant flamingo to the wide-eyed bush-baby, animals aplenty await. So pens and pencils at the ready and dive in. Enjoy bringing these wildlife wonders to life and turning them into your very own colored creations.

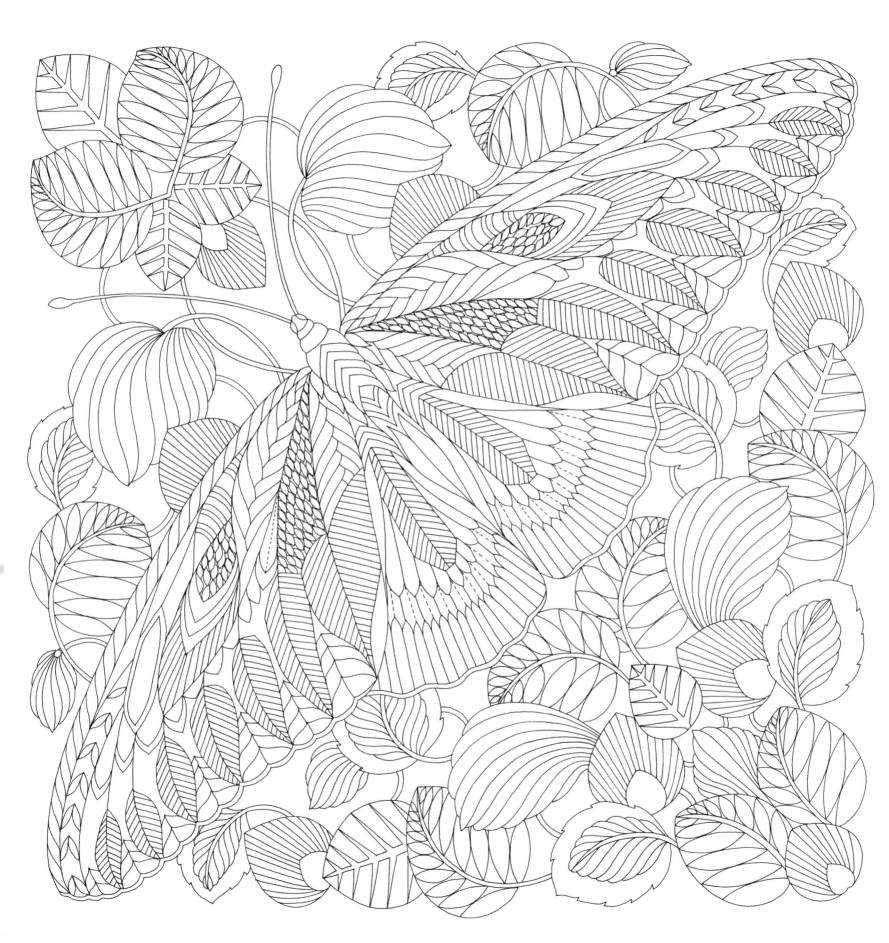

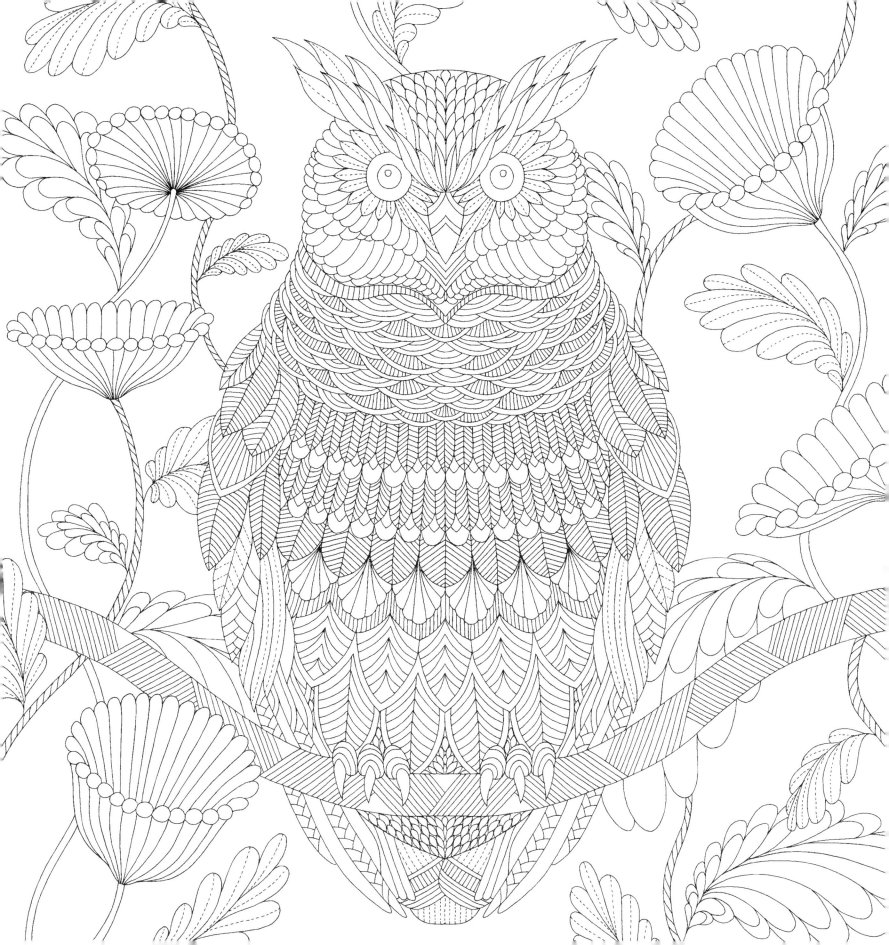

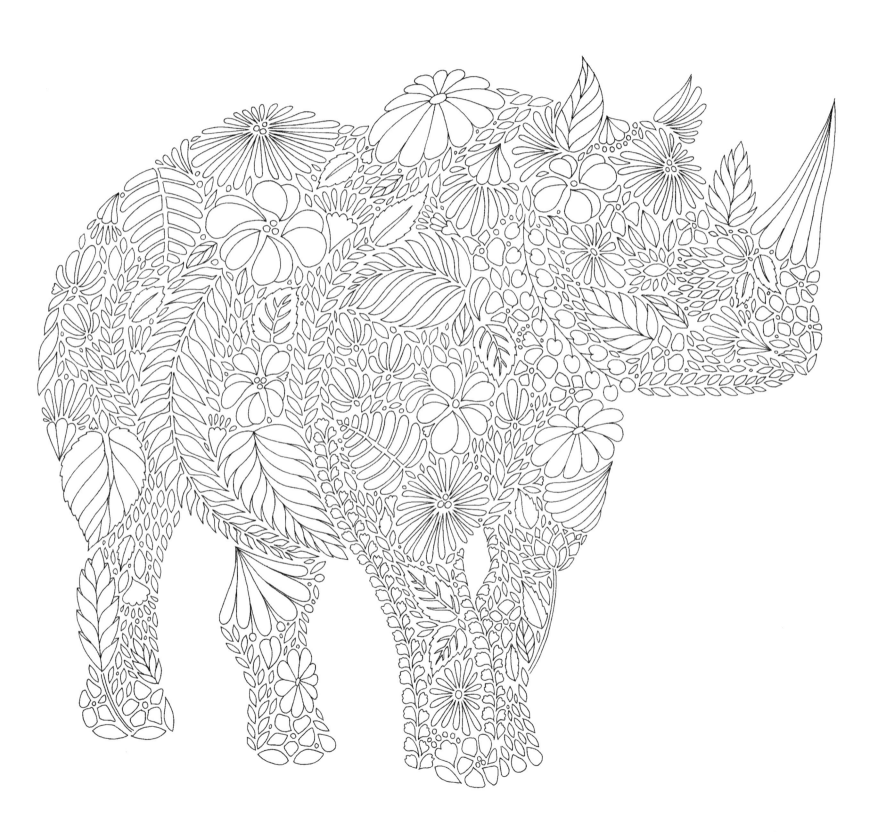

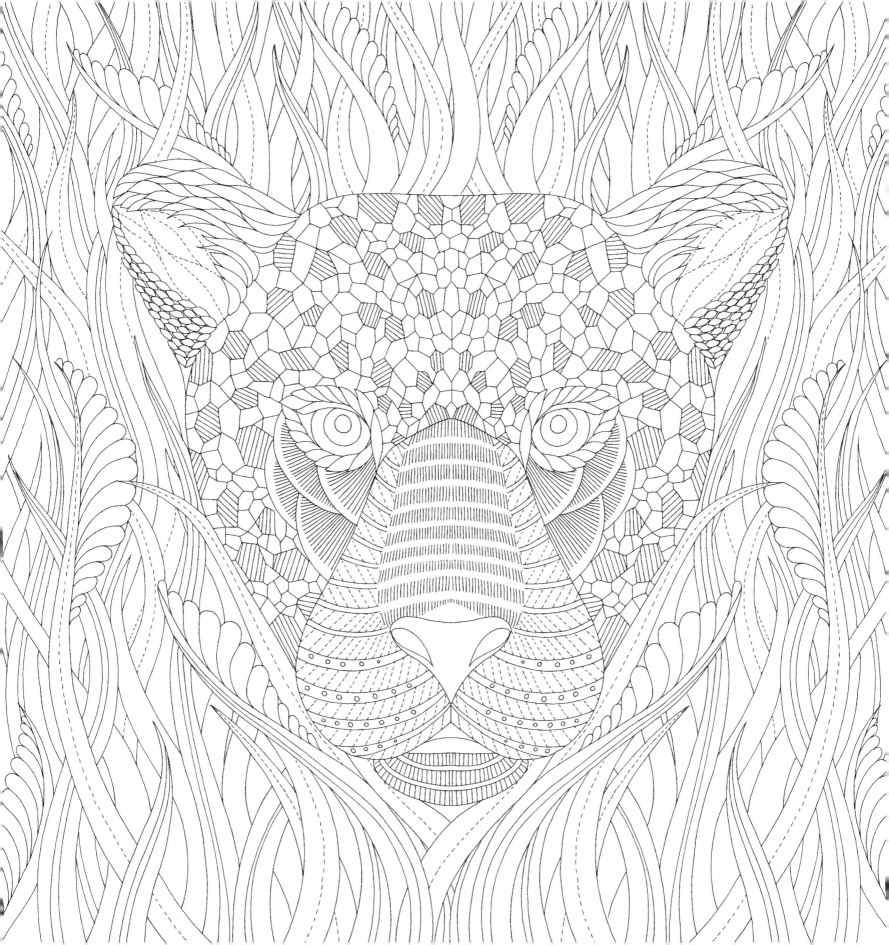

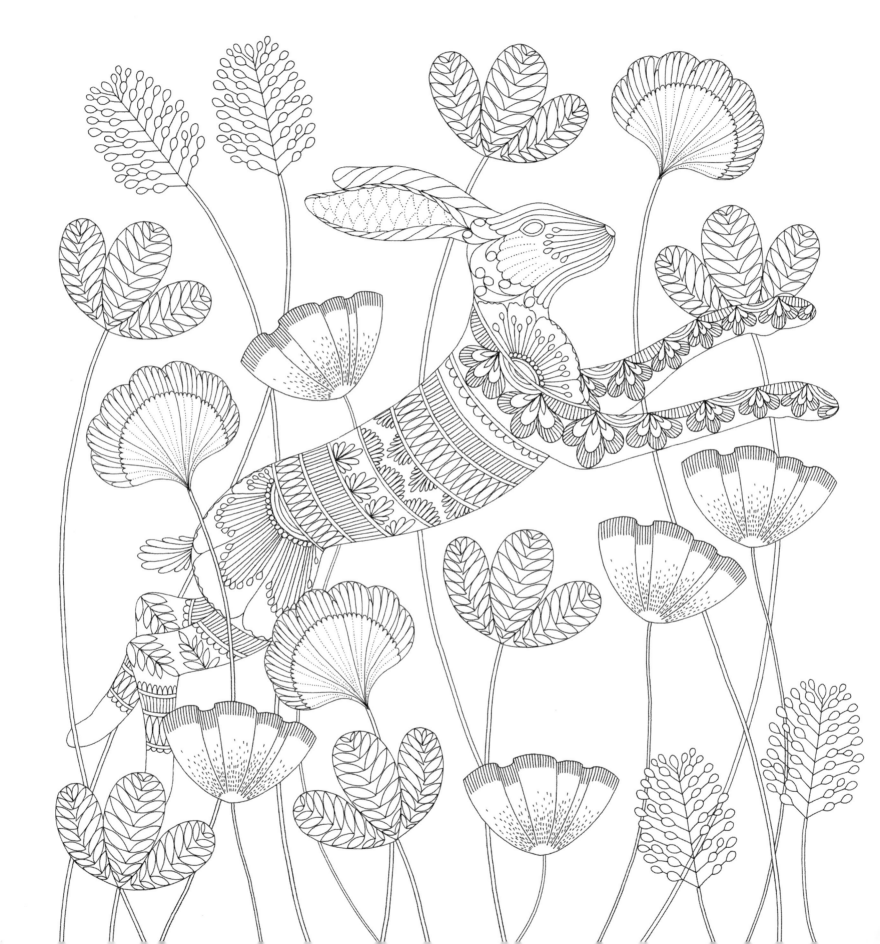

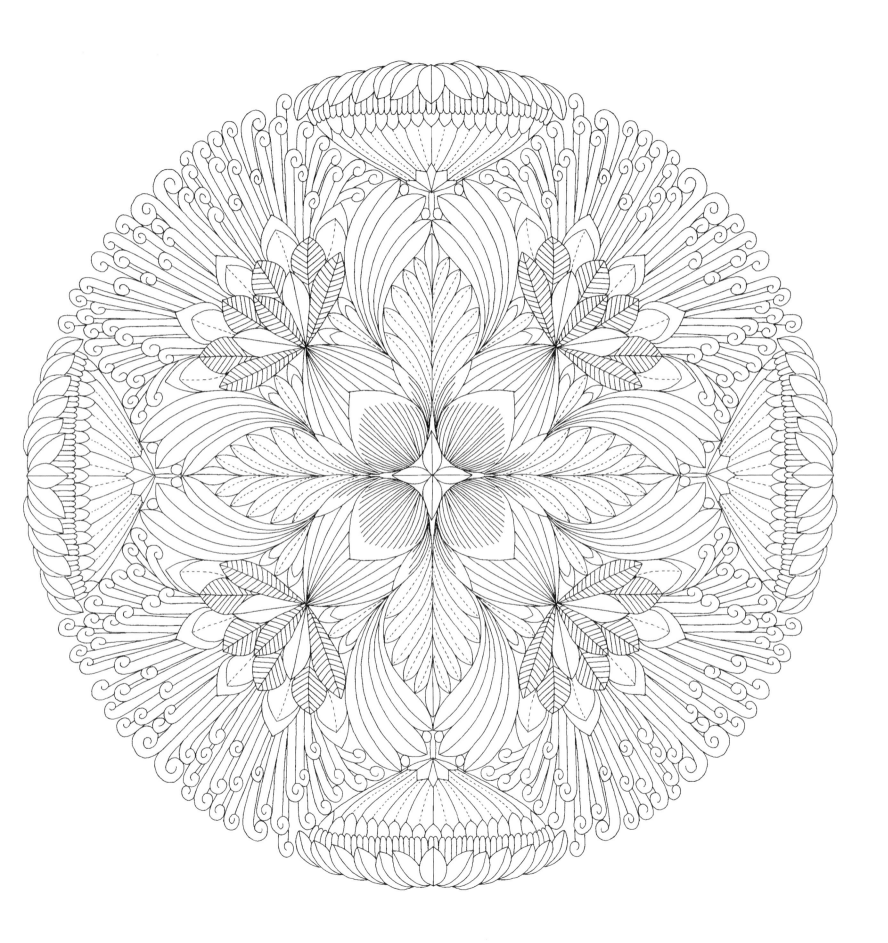

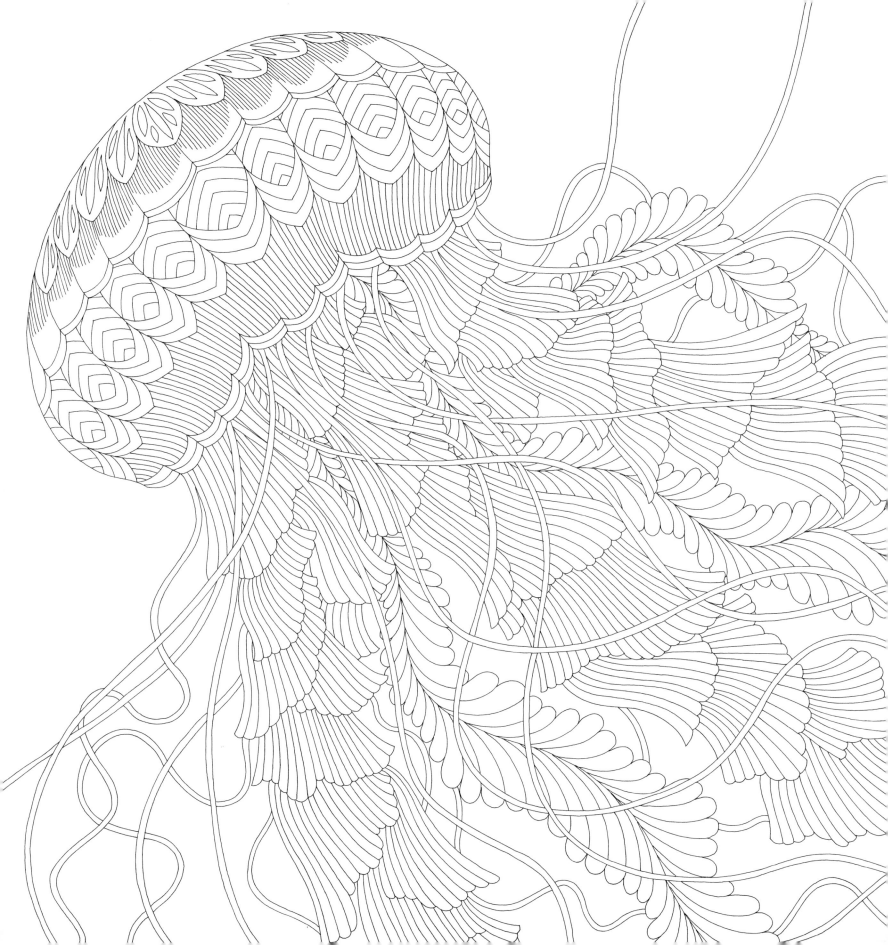

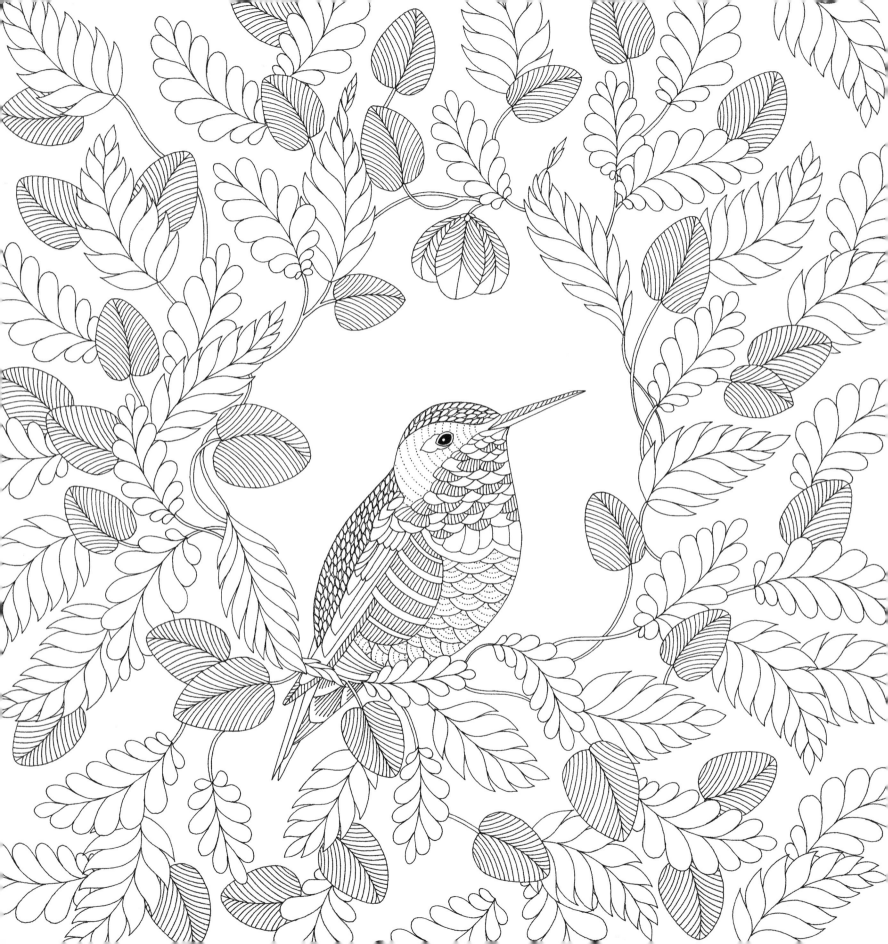

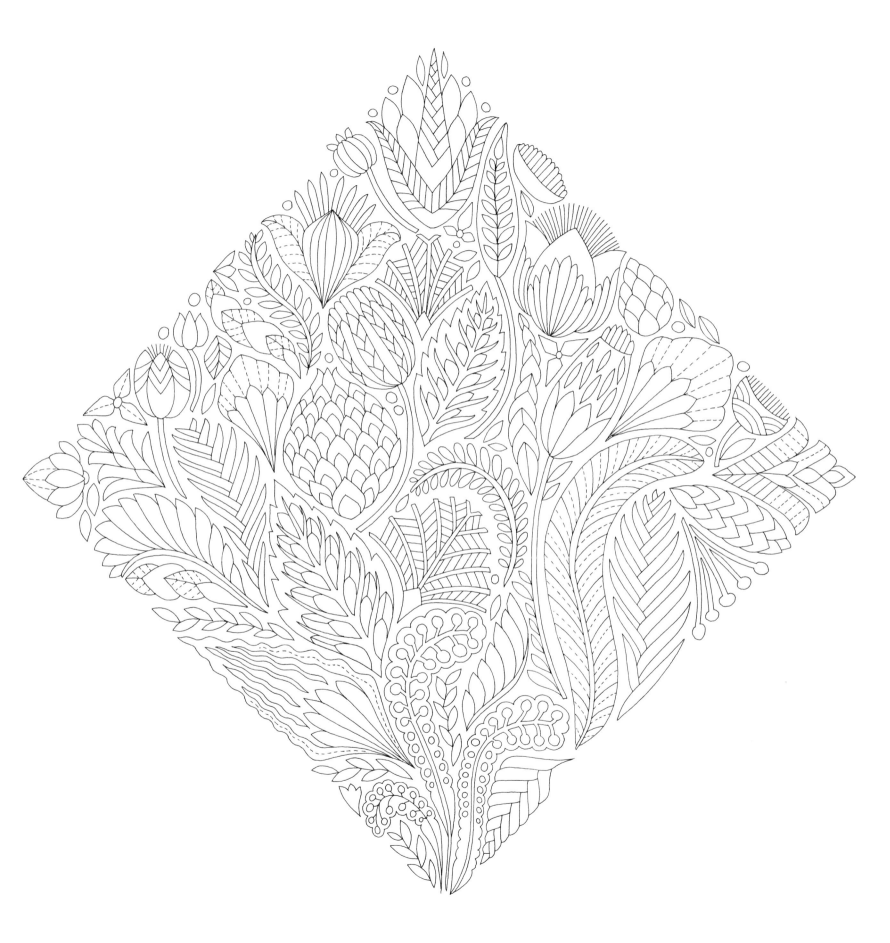

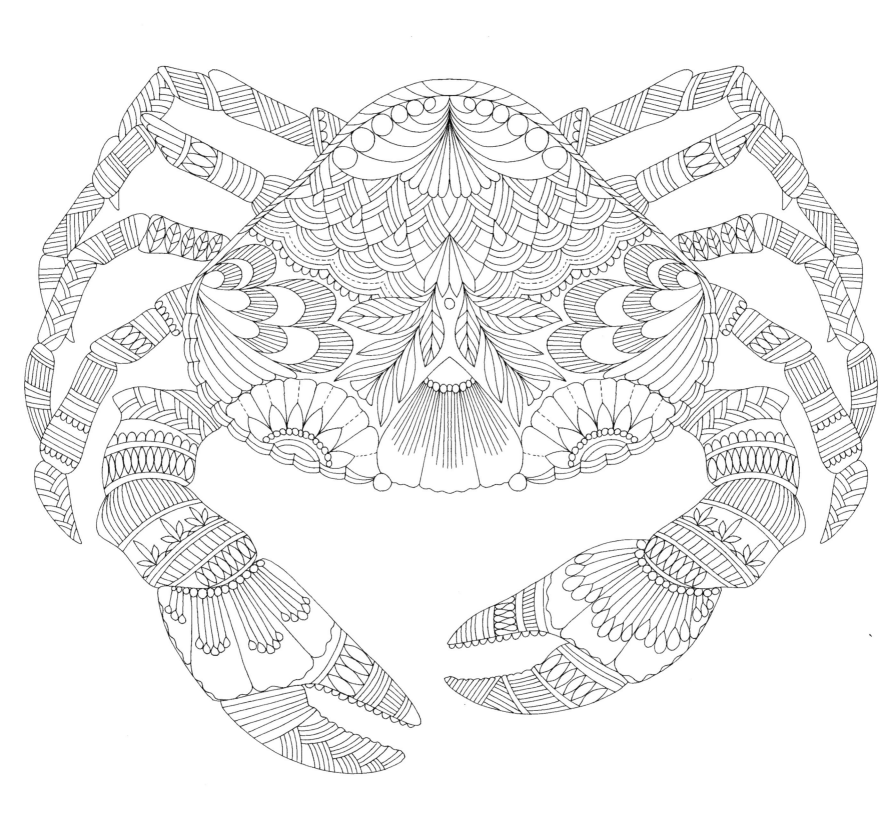

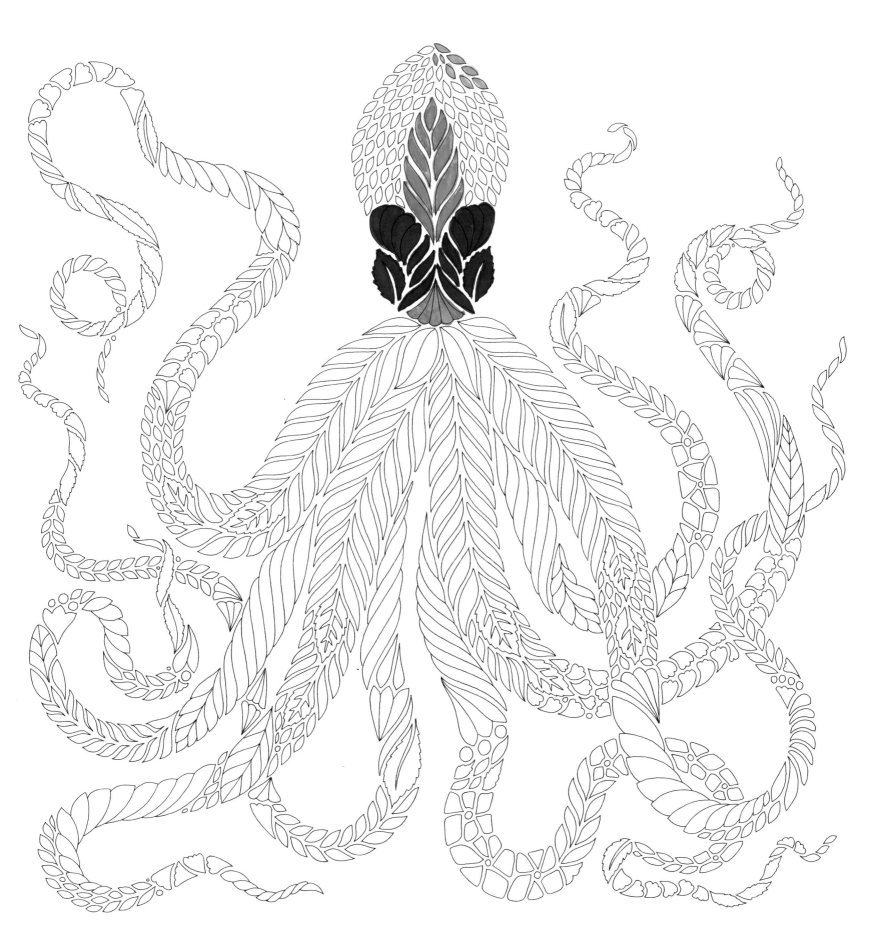

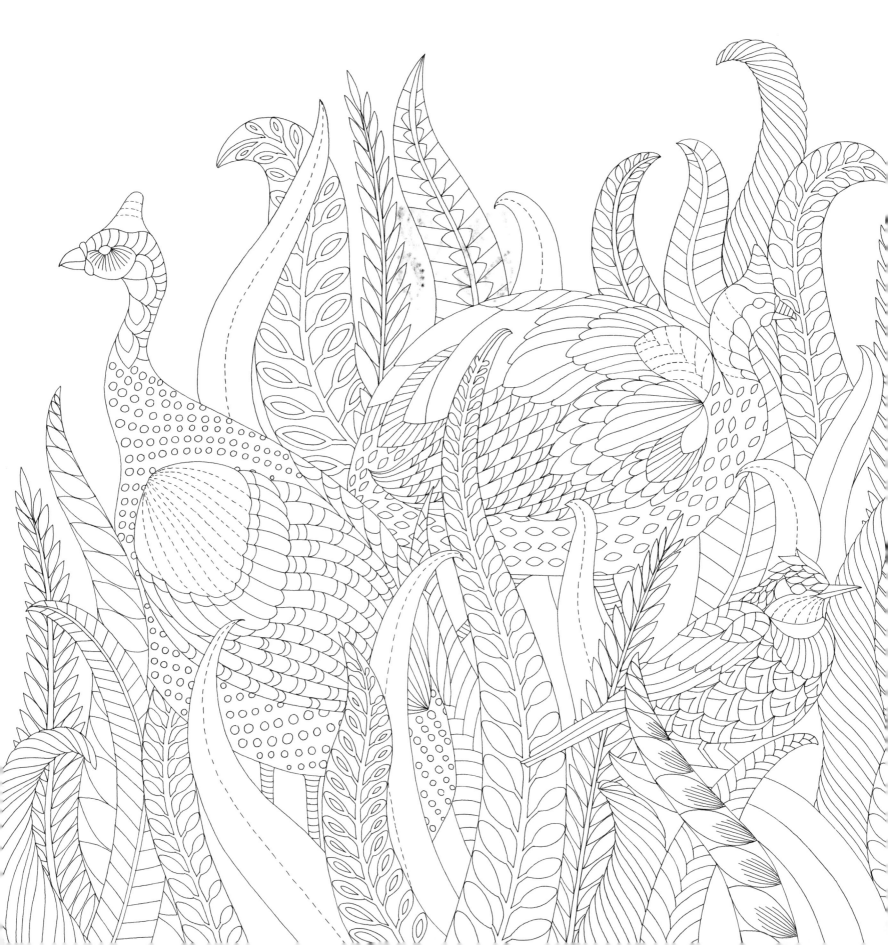

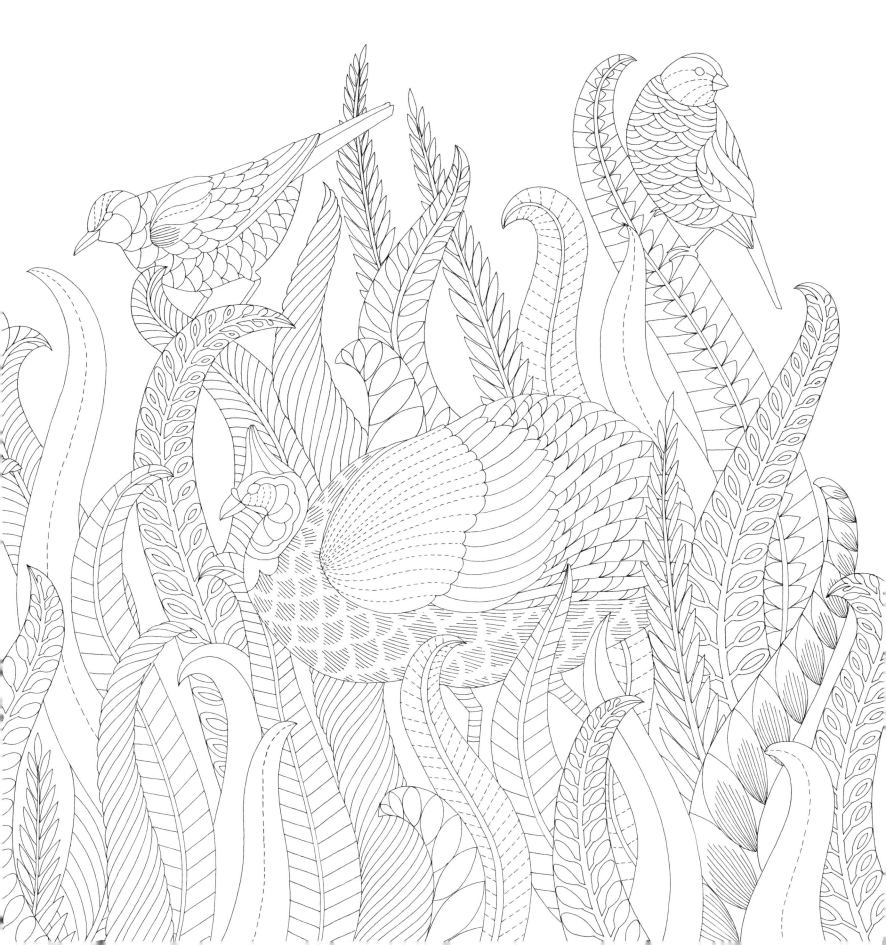

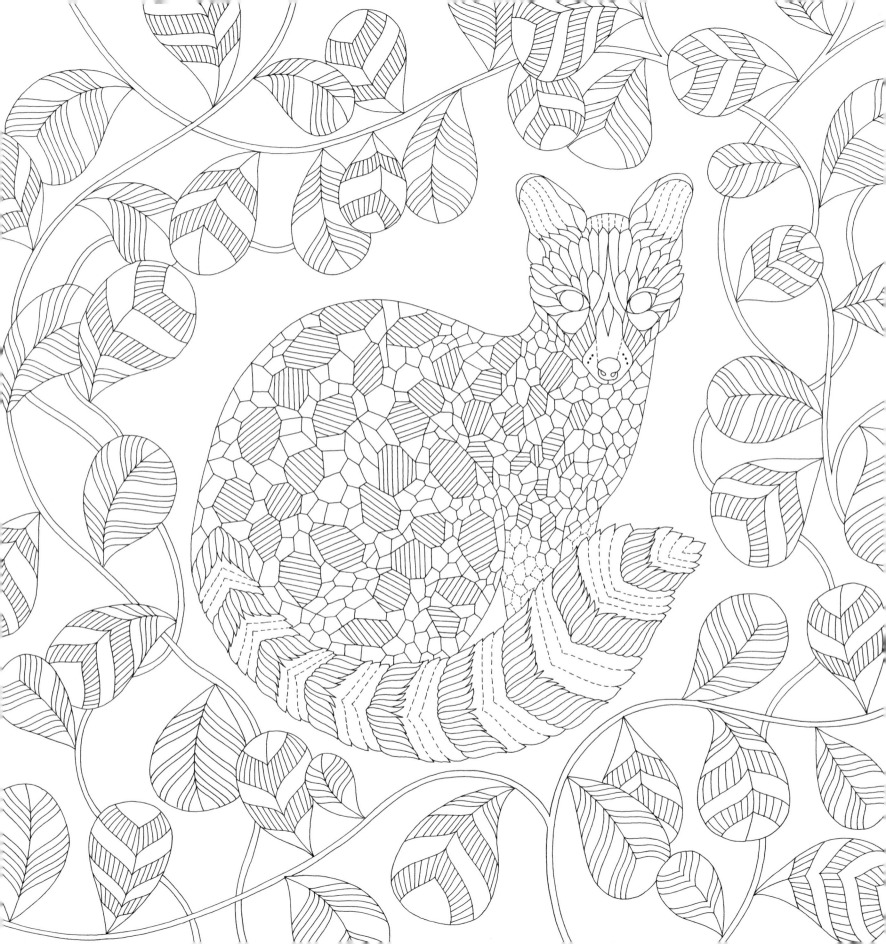

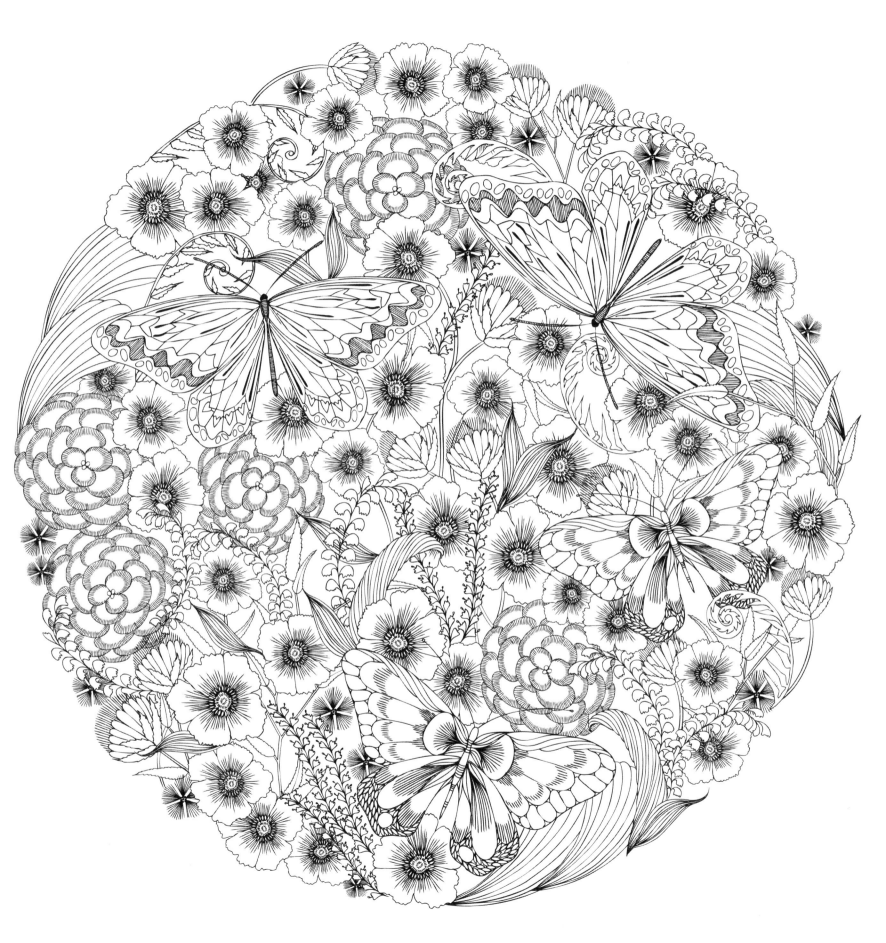

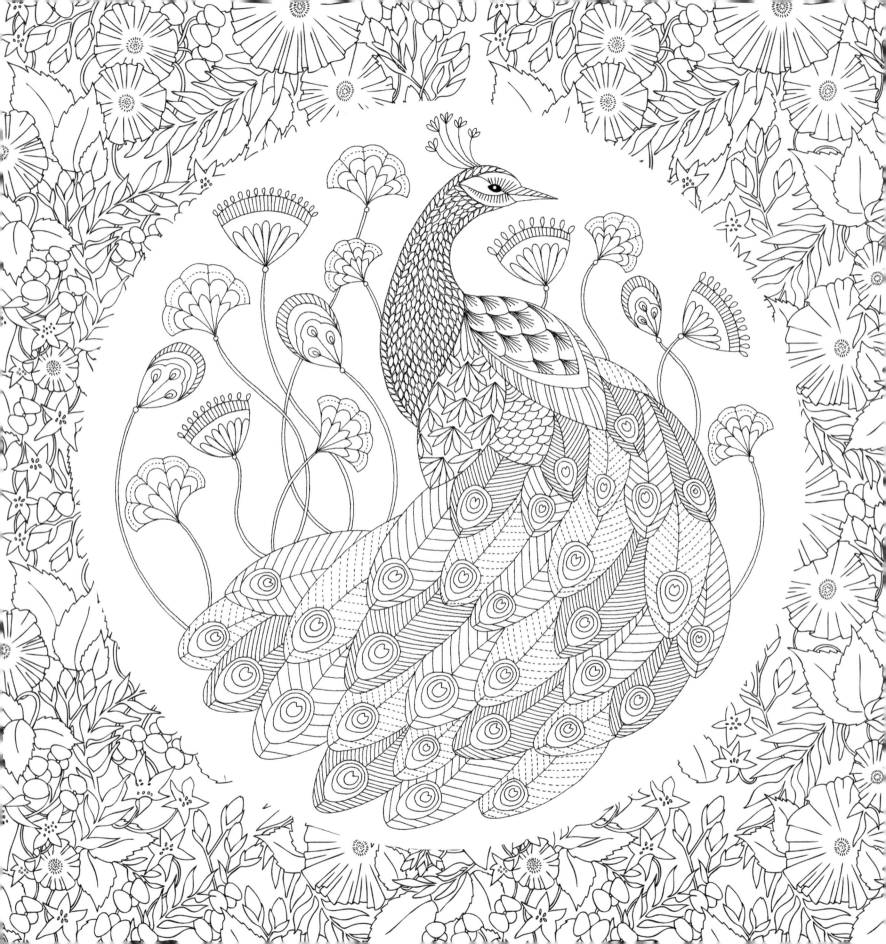

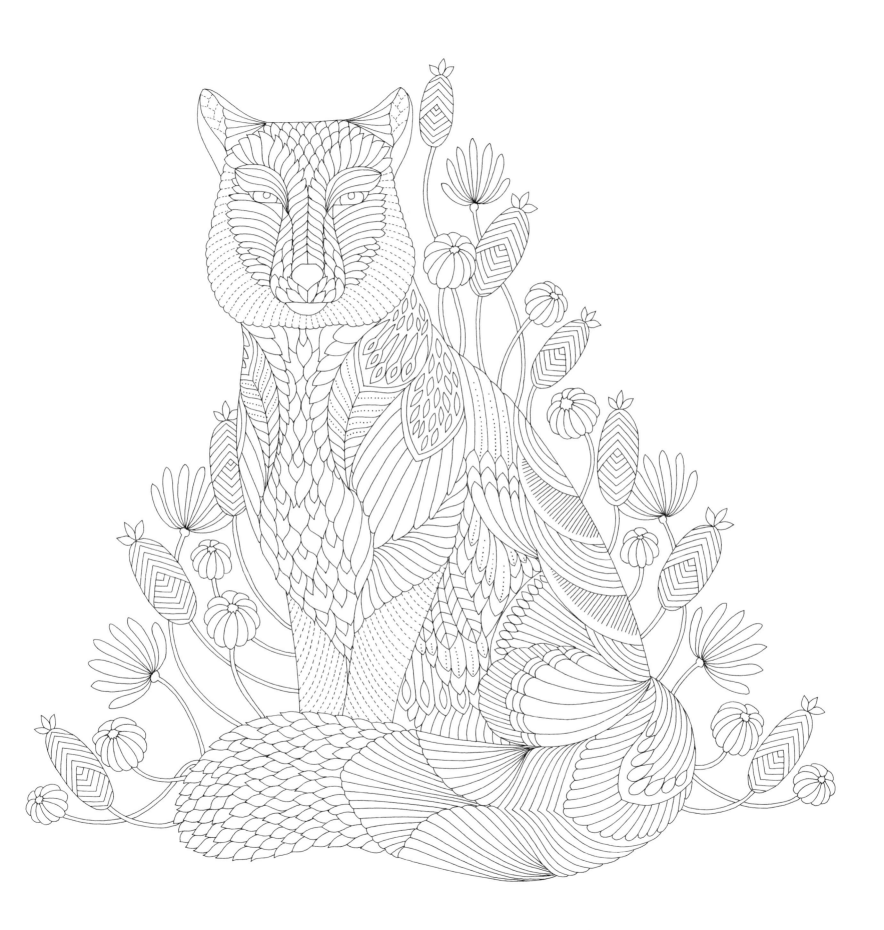

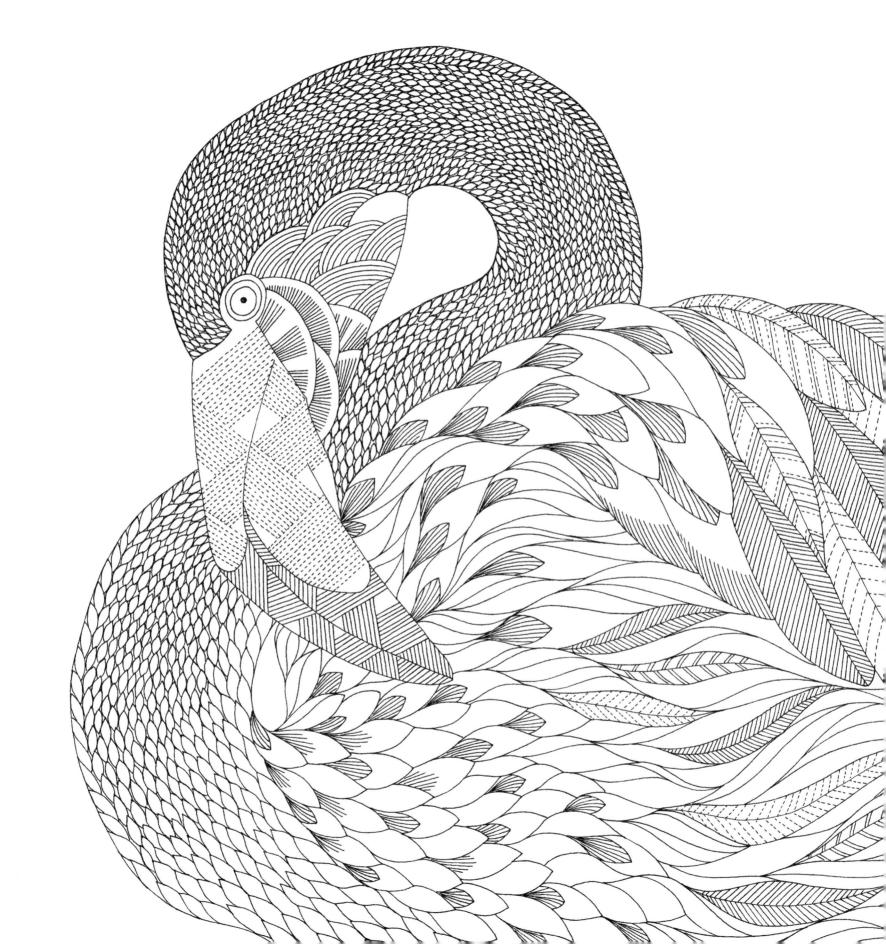

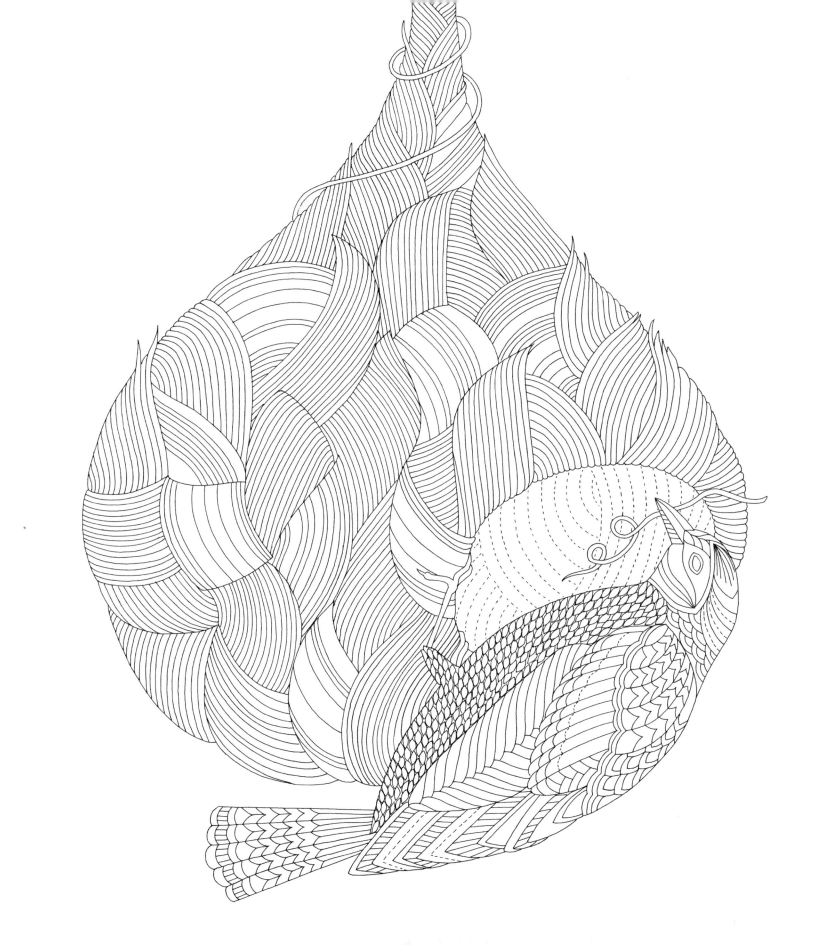

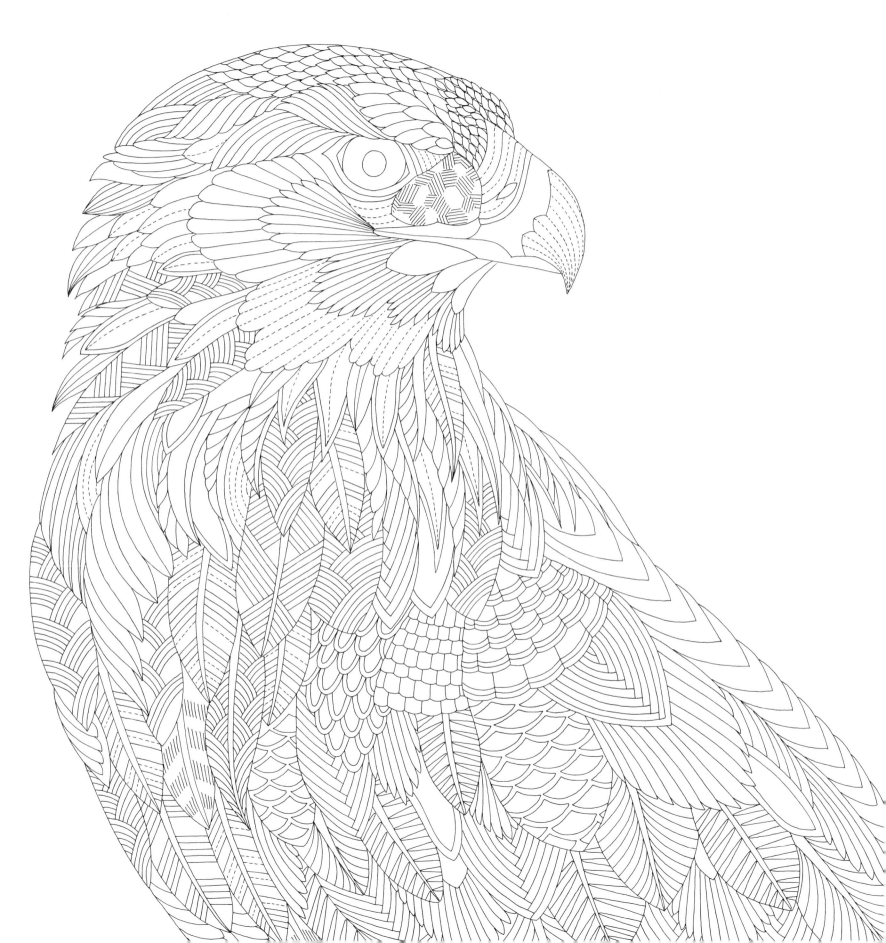

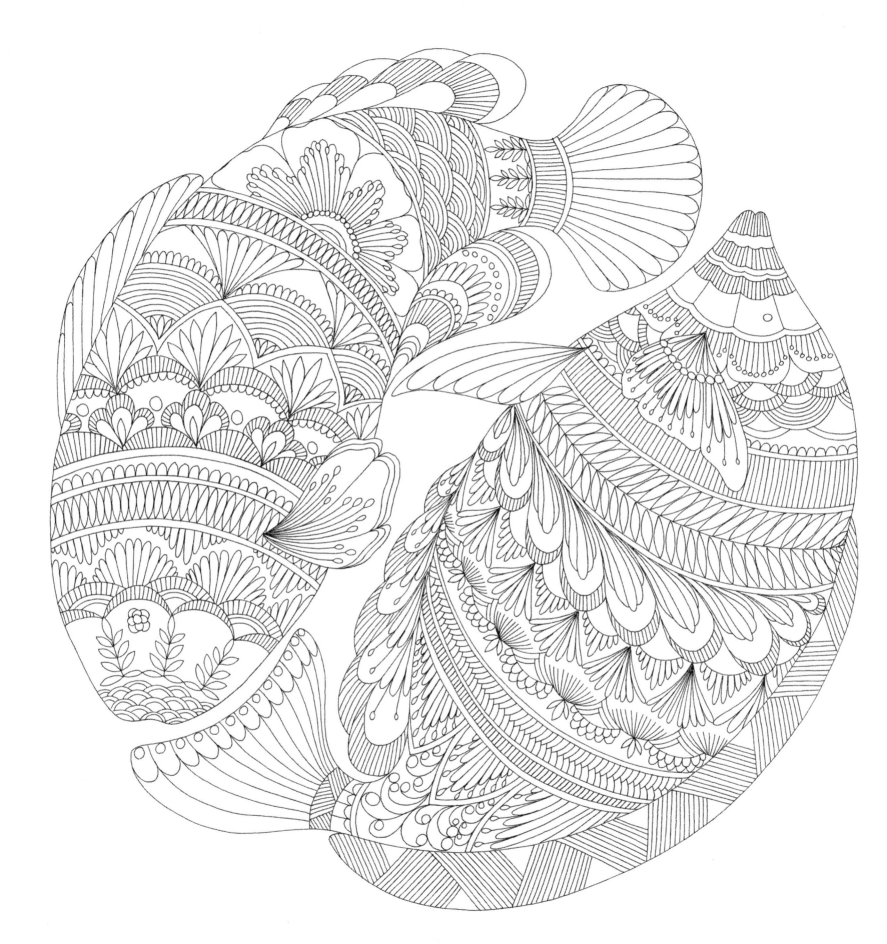

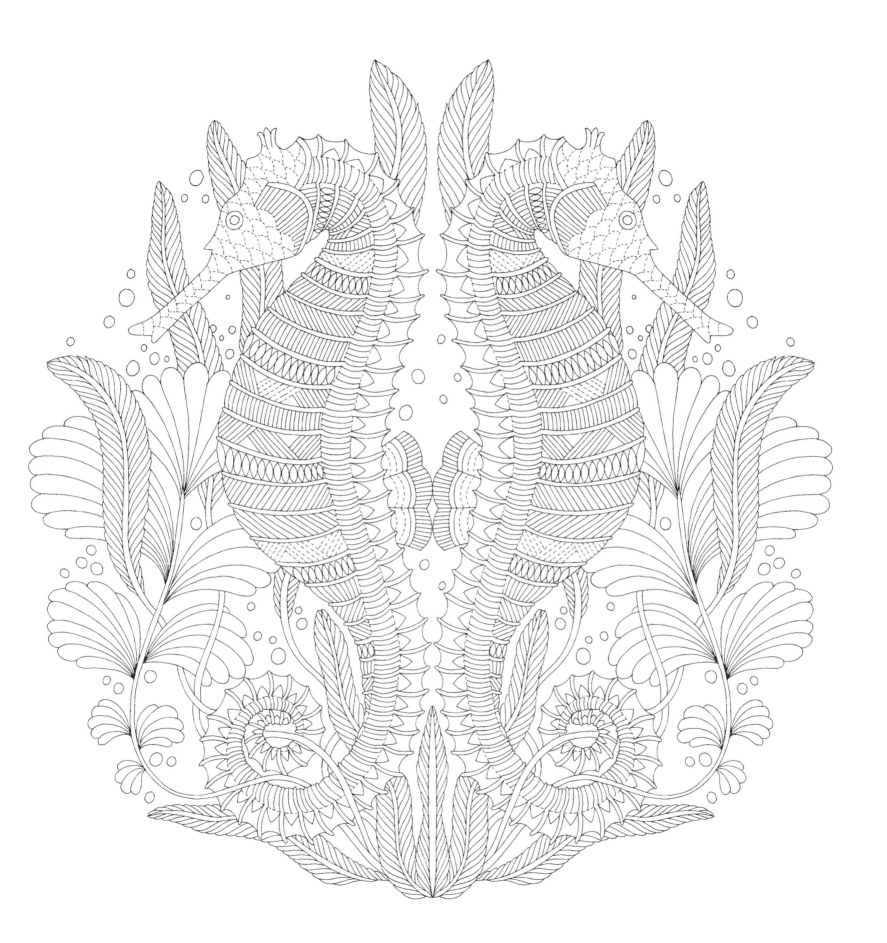

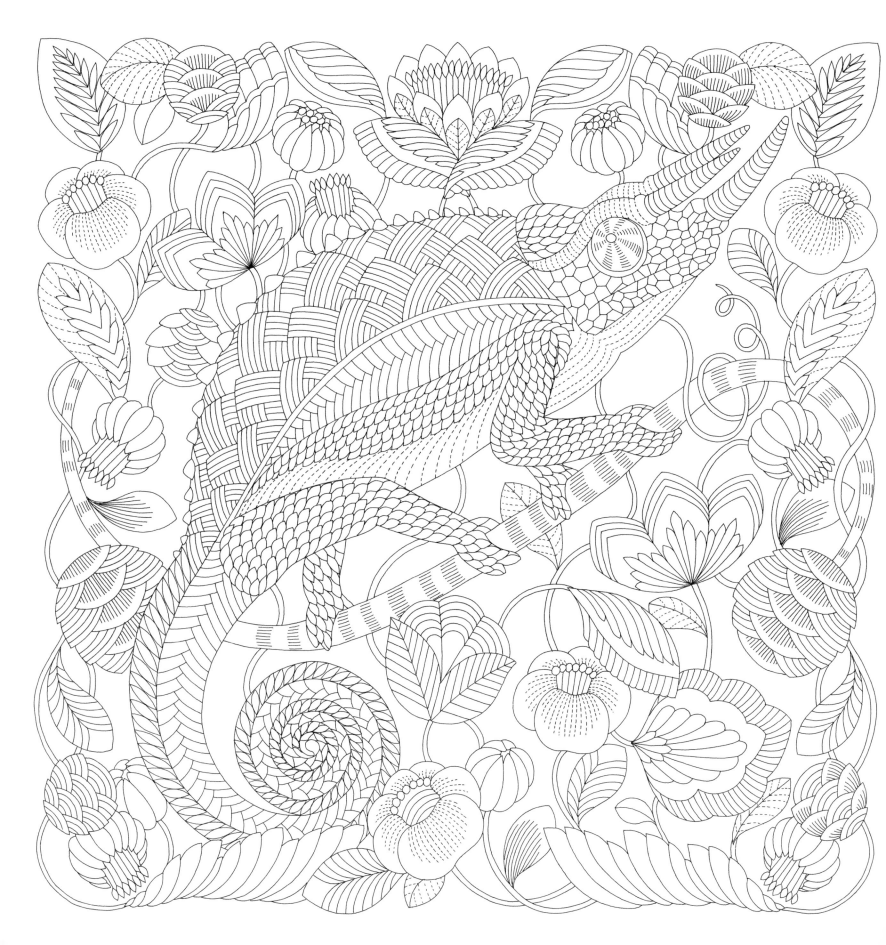

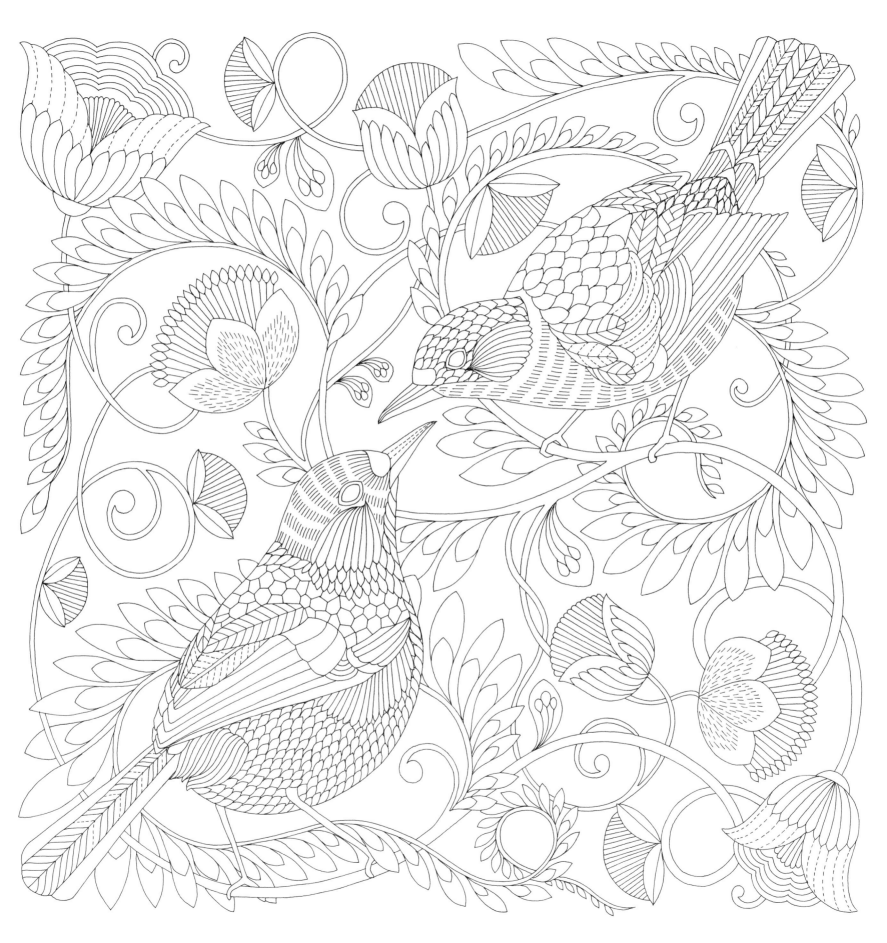

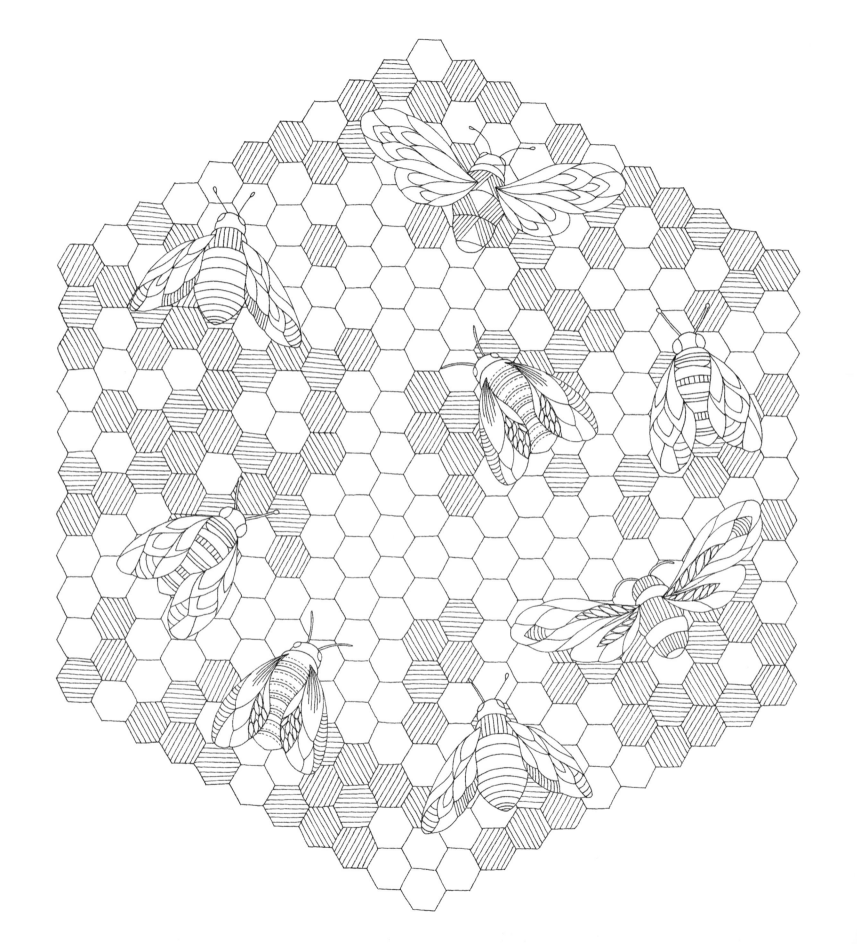

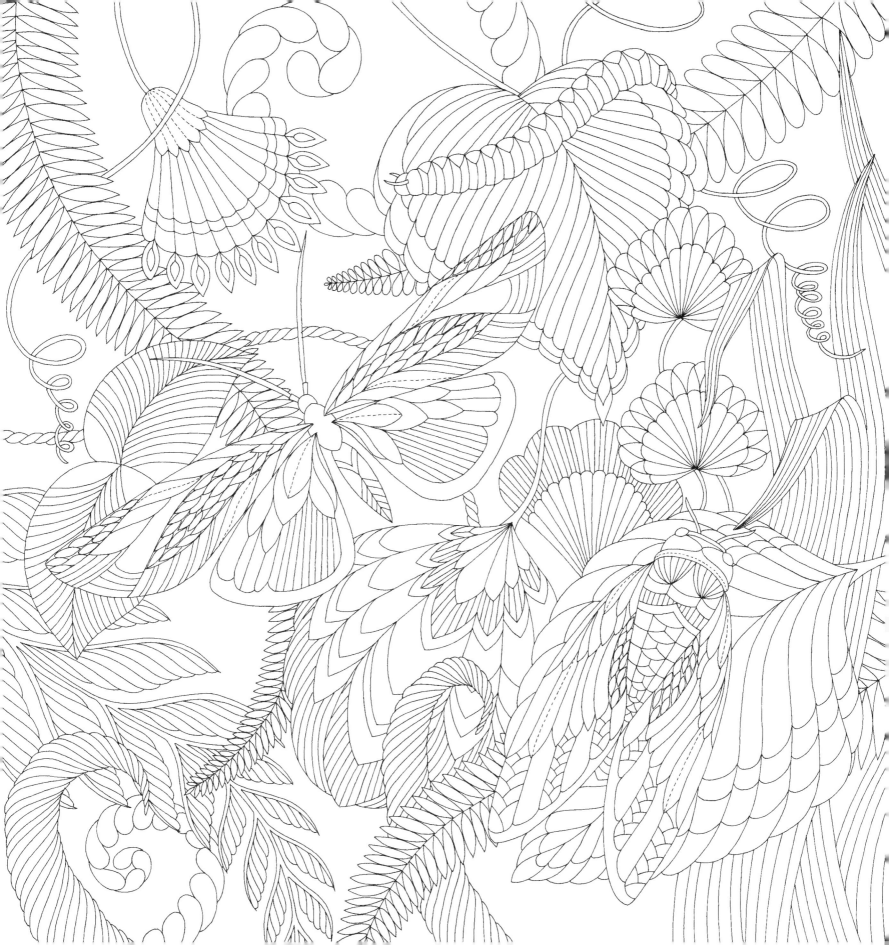

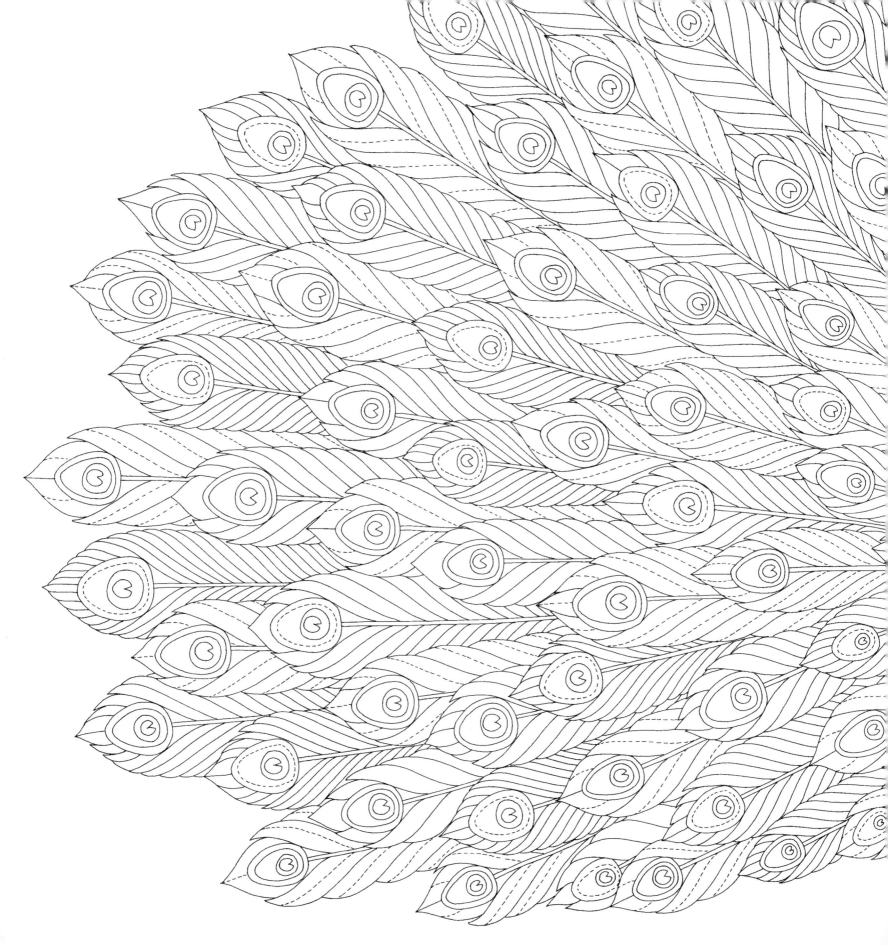

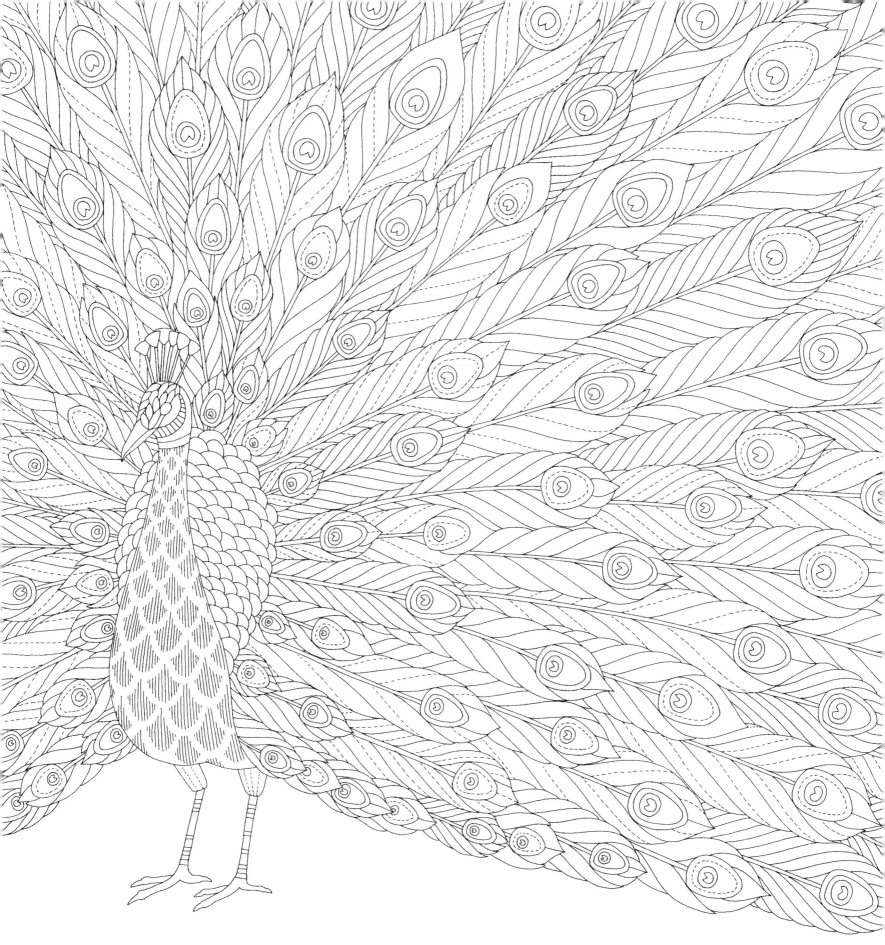

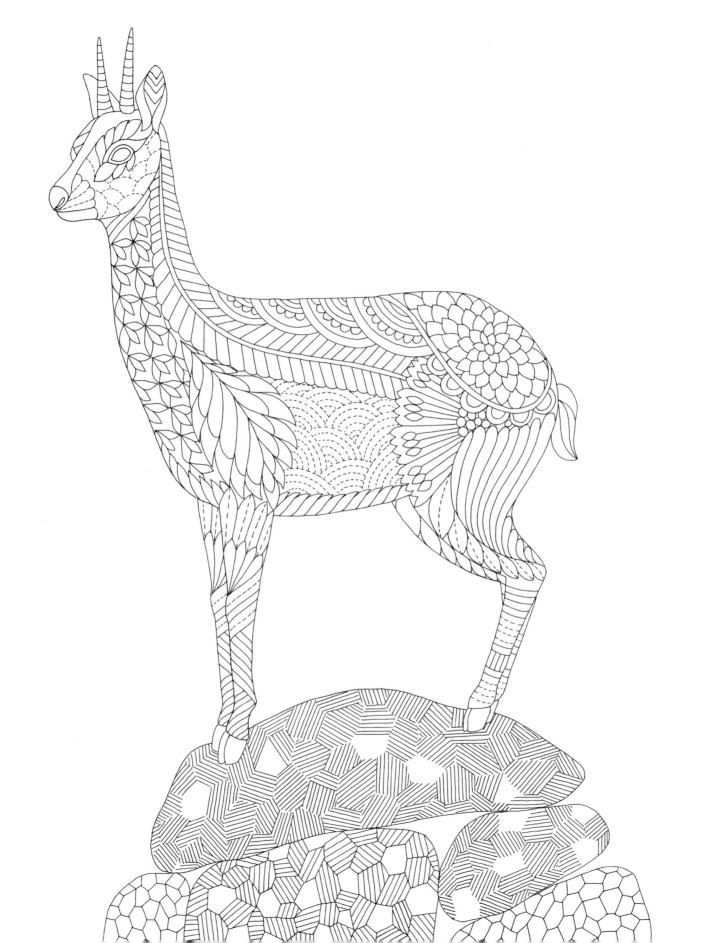

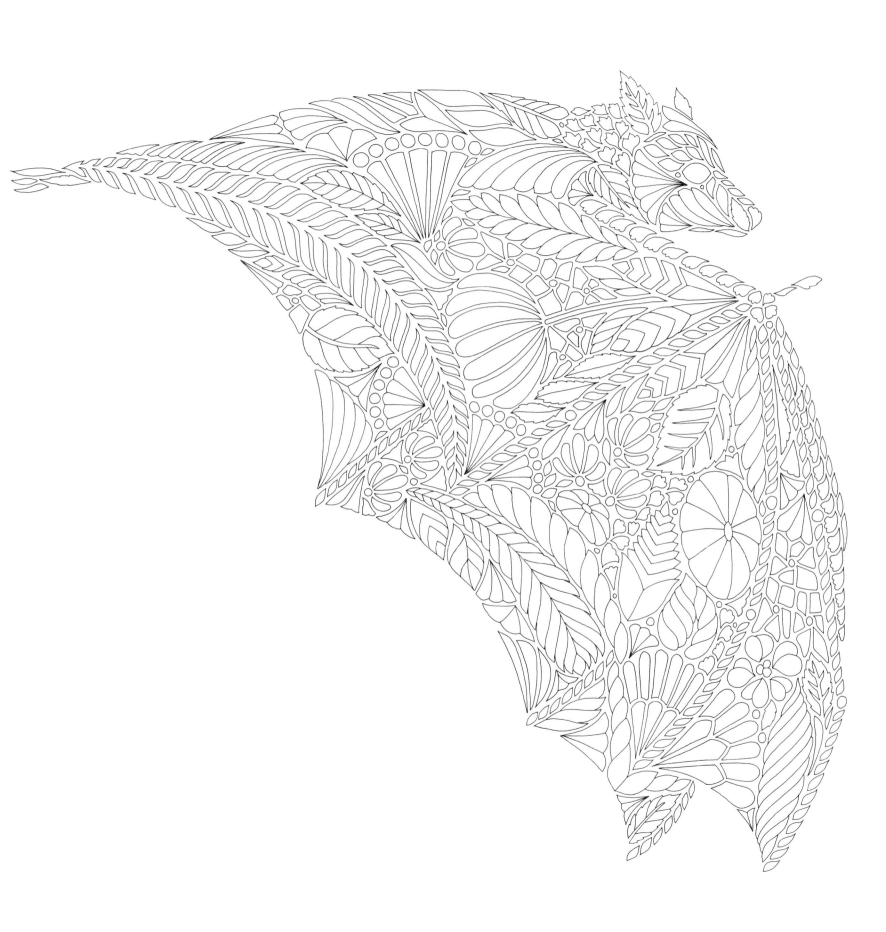

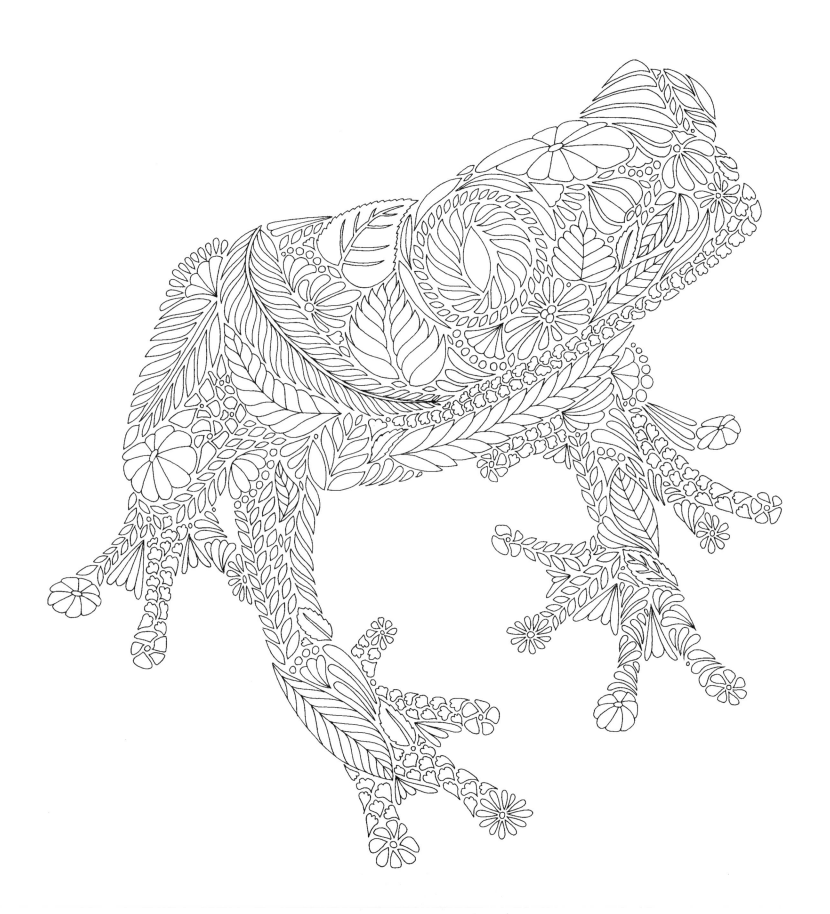

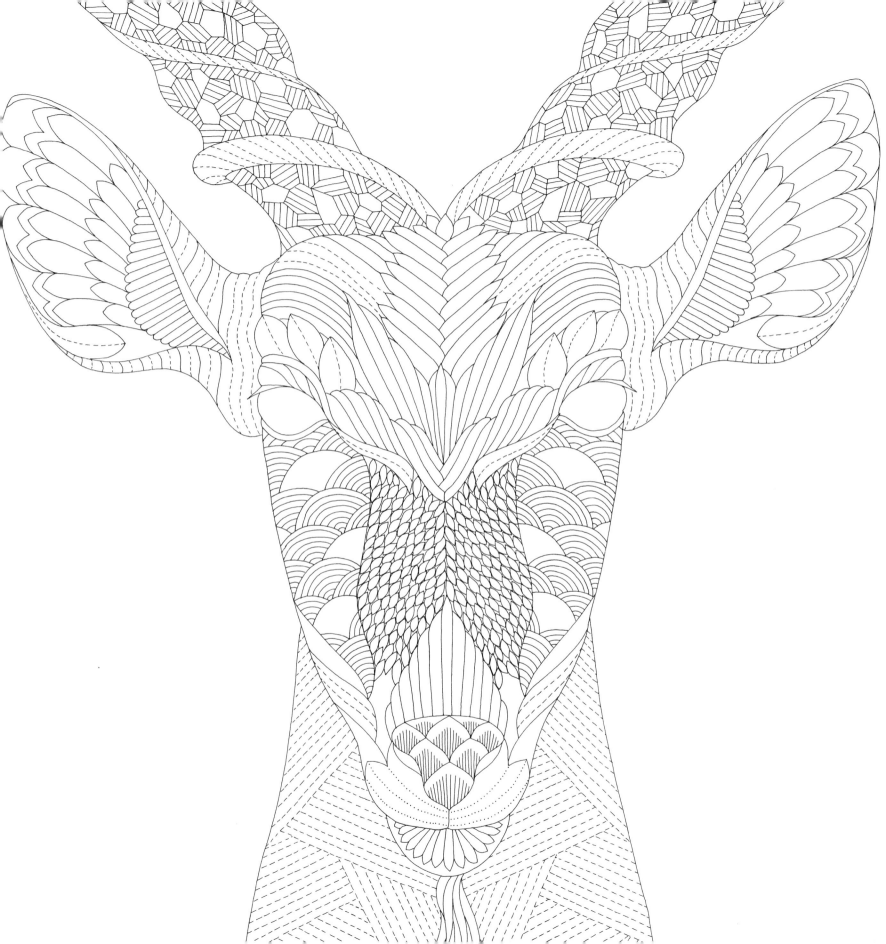

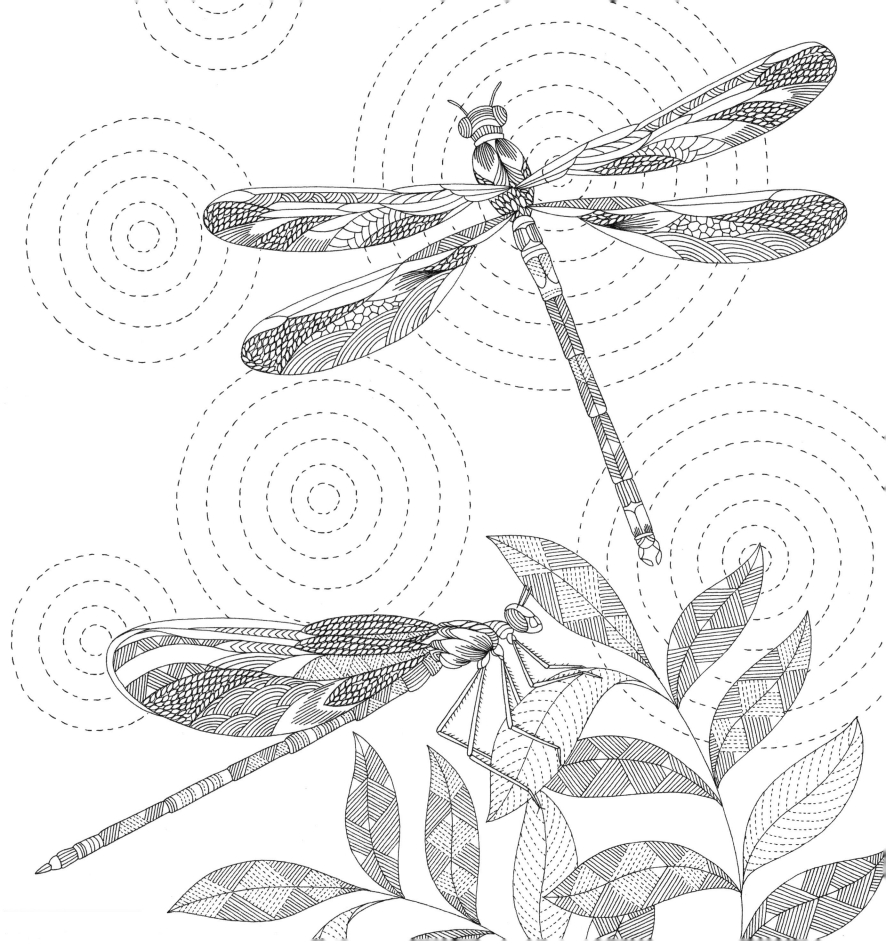

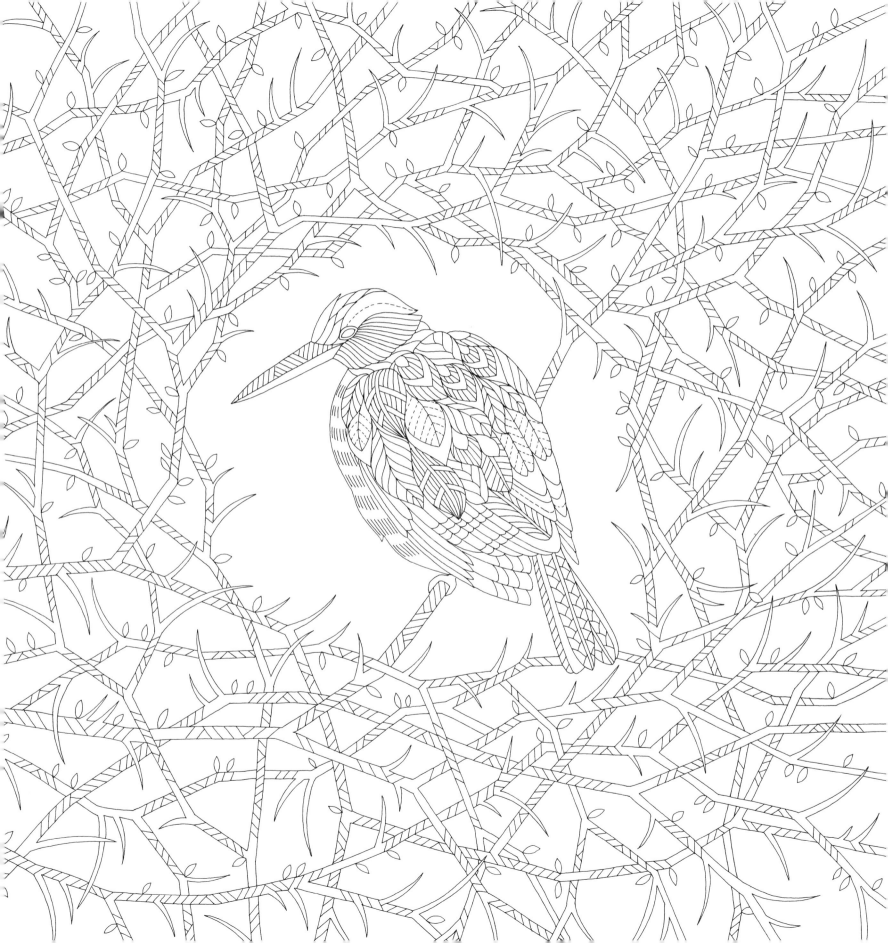

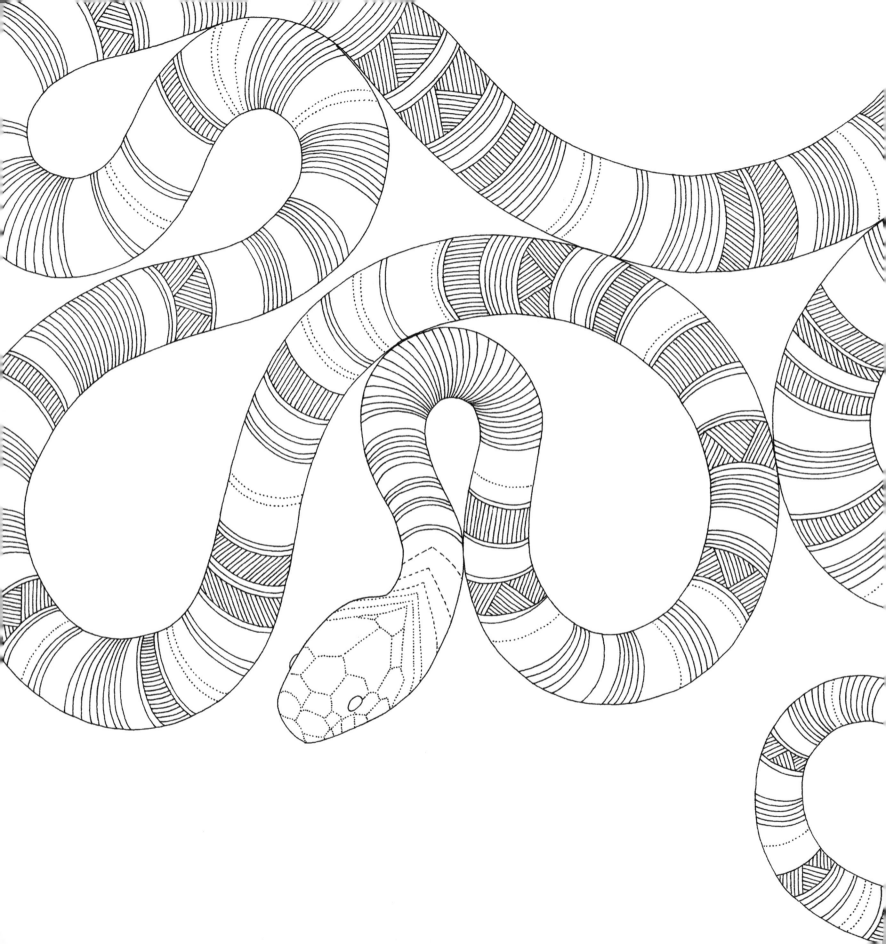

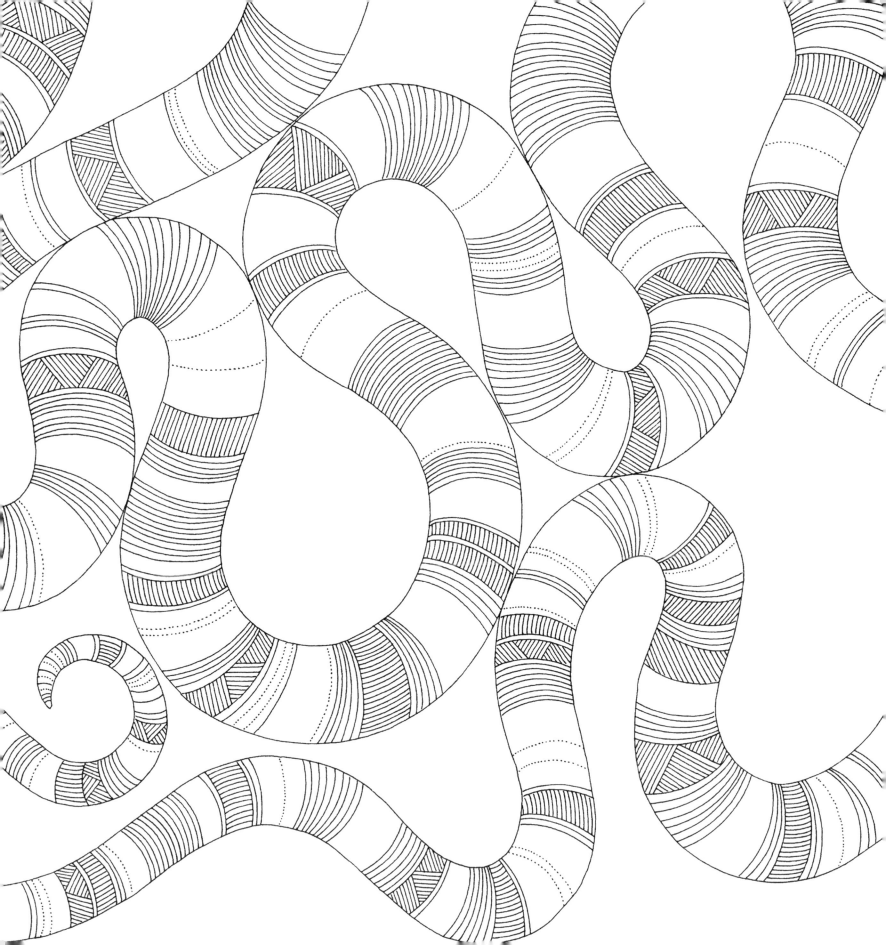

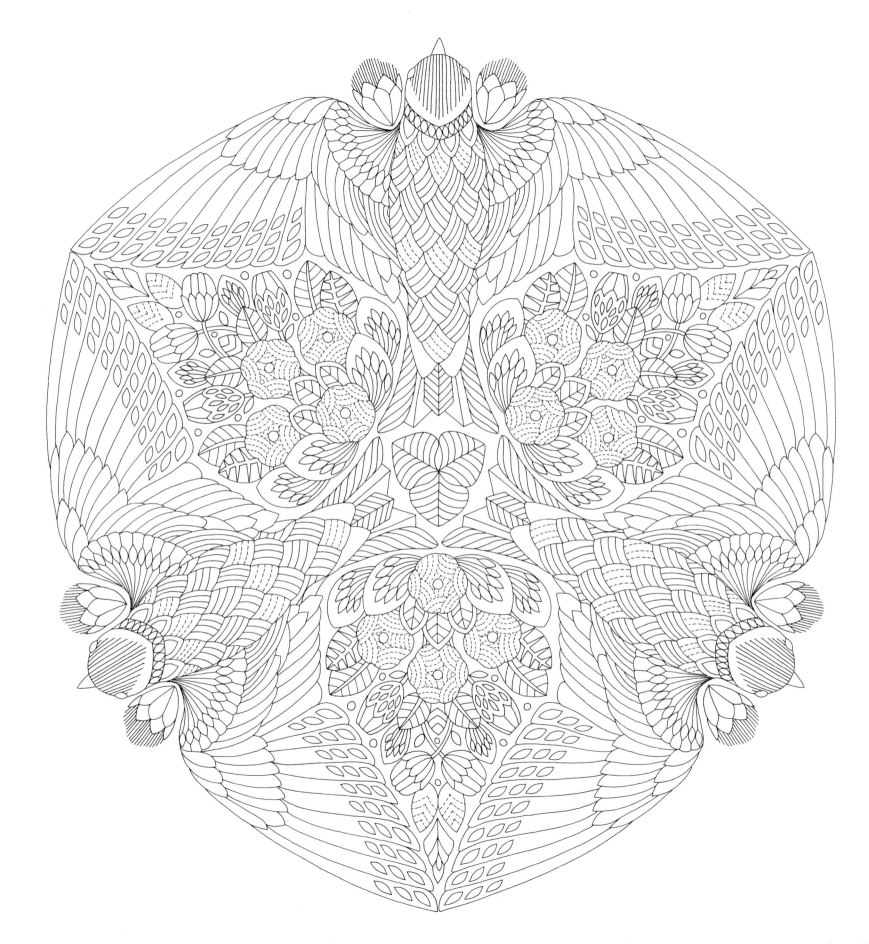

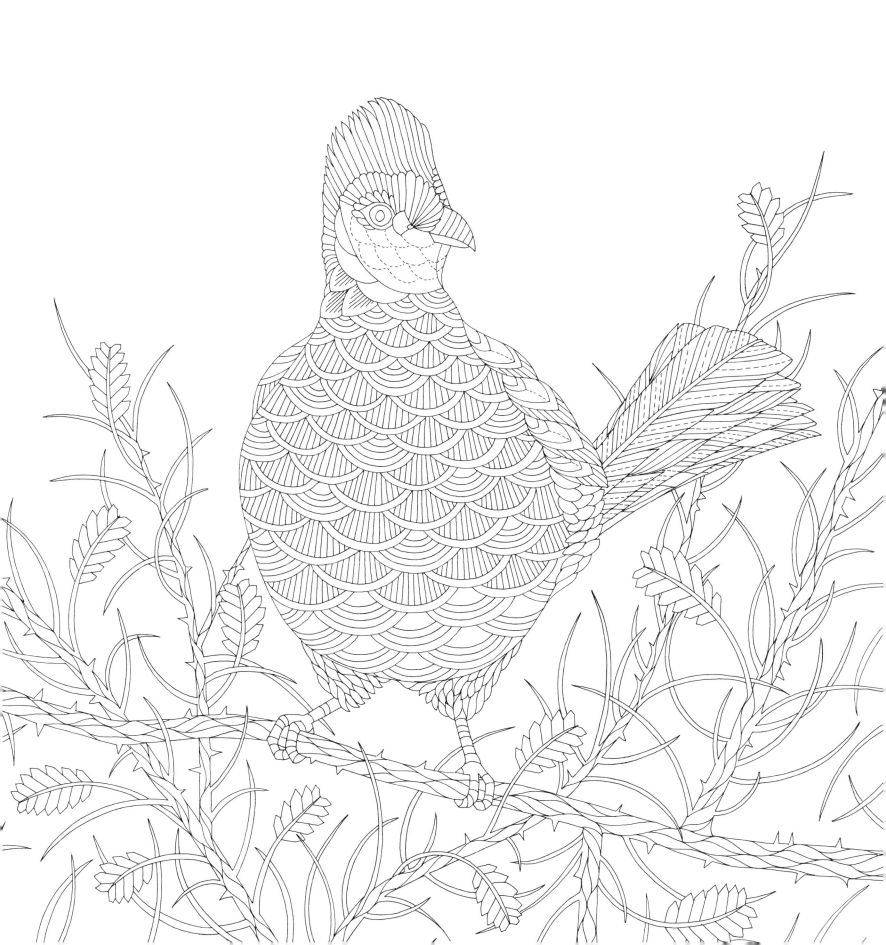

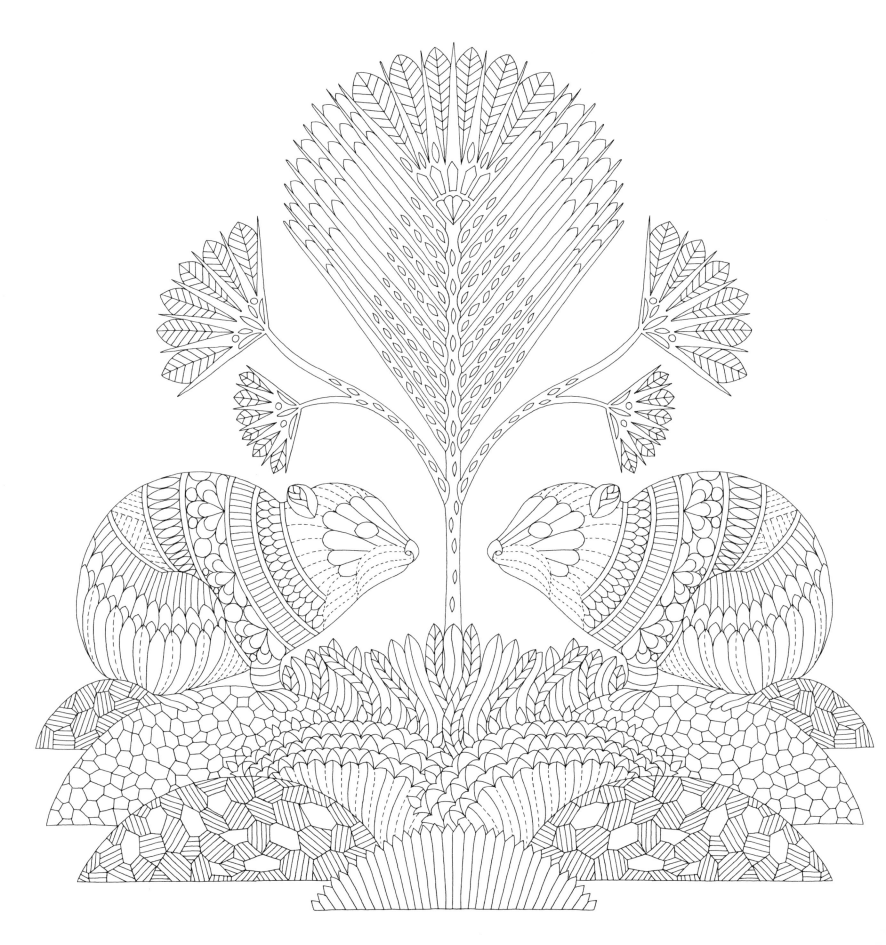

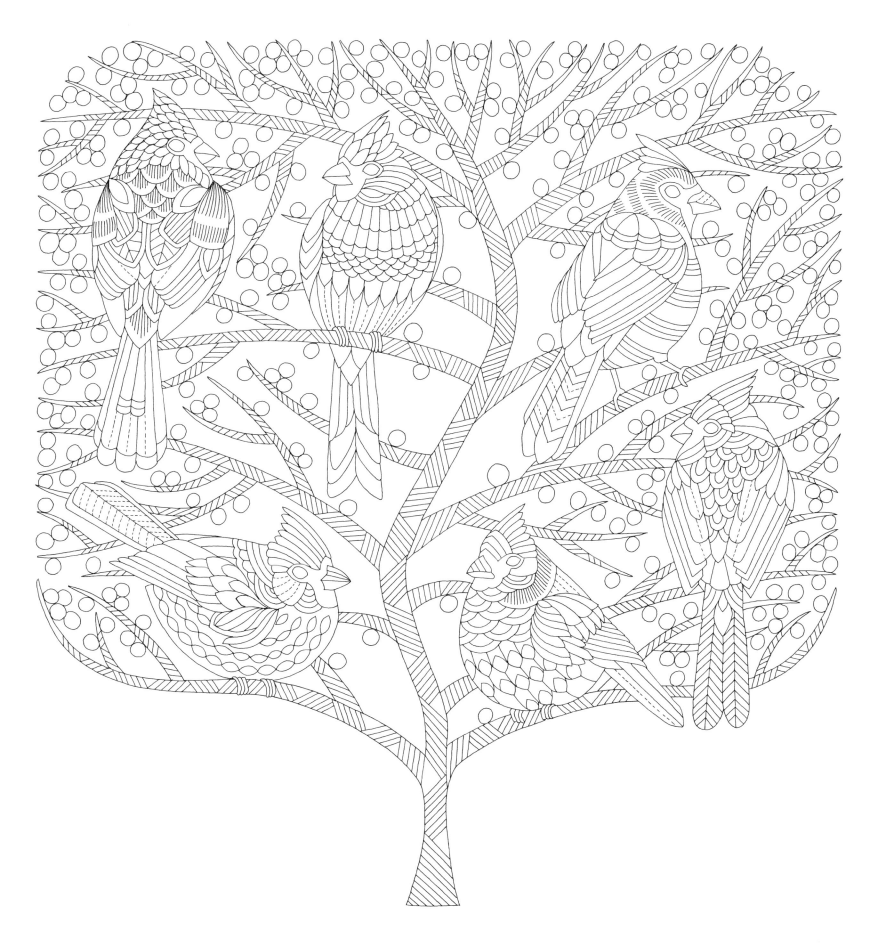

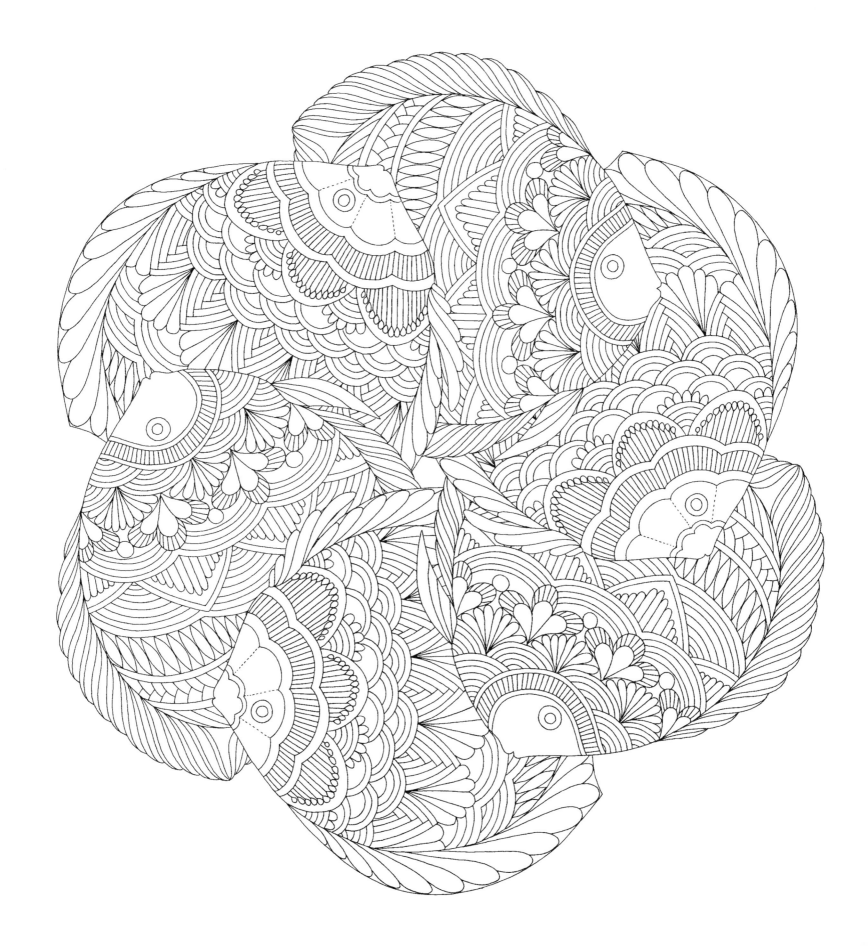

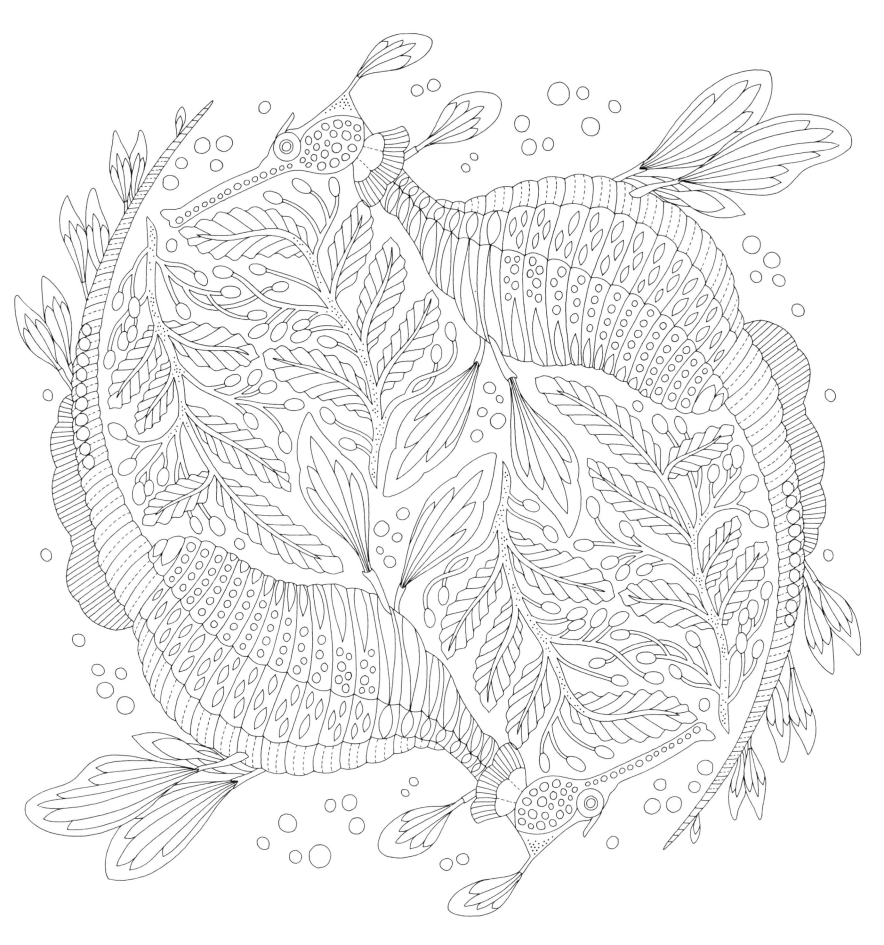

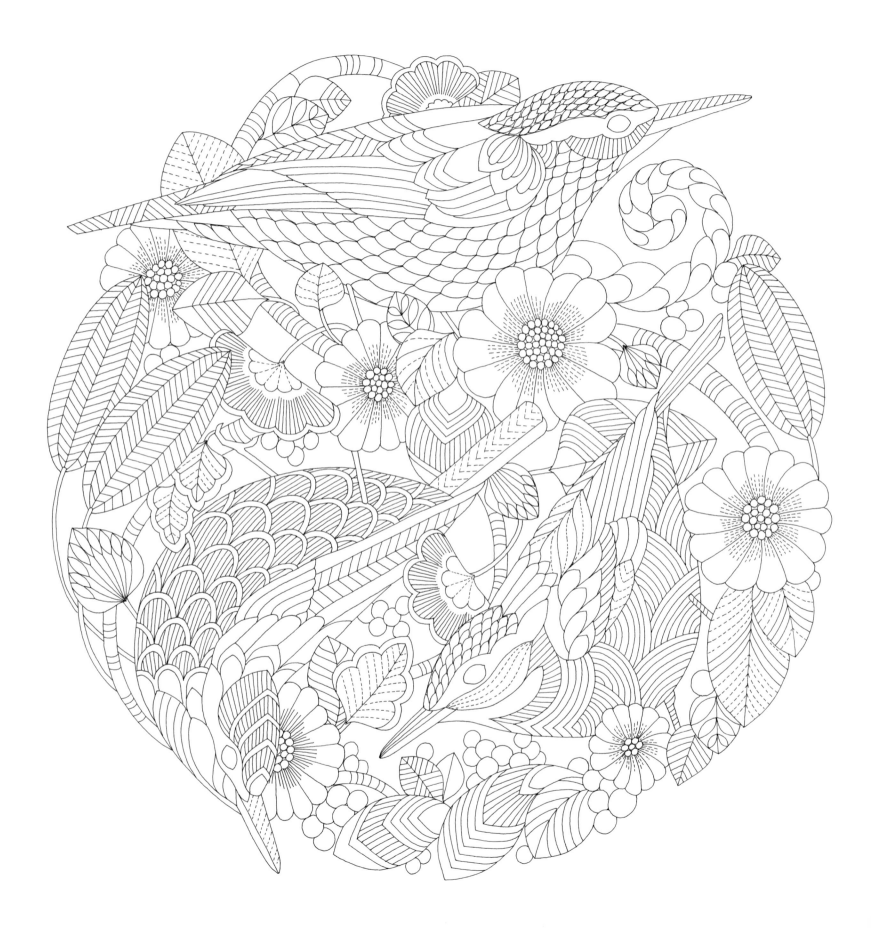

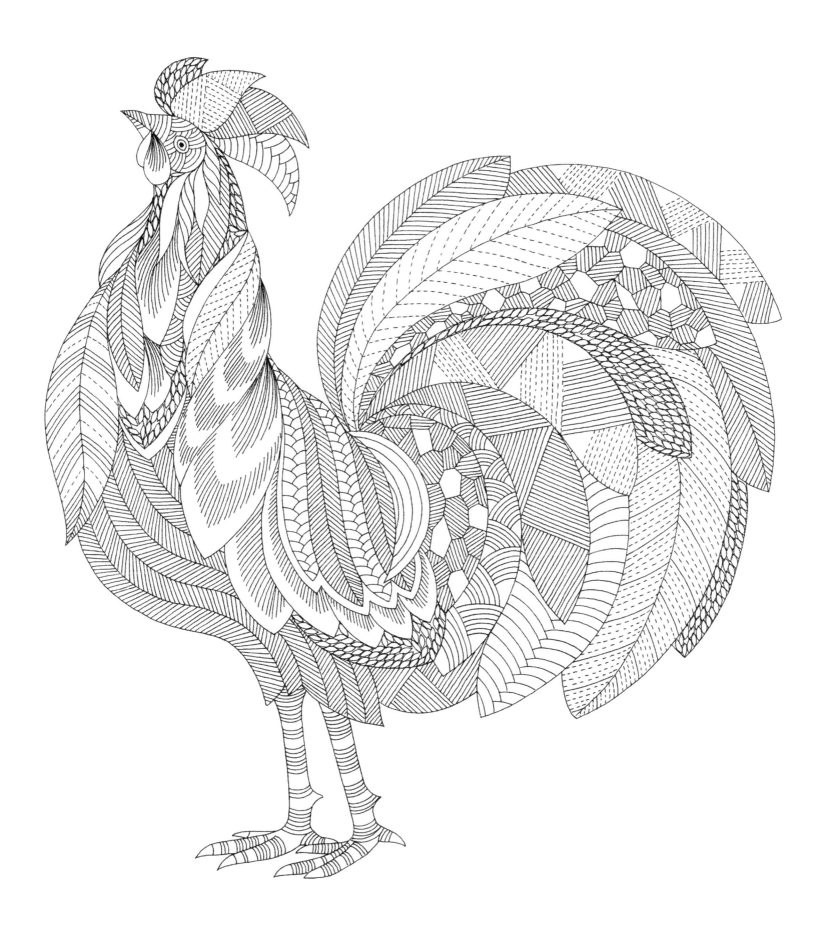

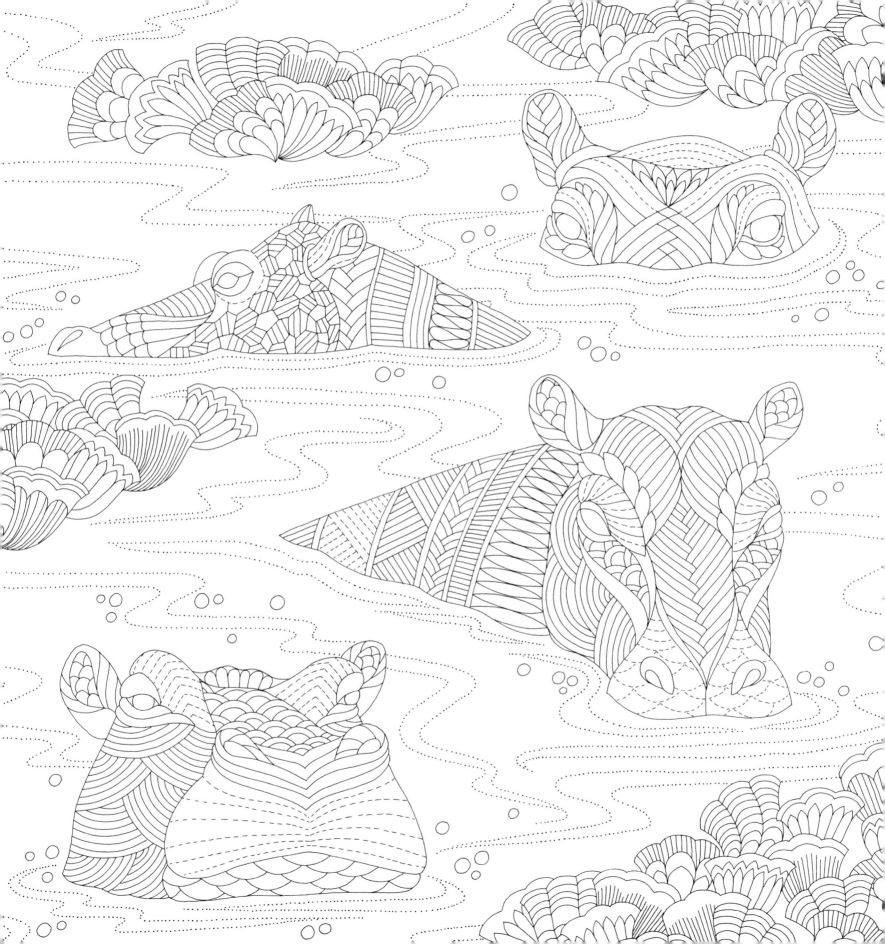

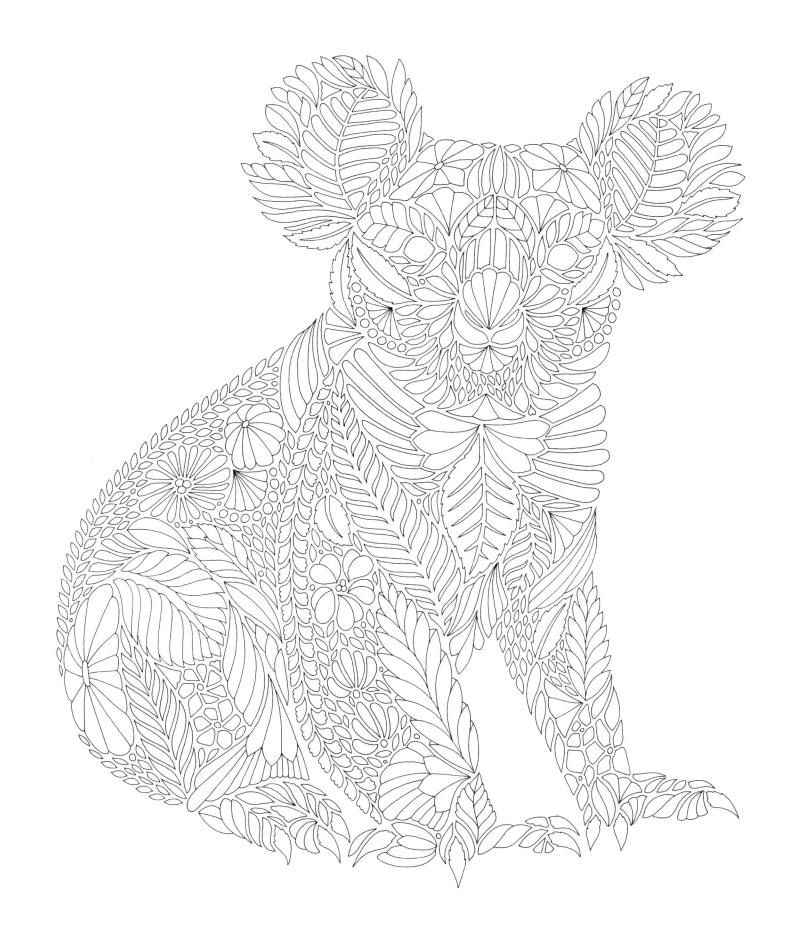

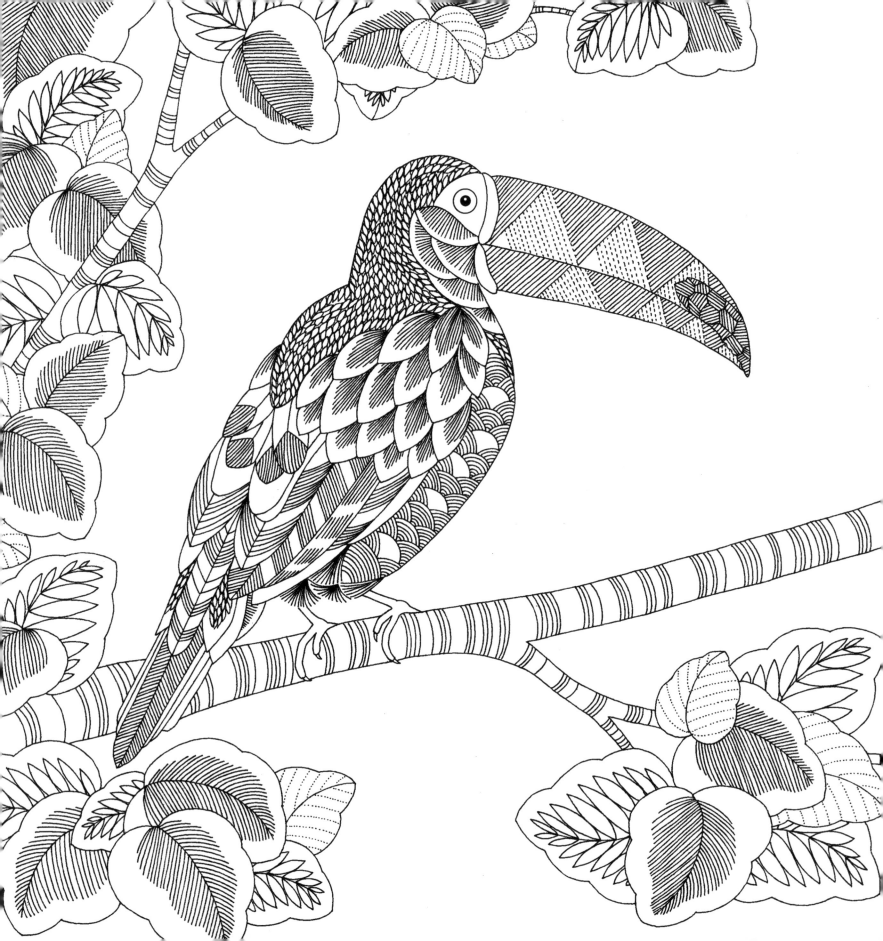

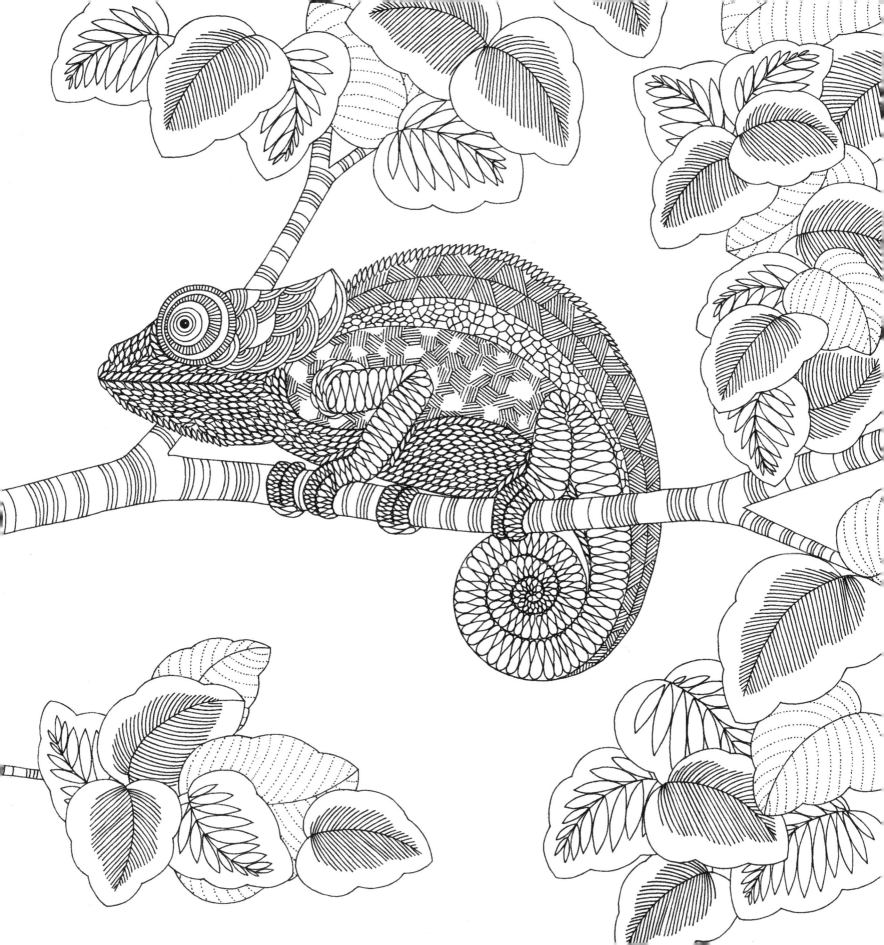

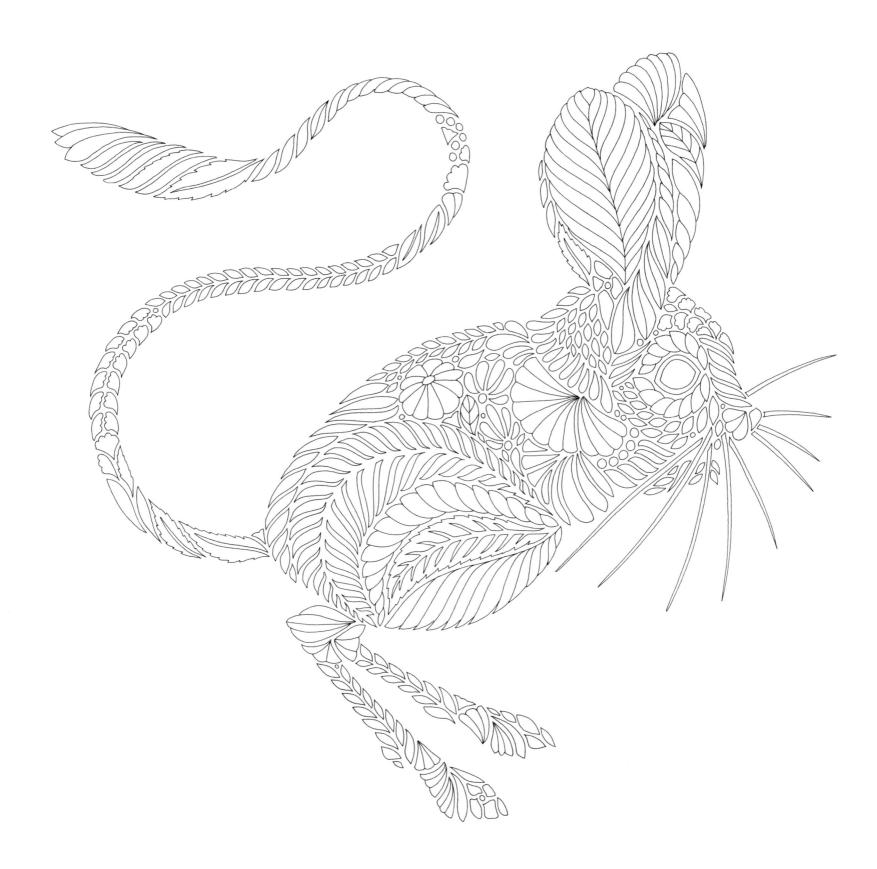

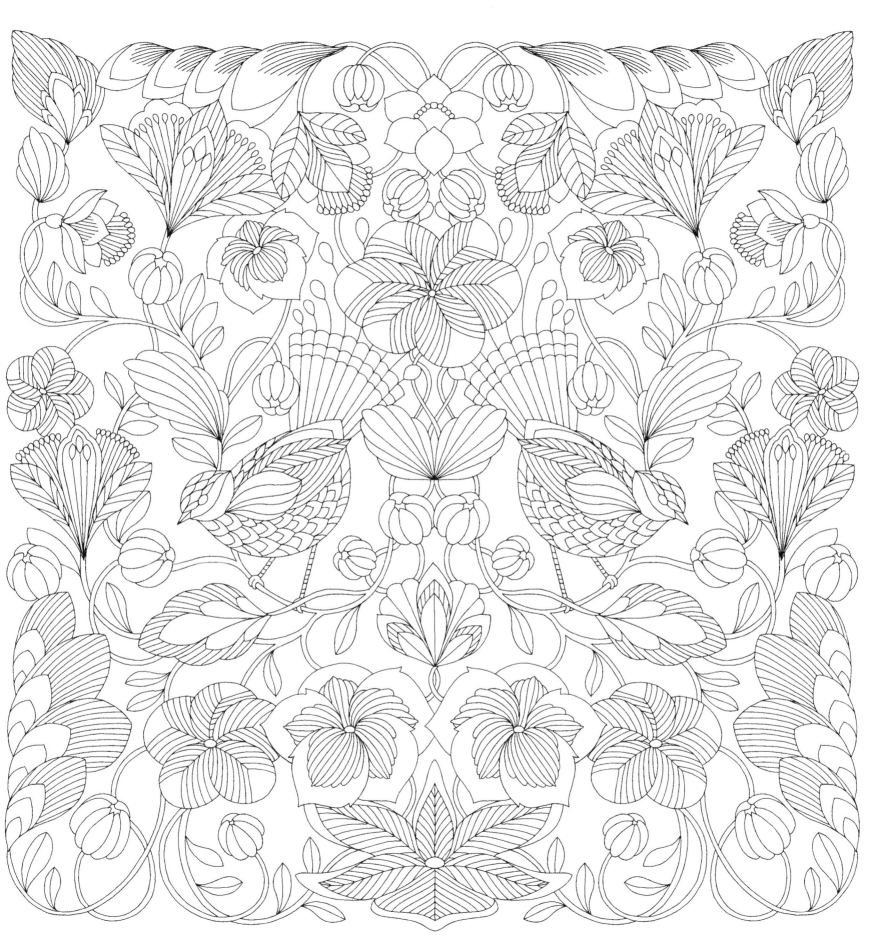

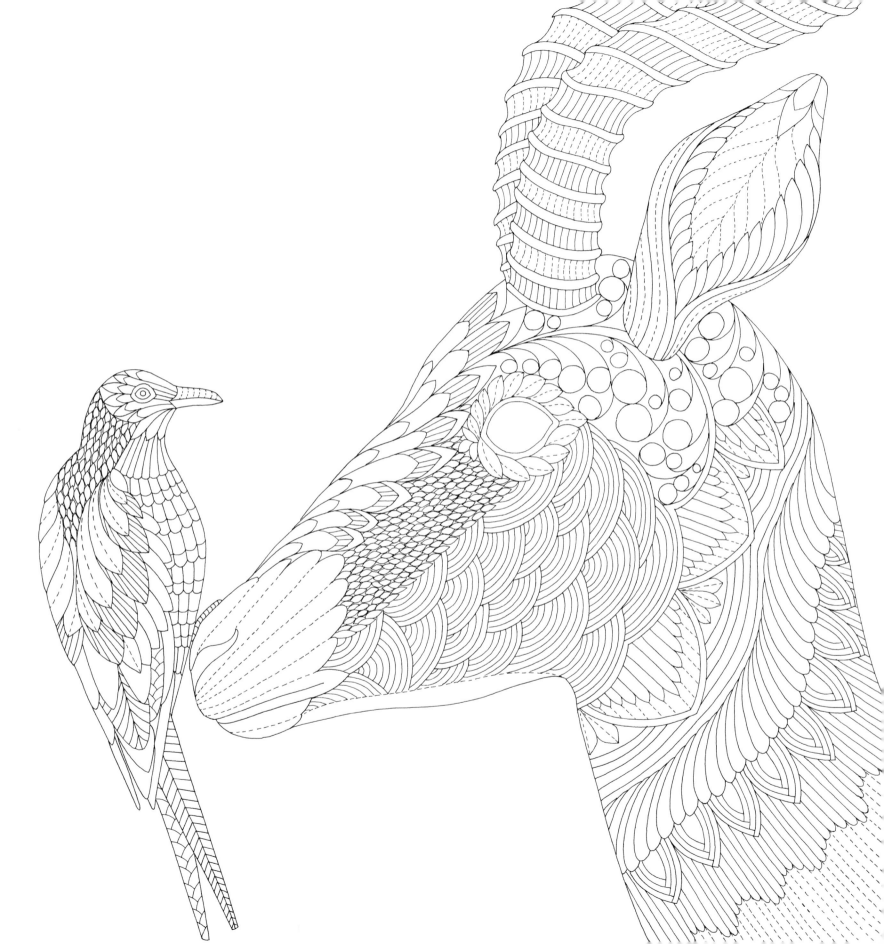

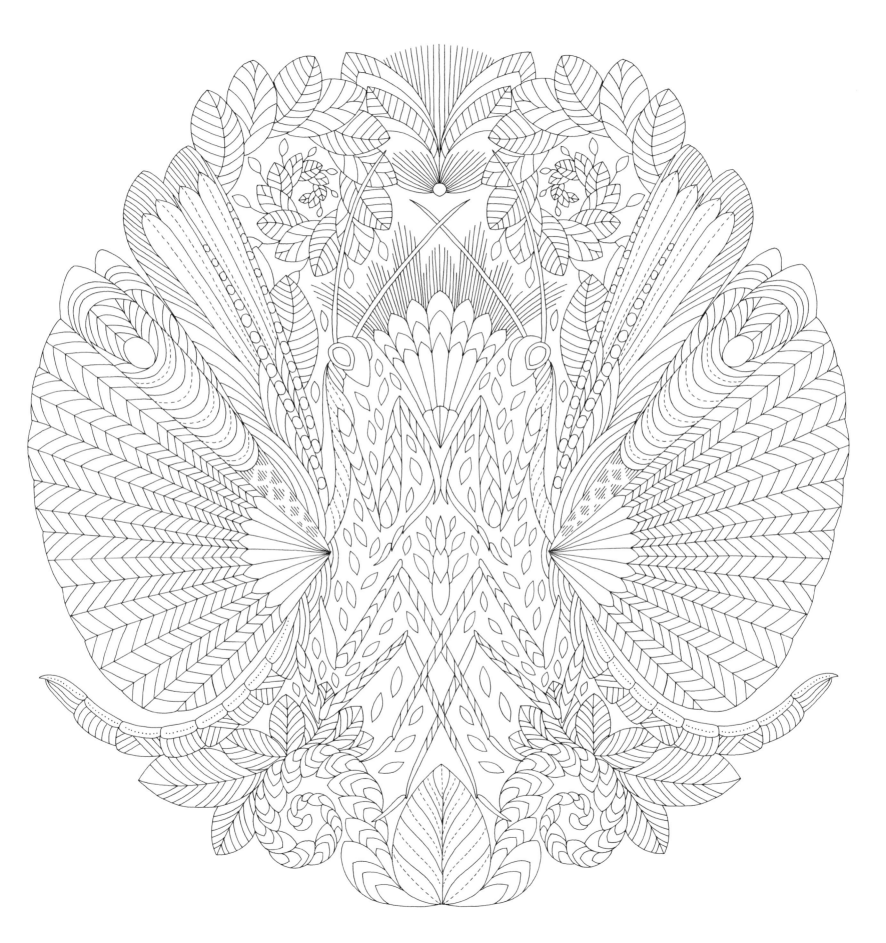

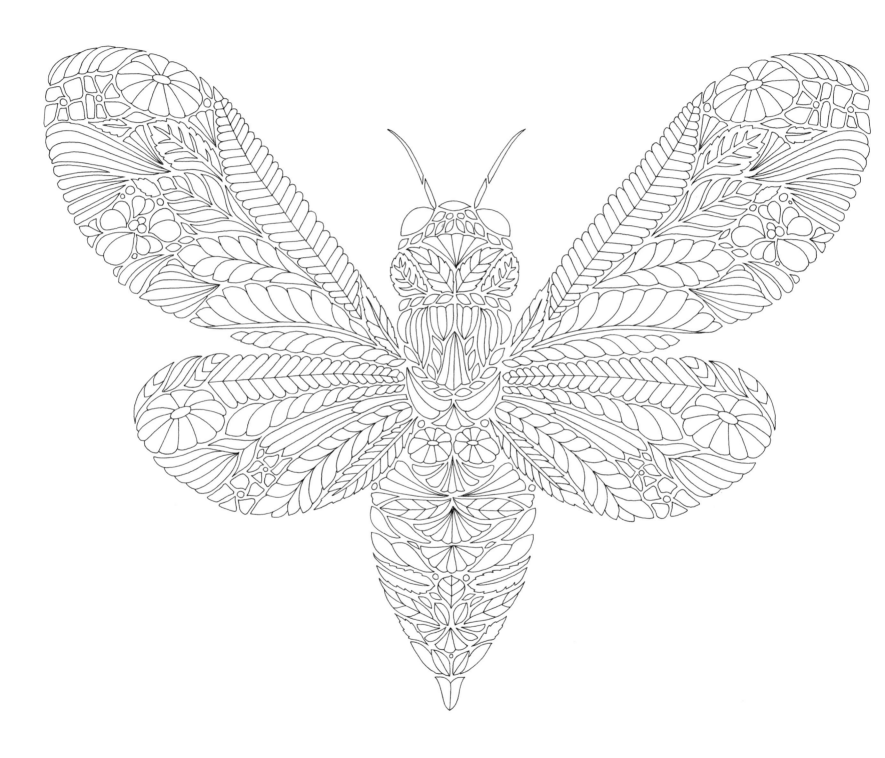

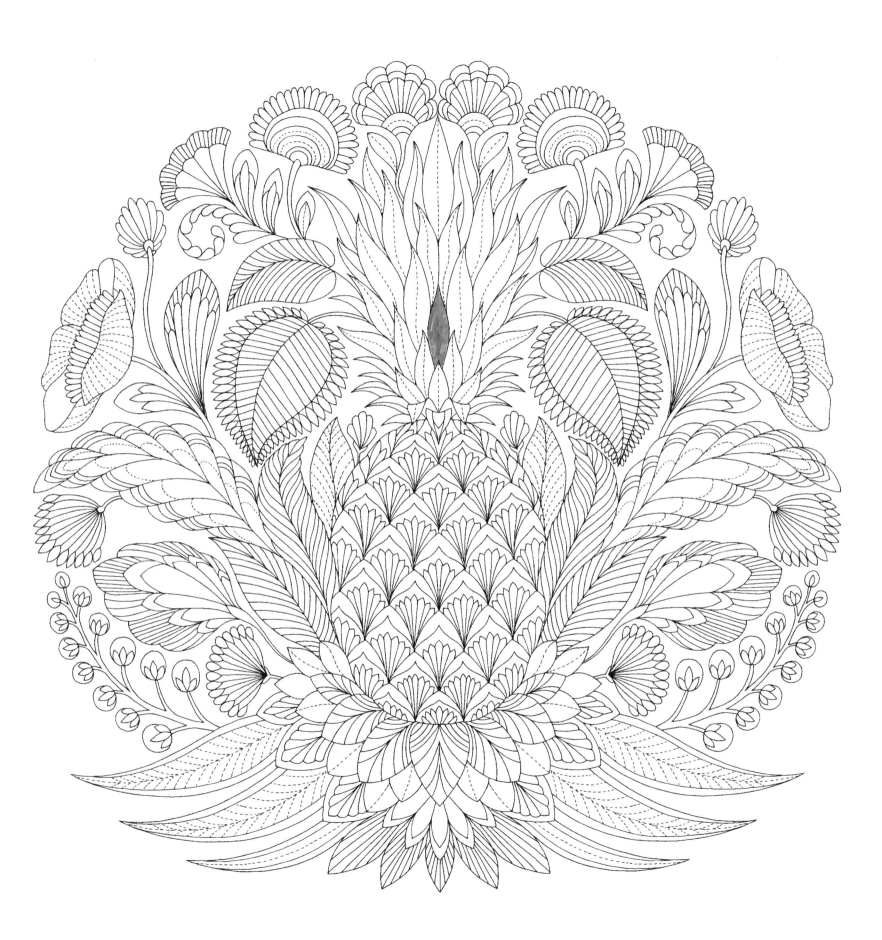

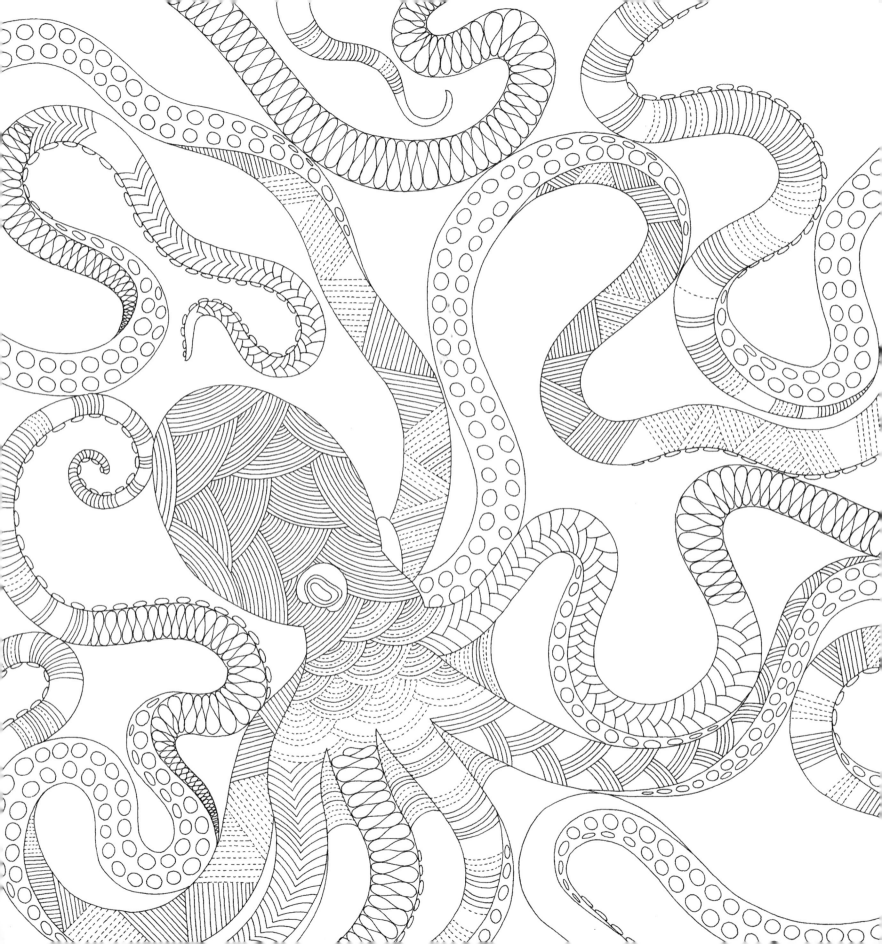

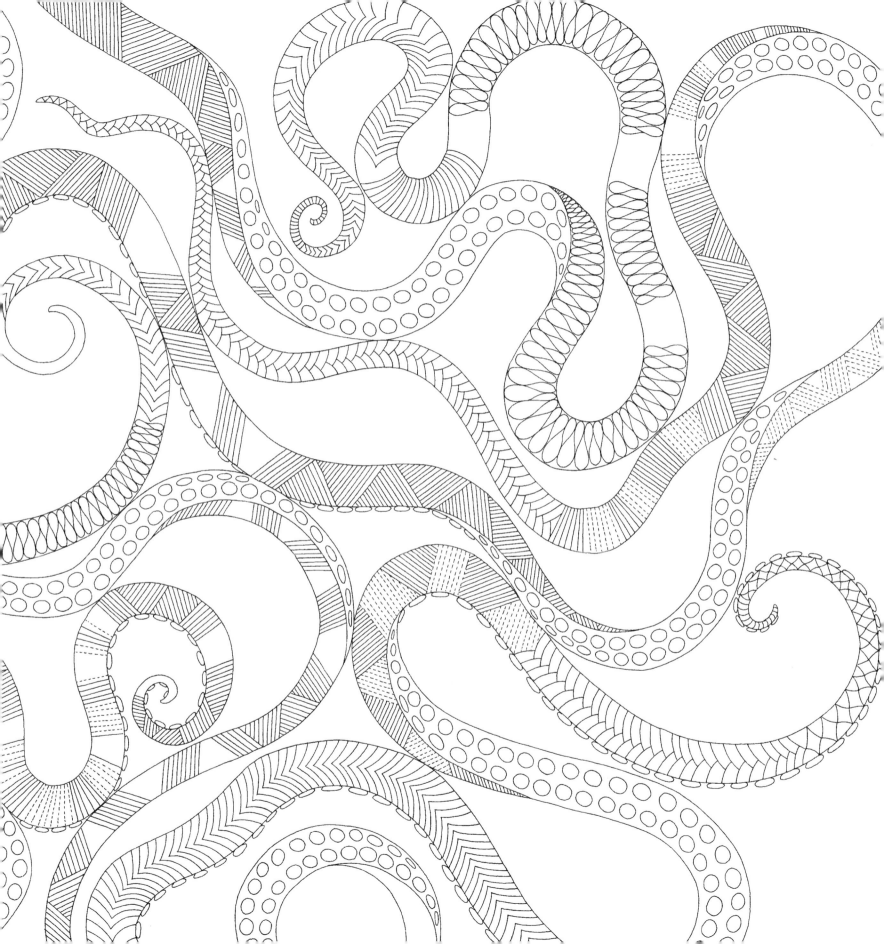

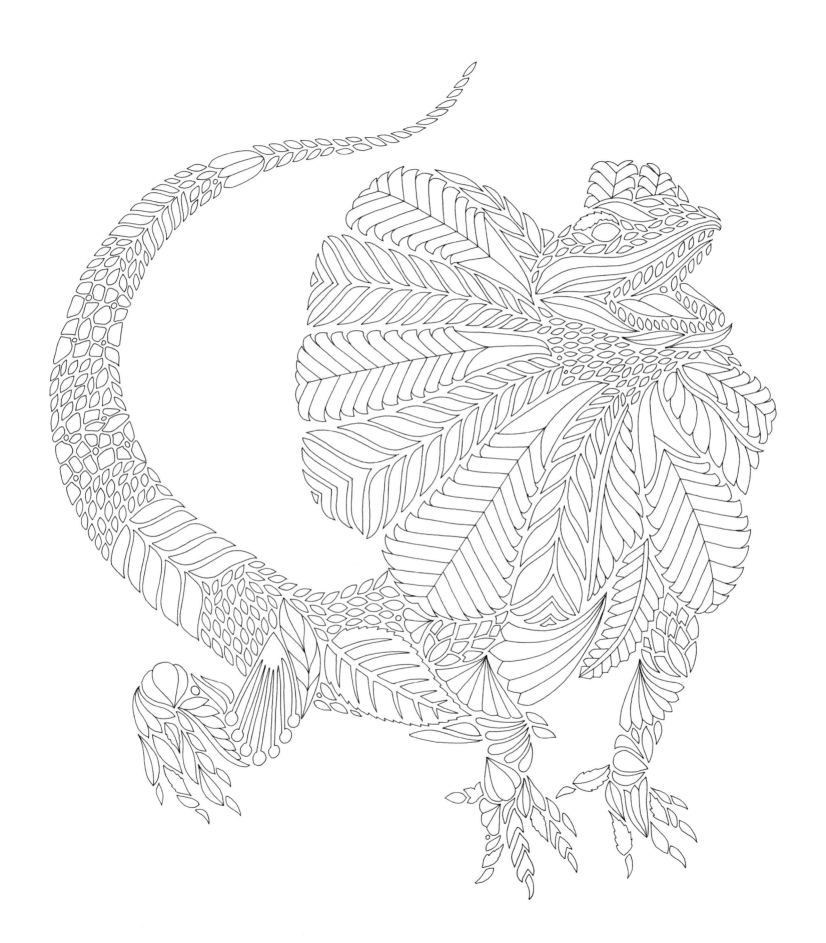

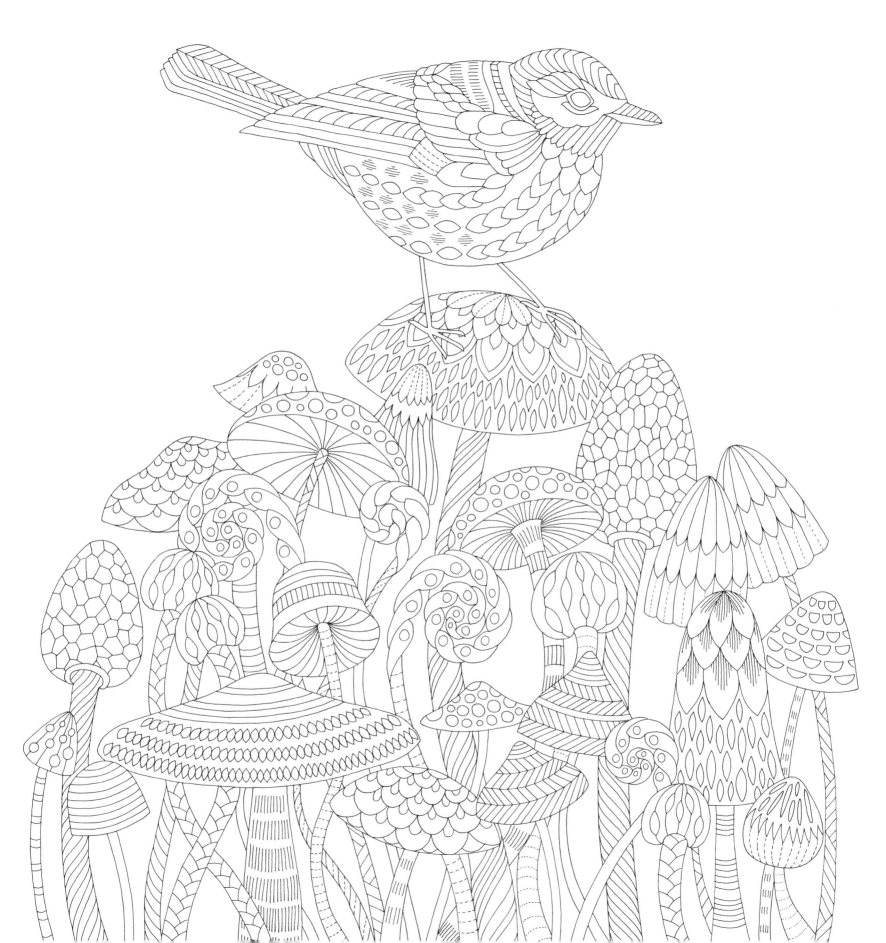

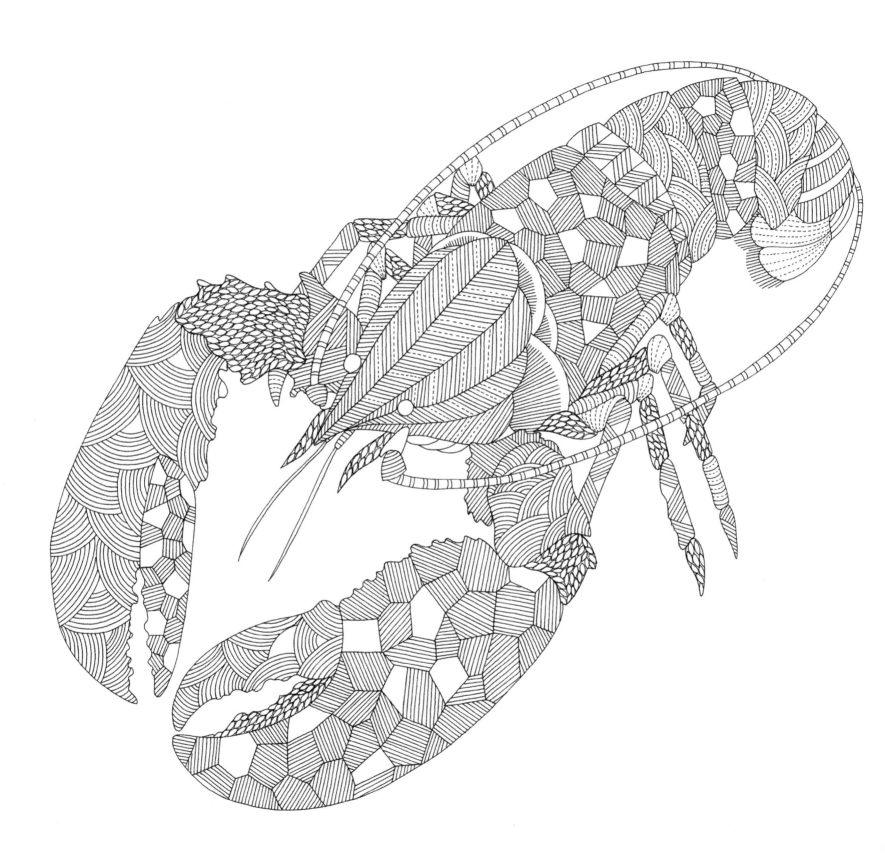

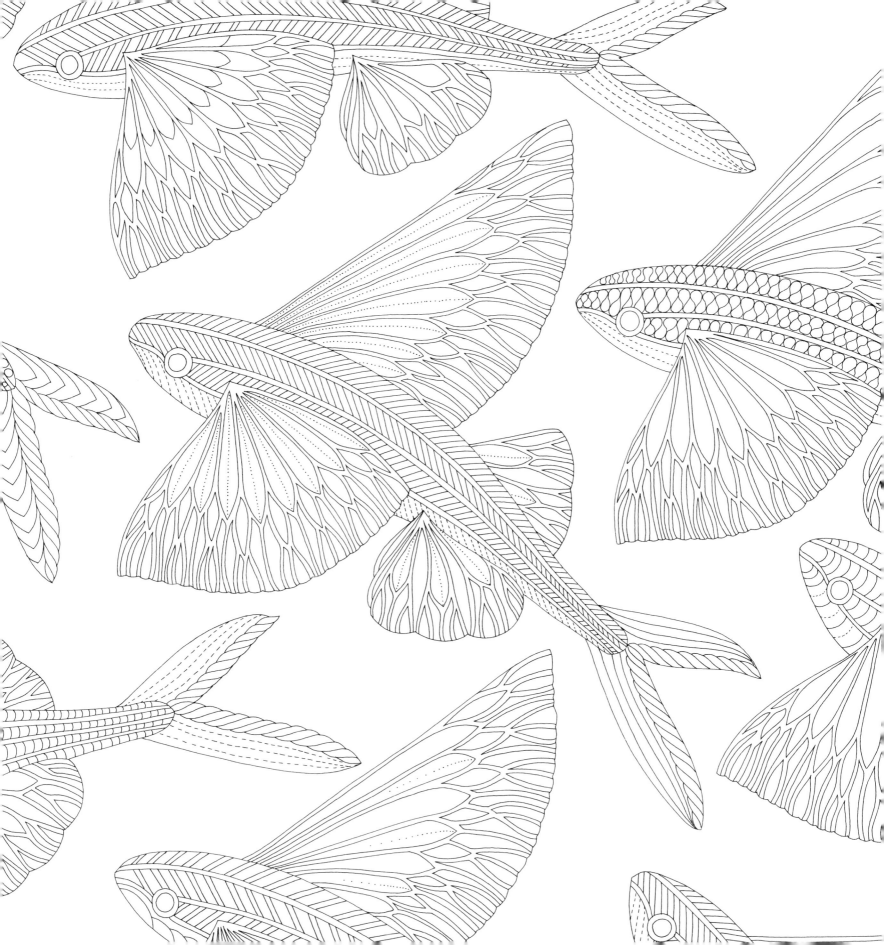

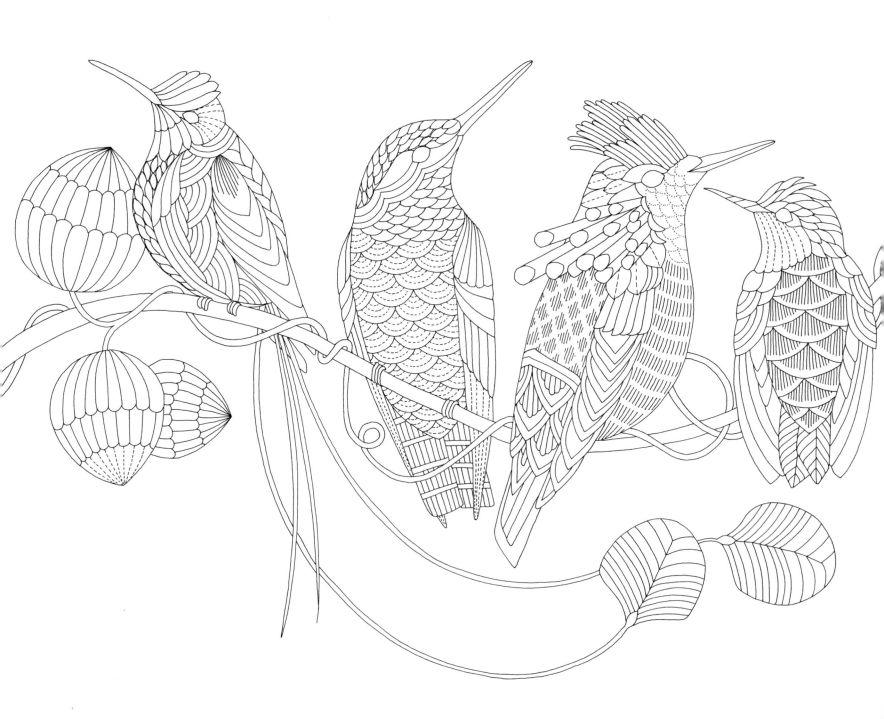

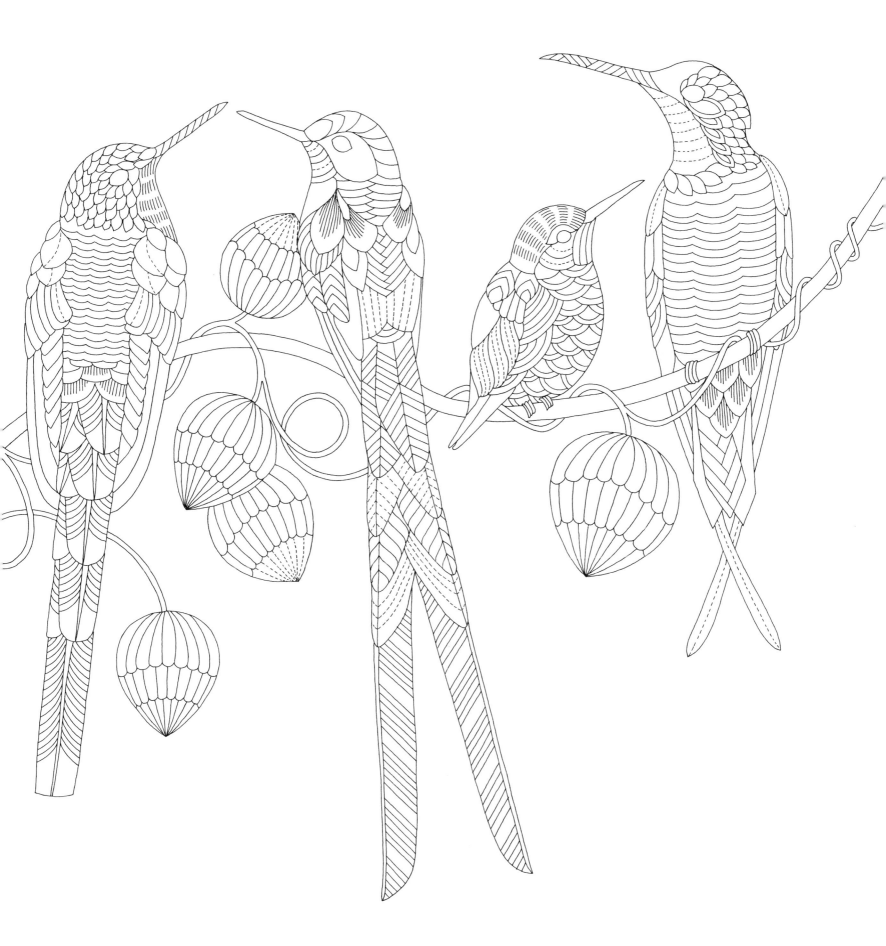

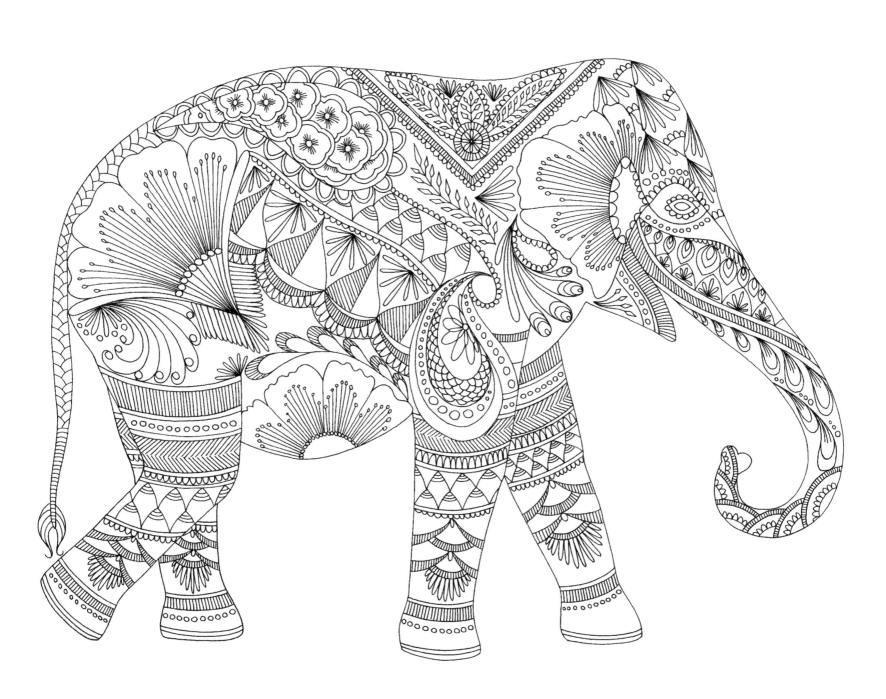

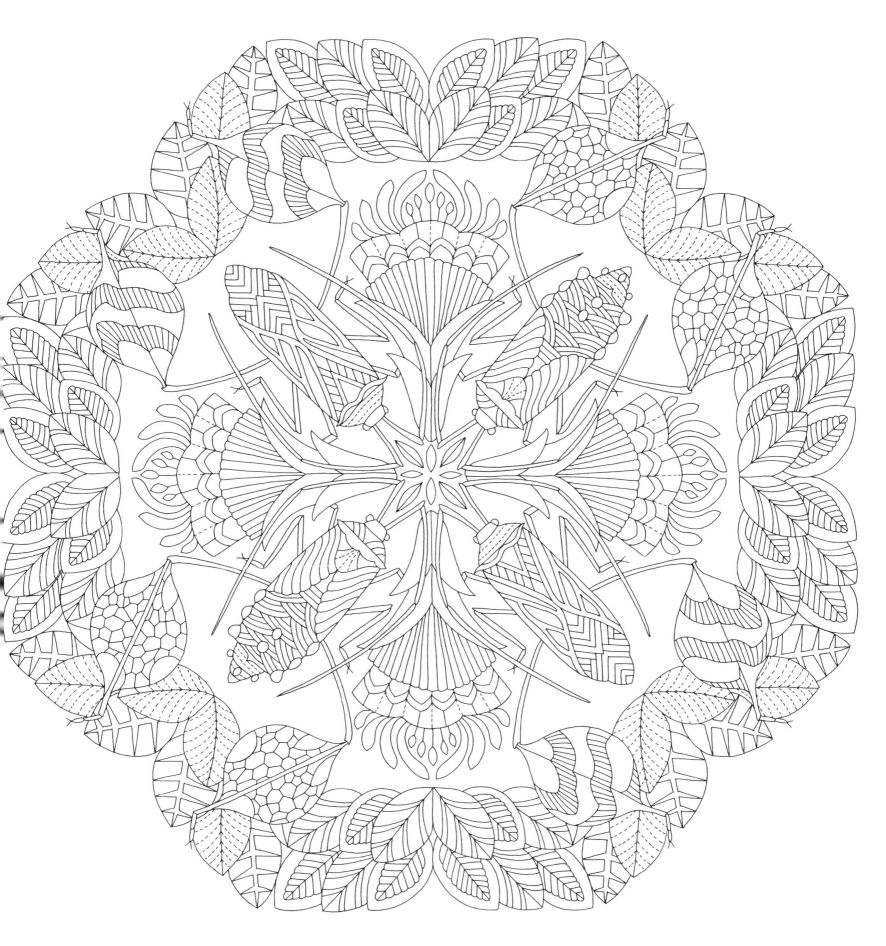

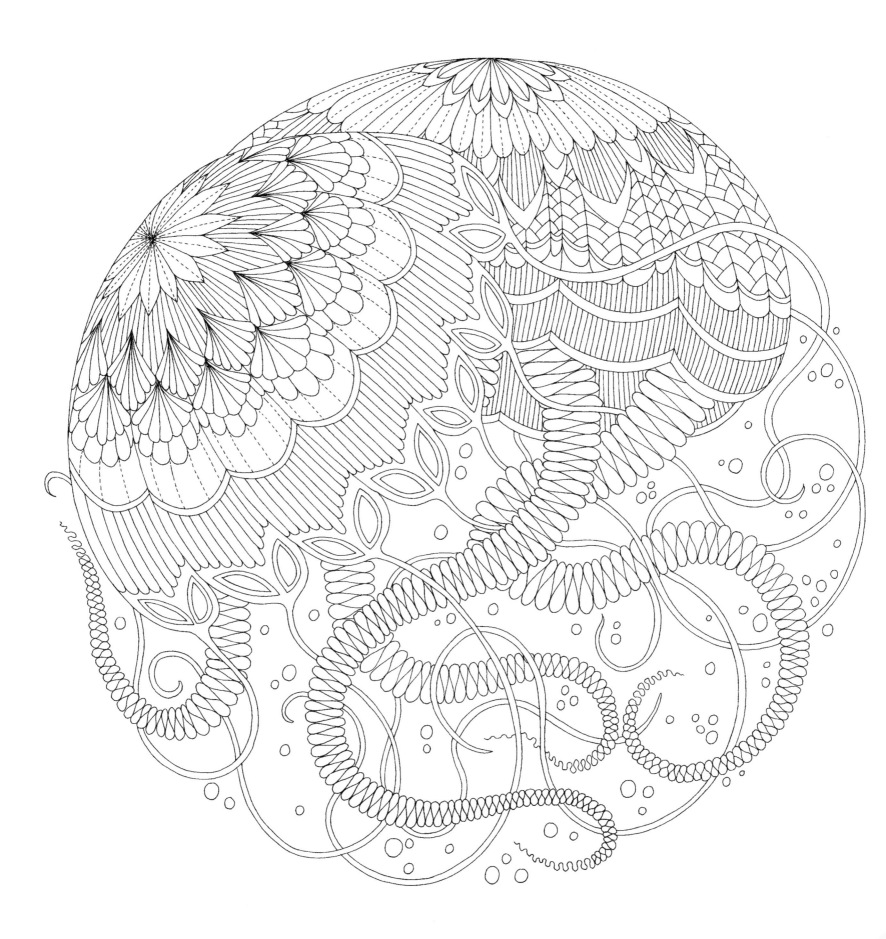

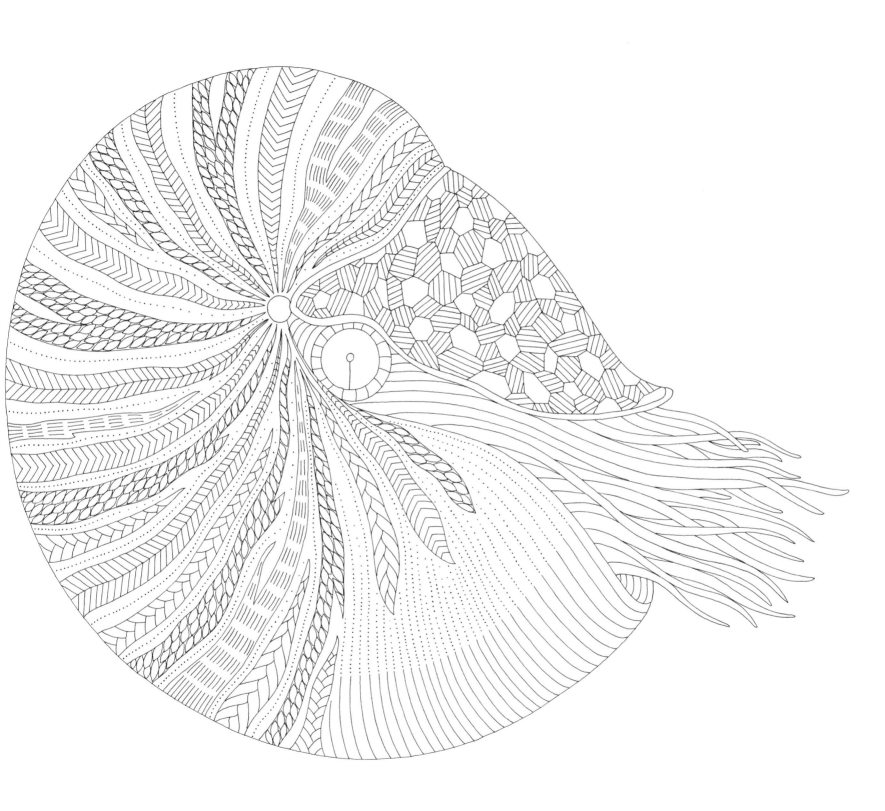

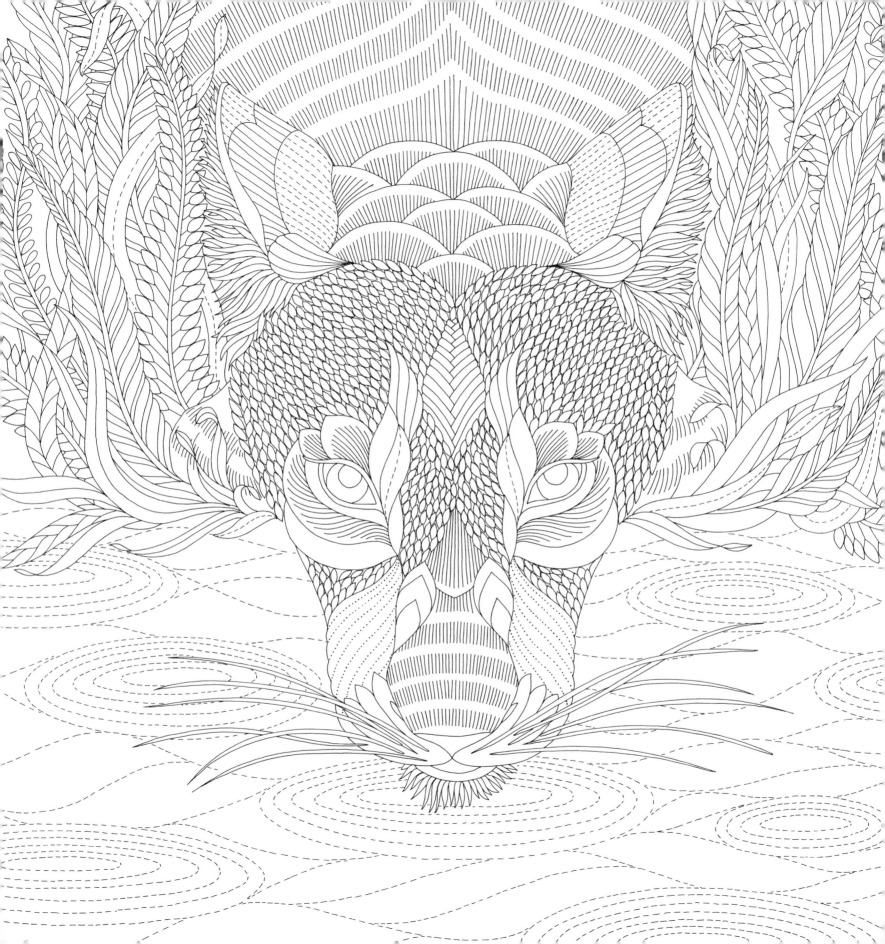

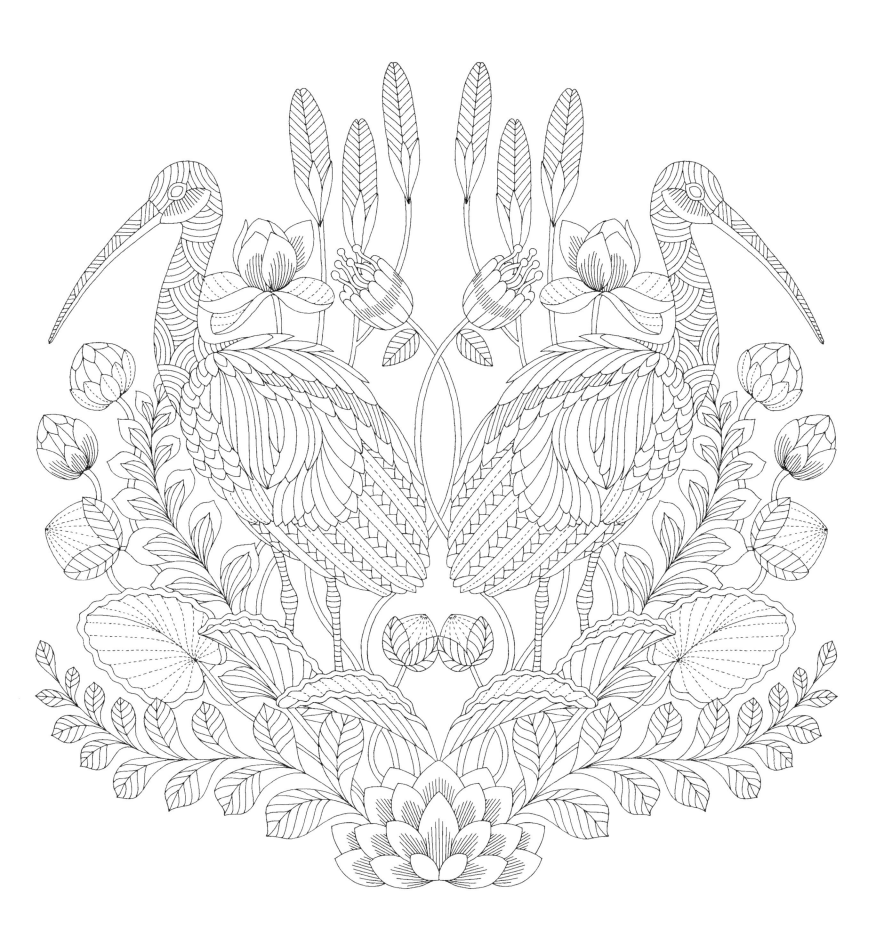

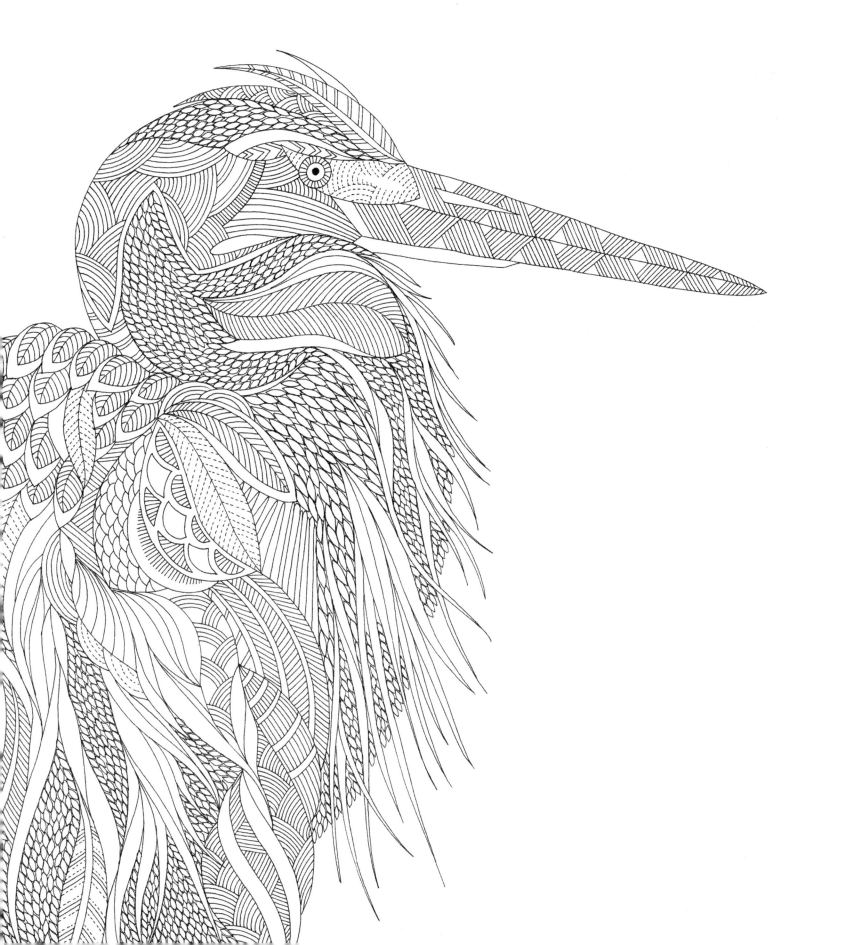

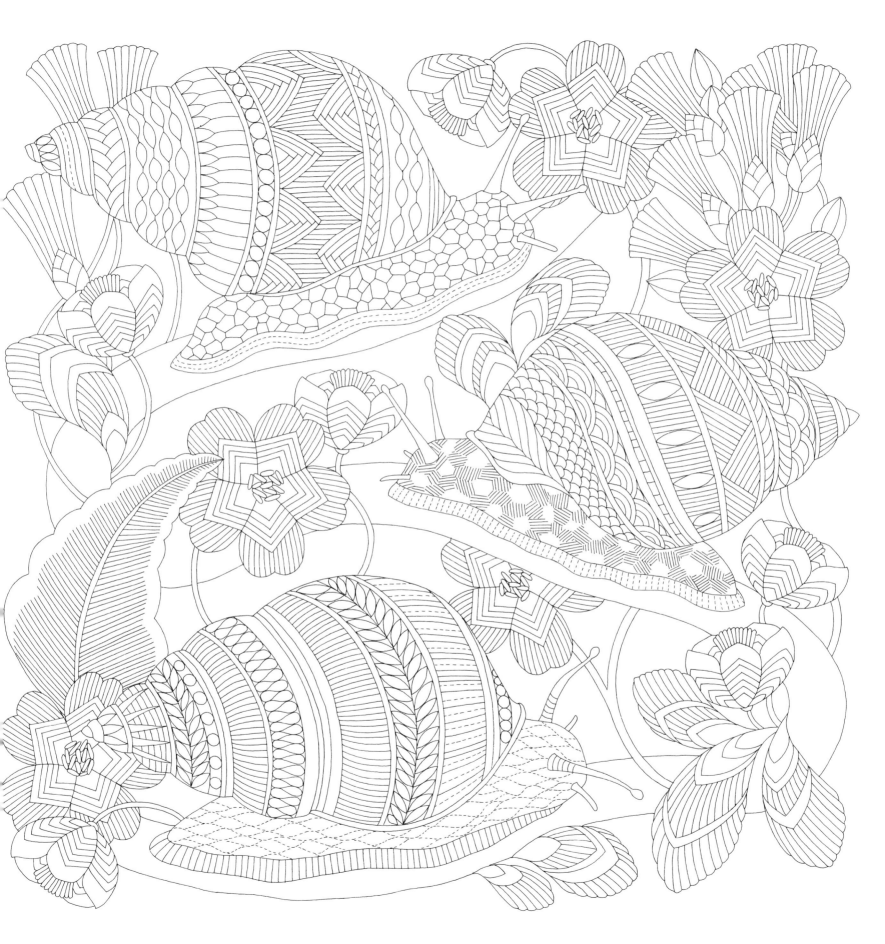

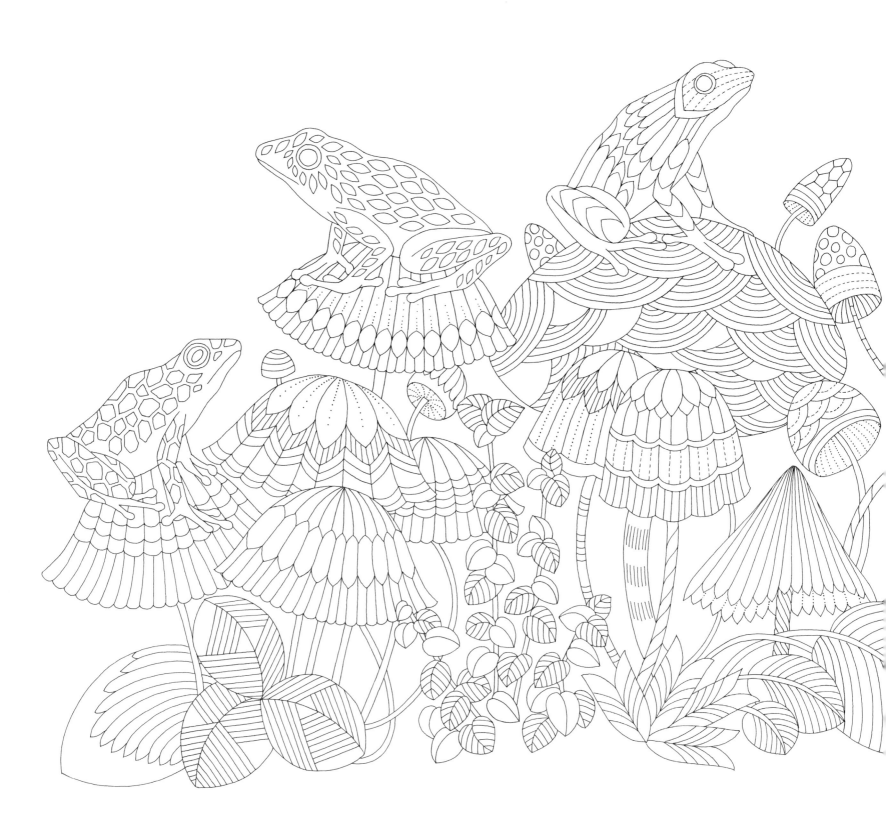

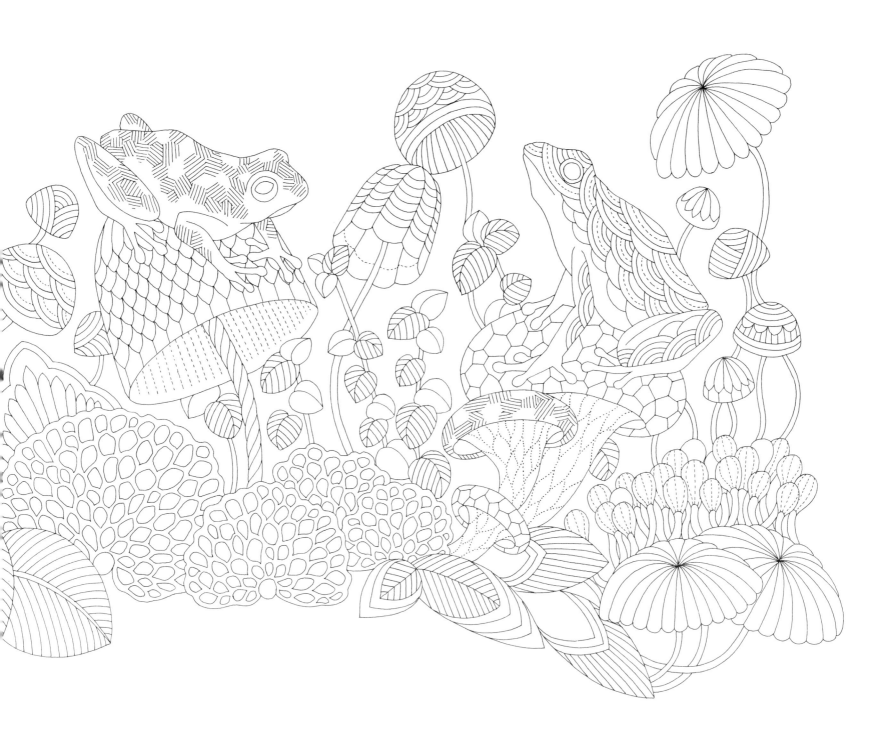

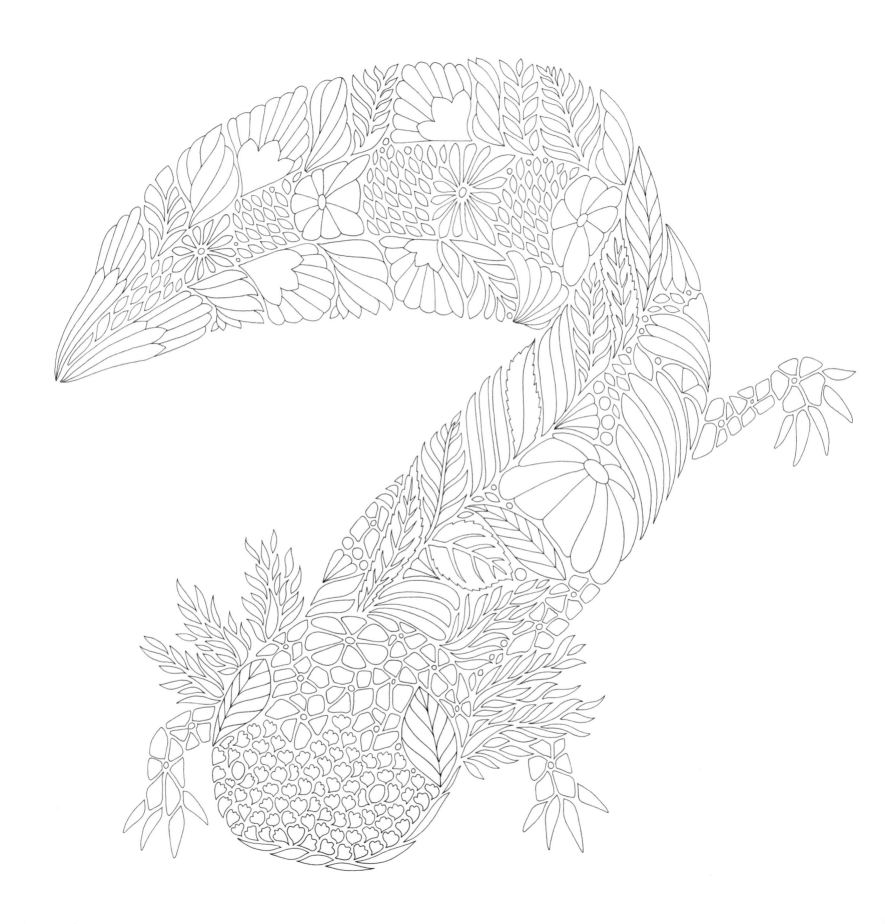

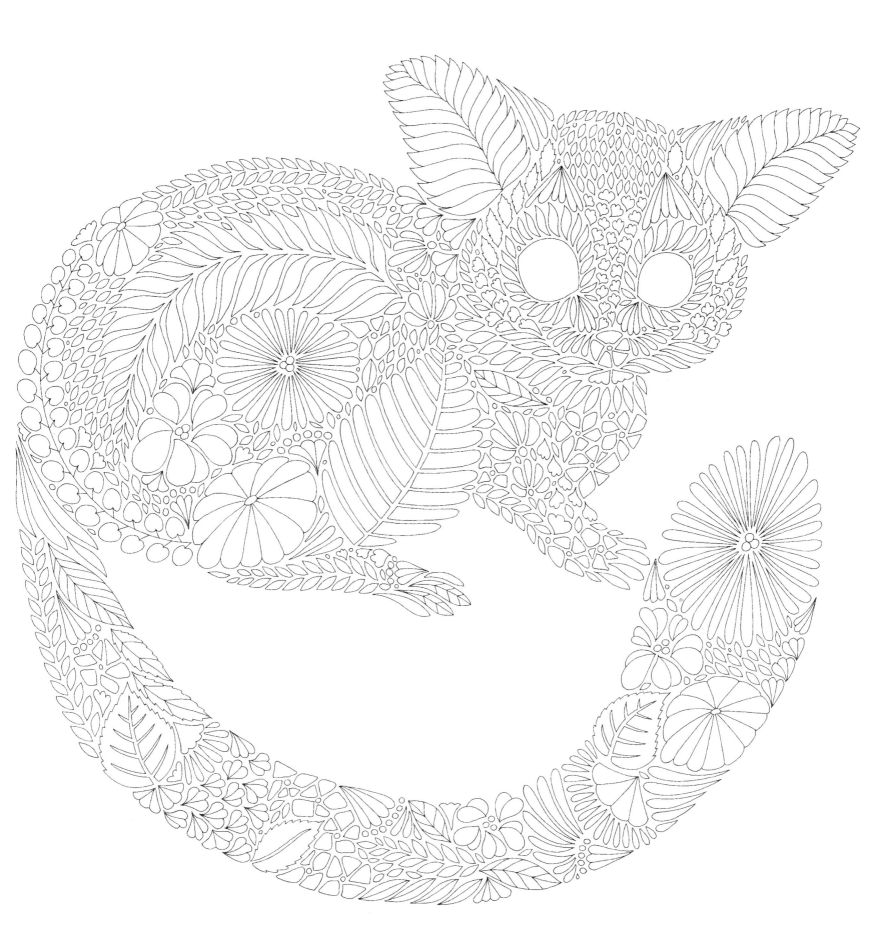

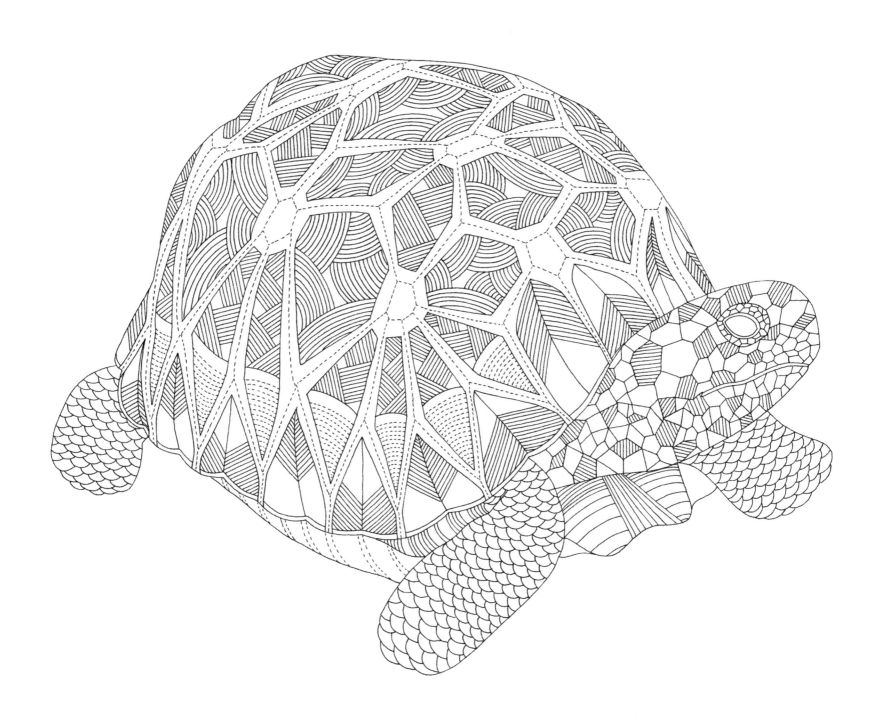

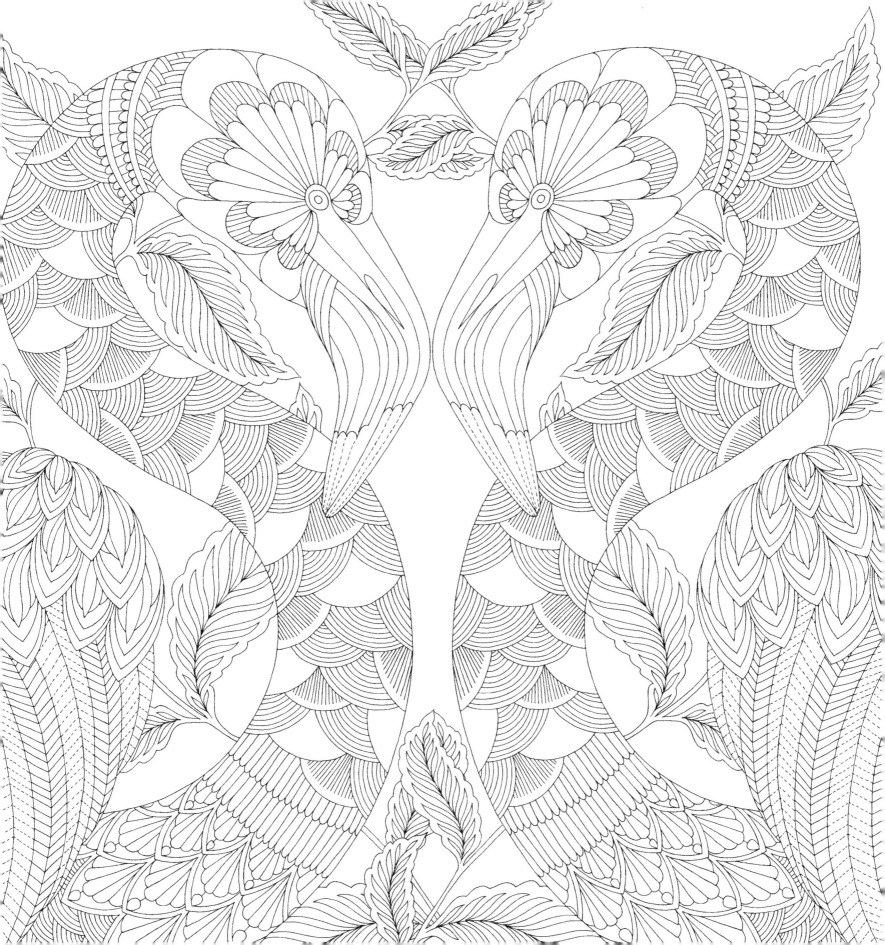

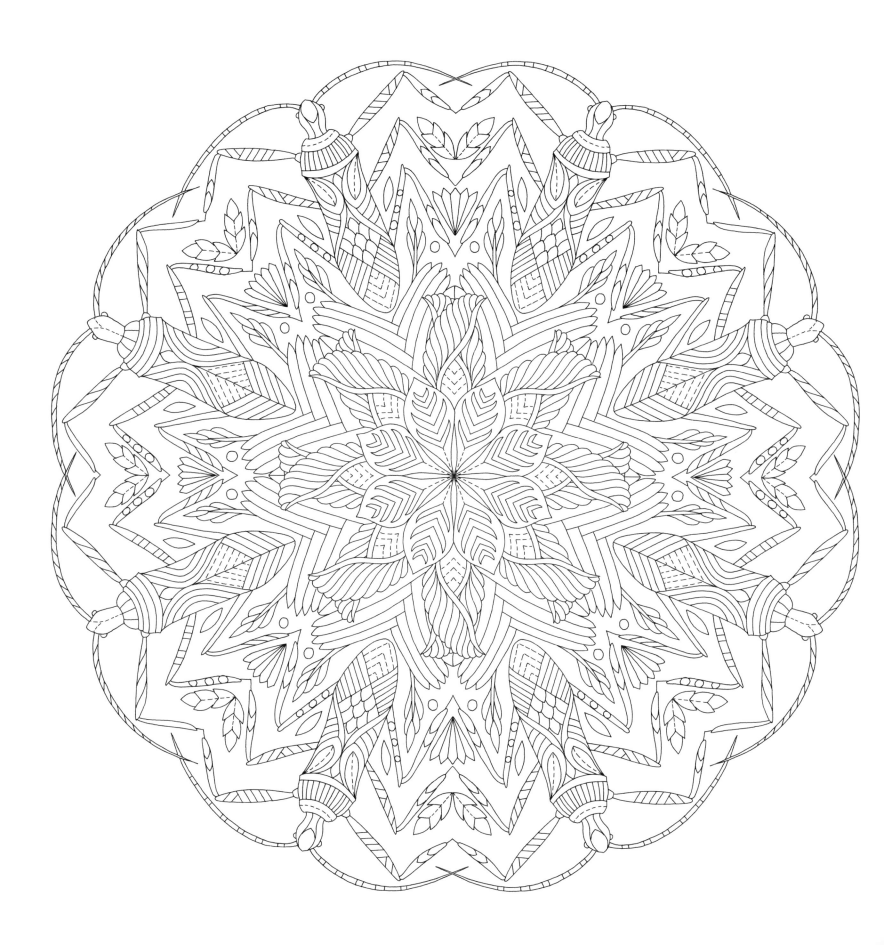

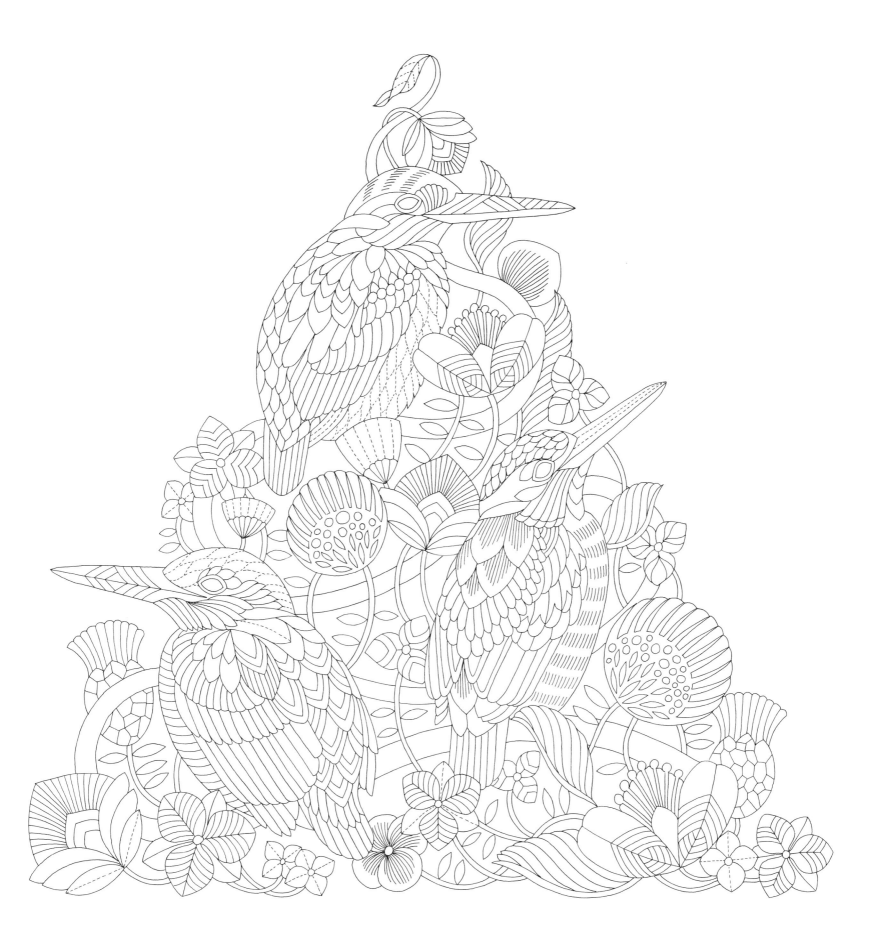

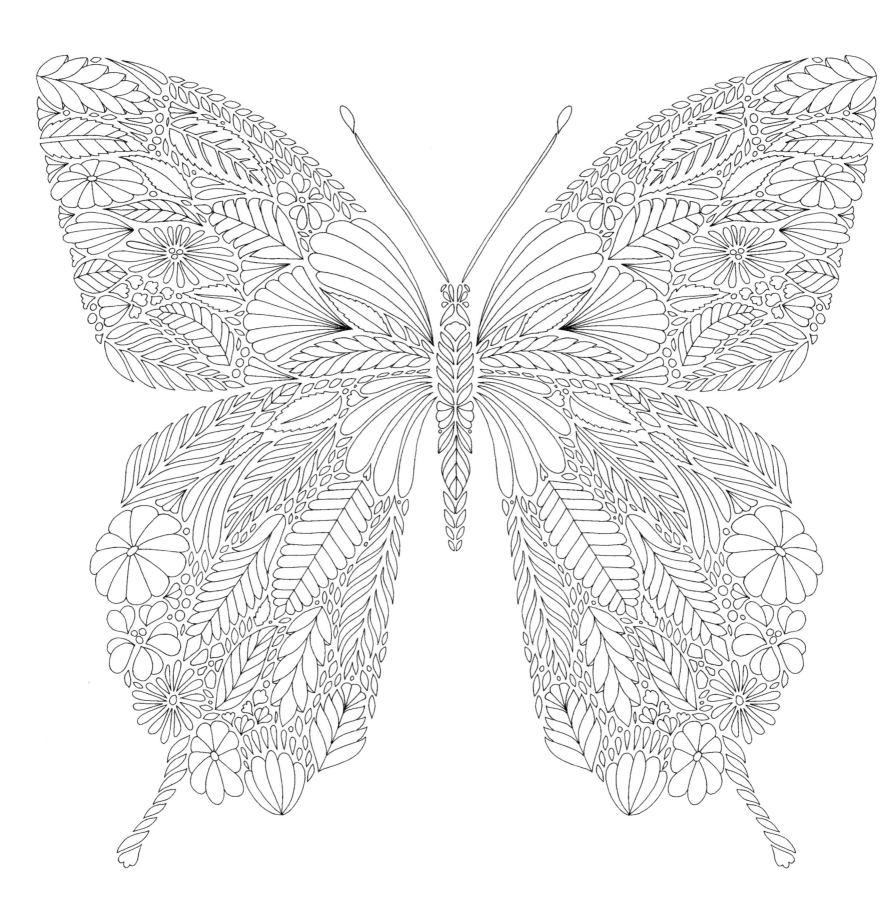

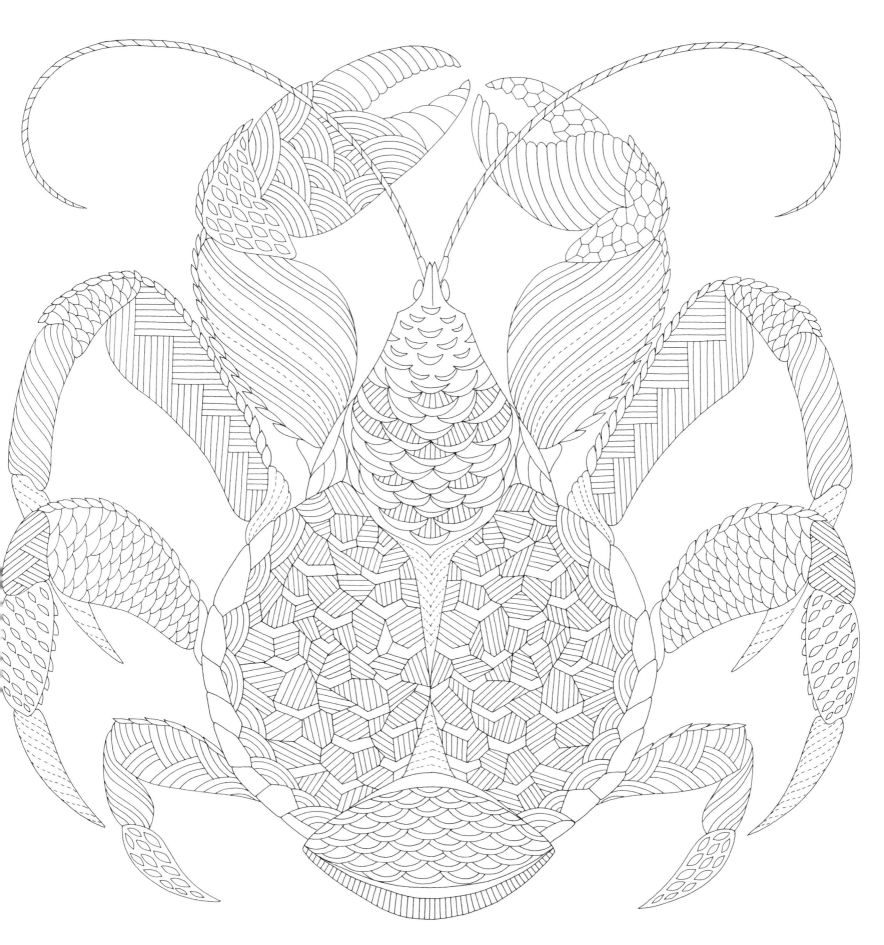

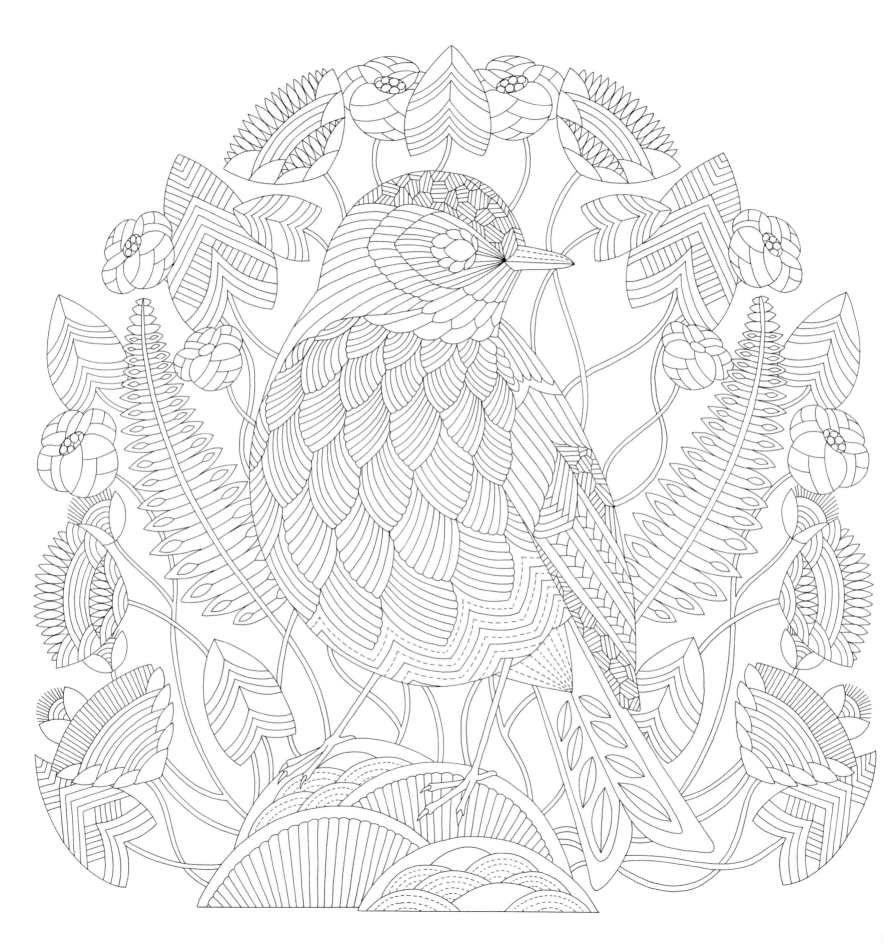

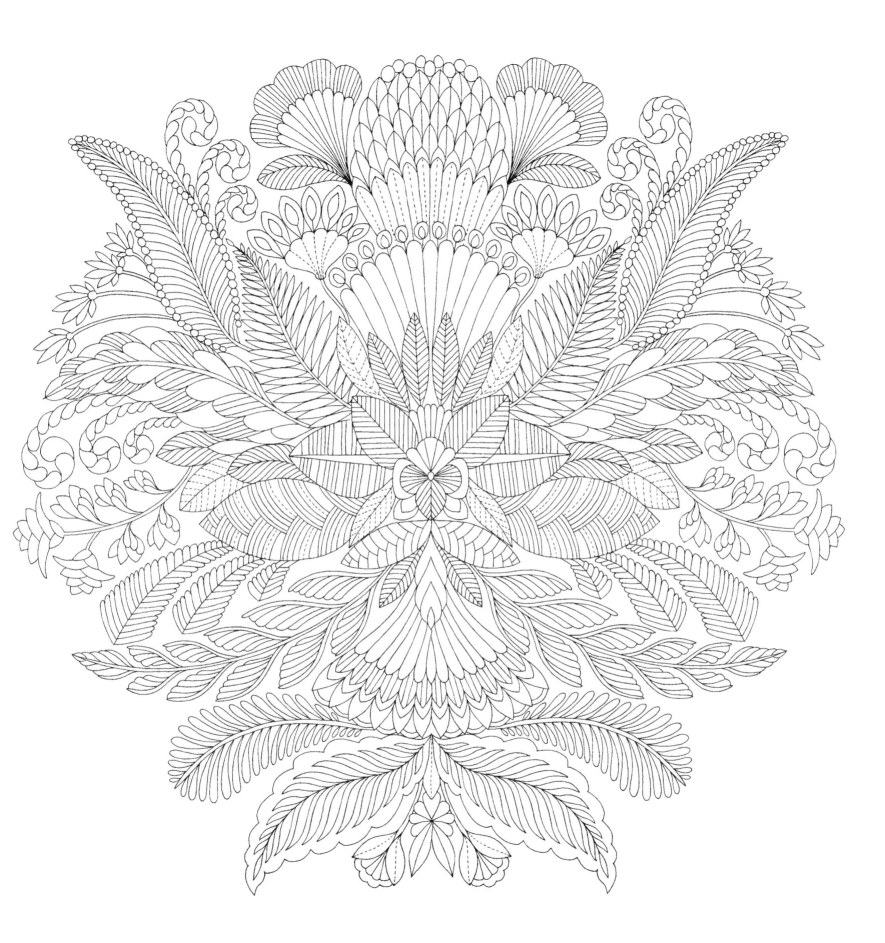

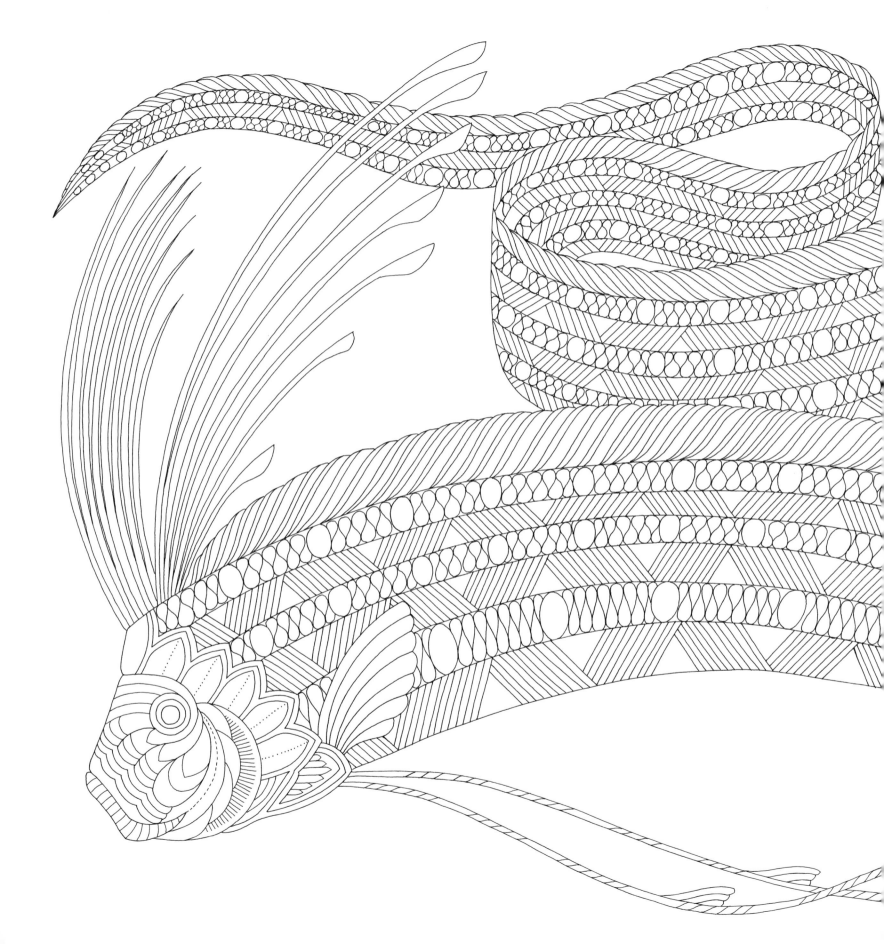

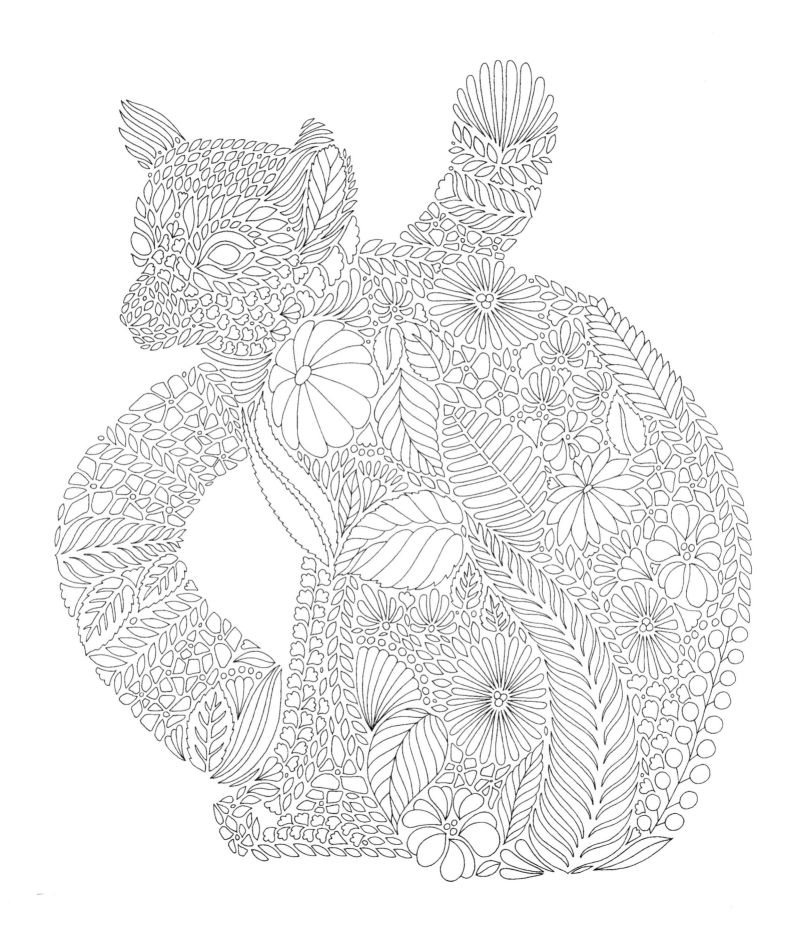

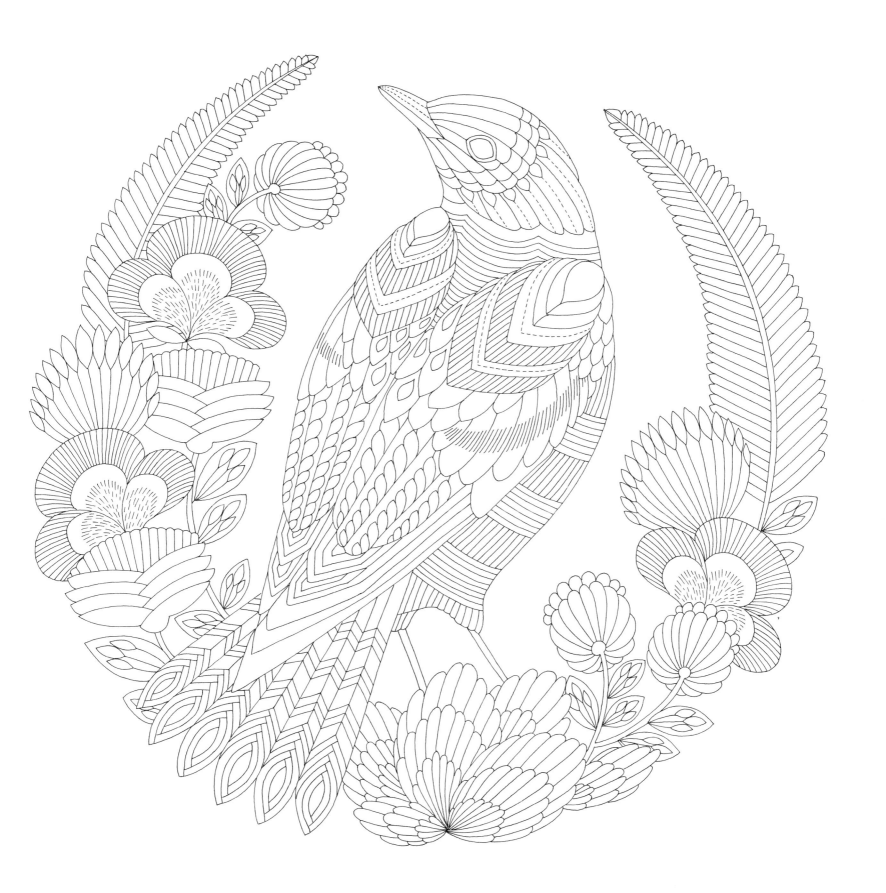

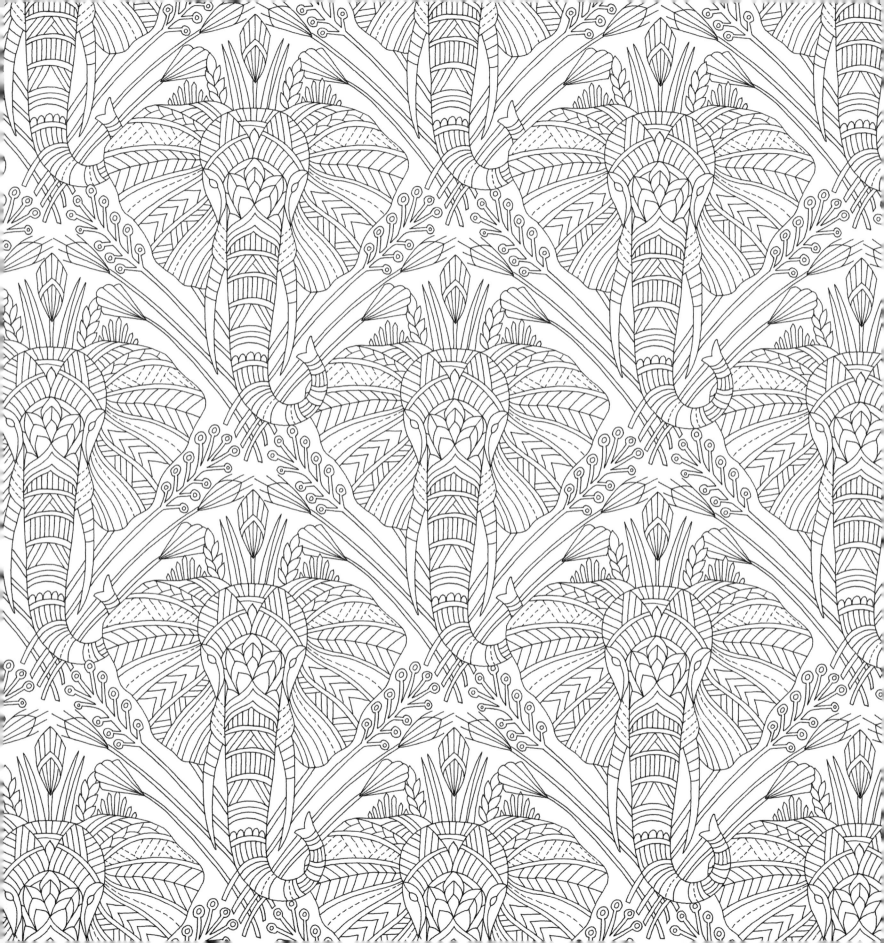

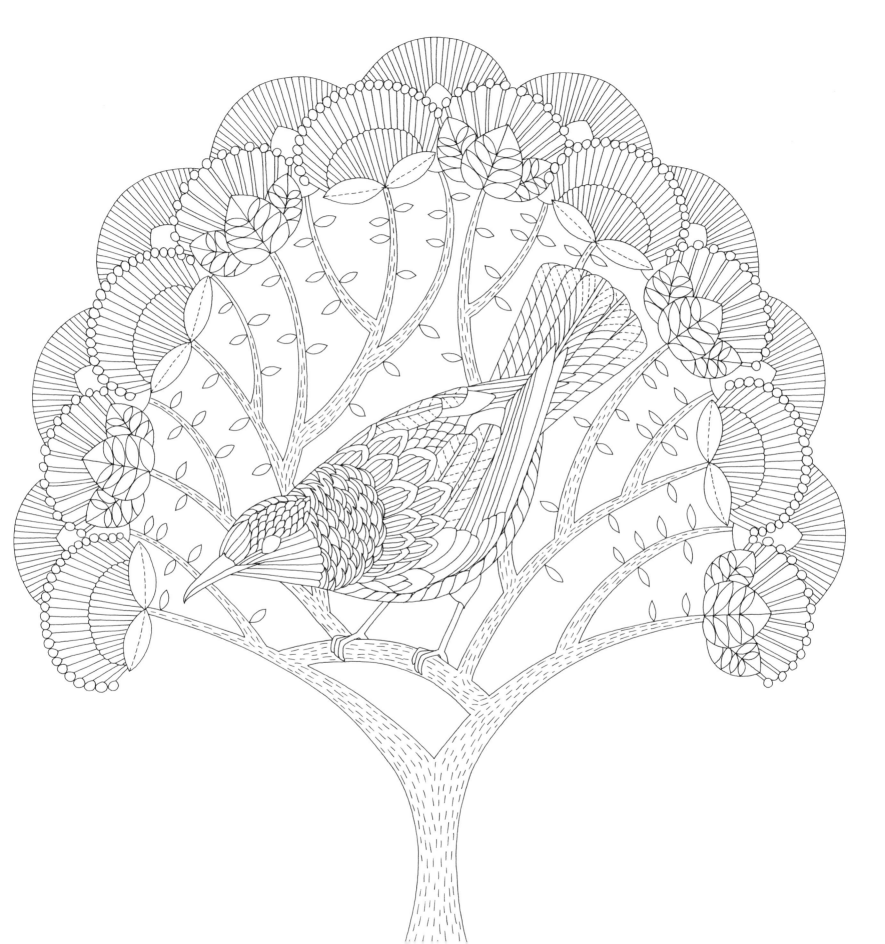

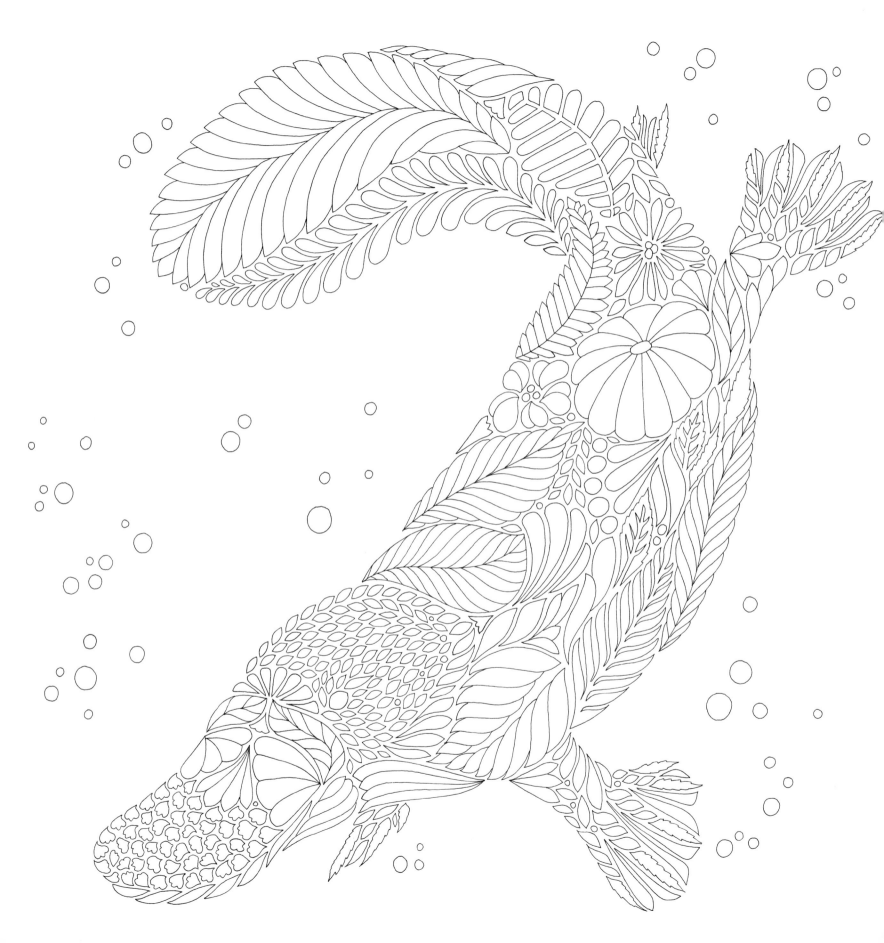

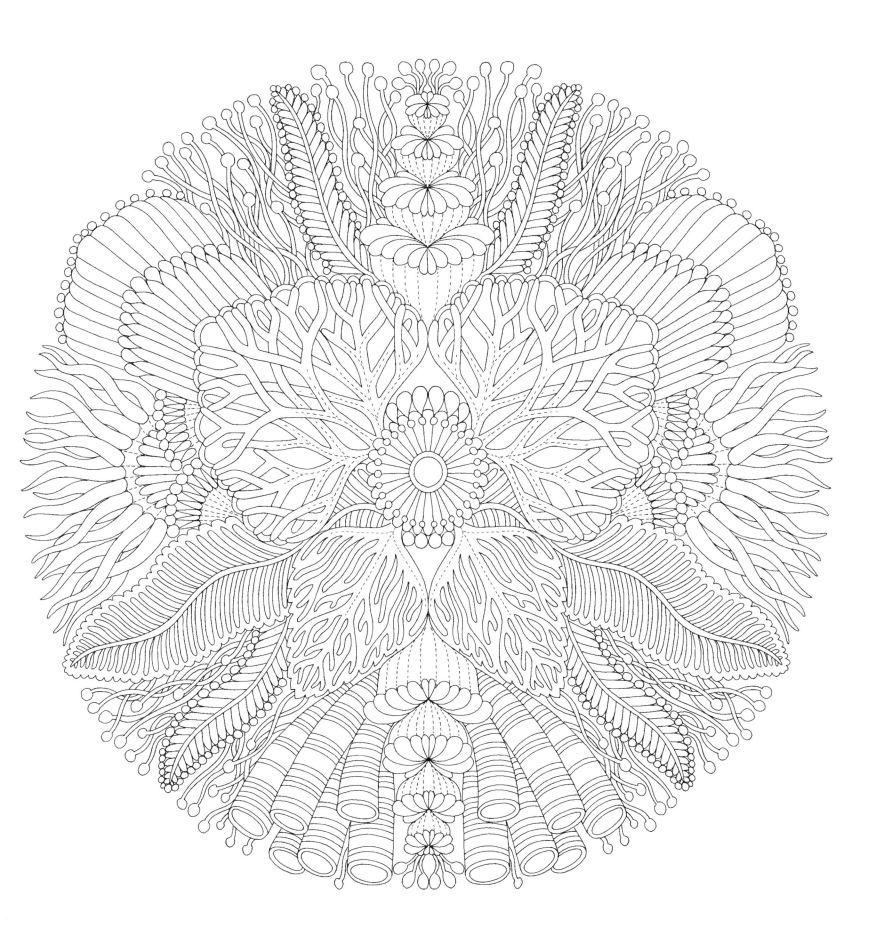

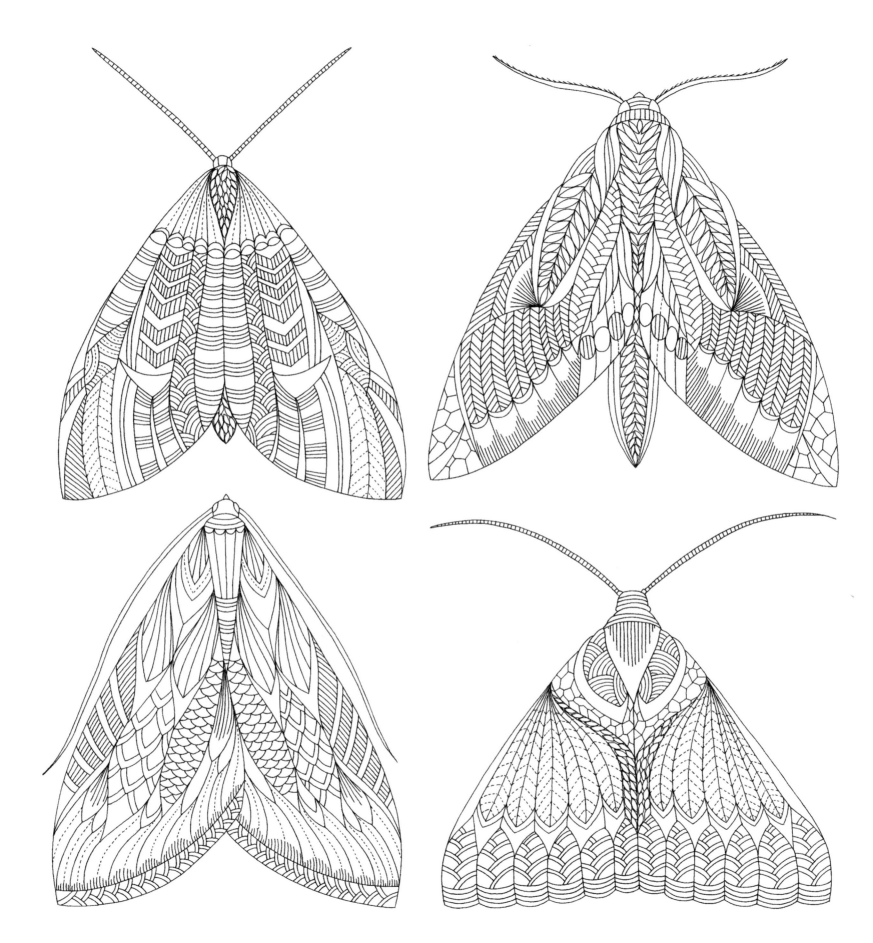

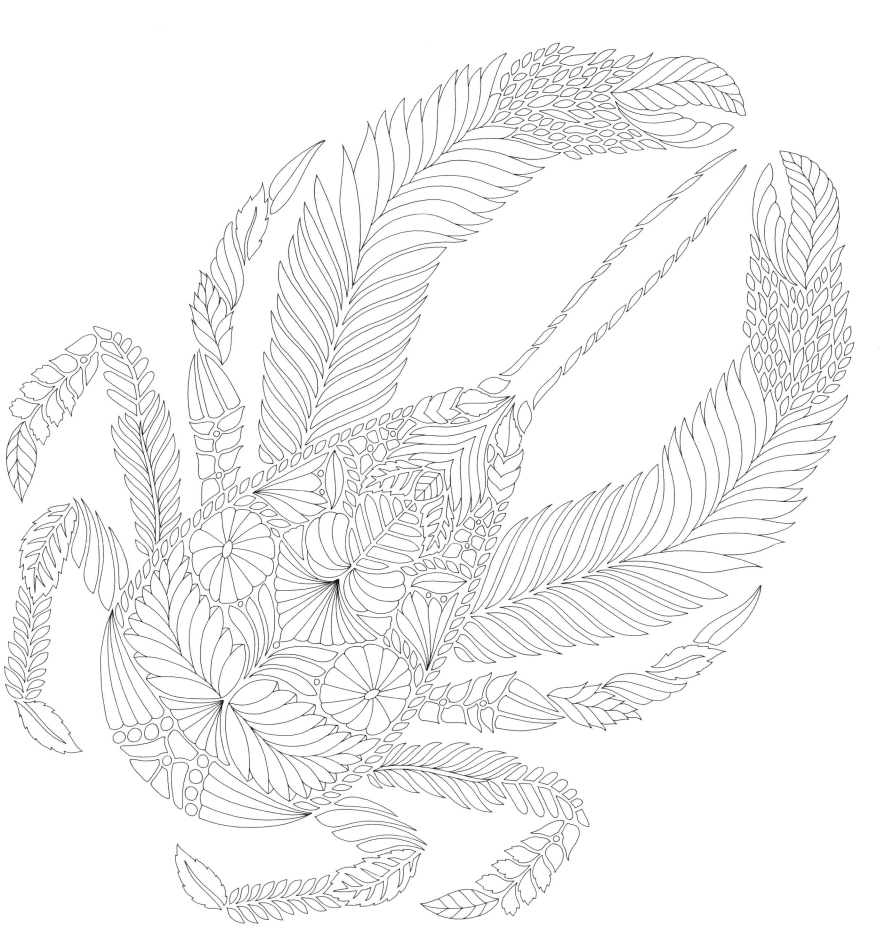

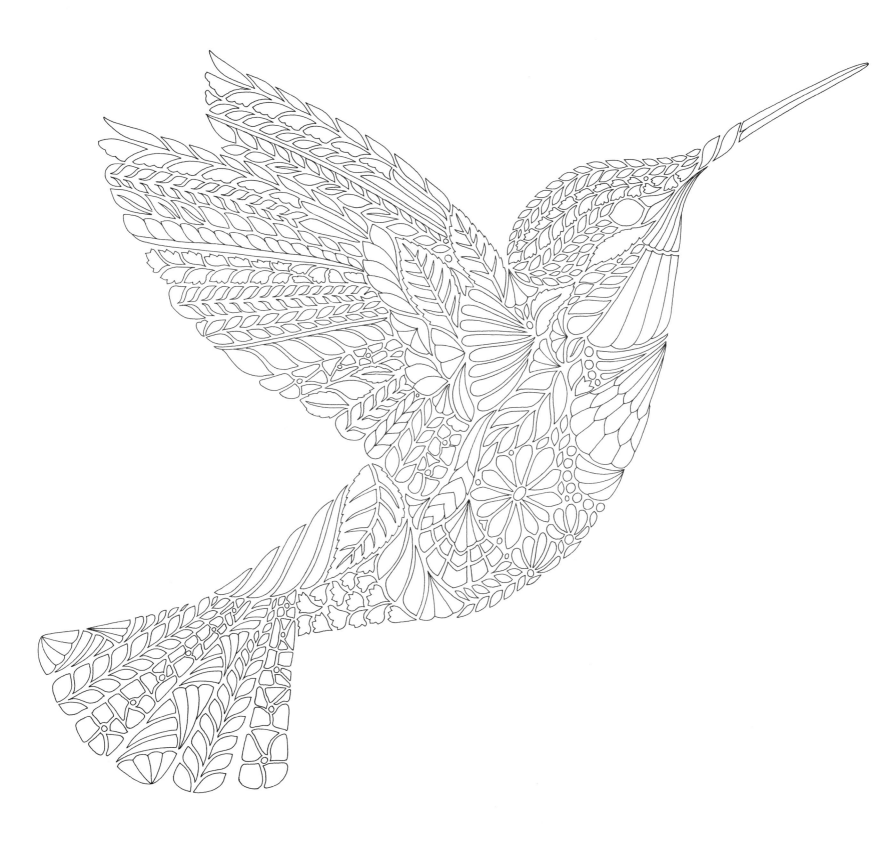

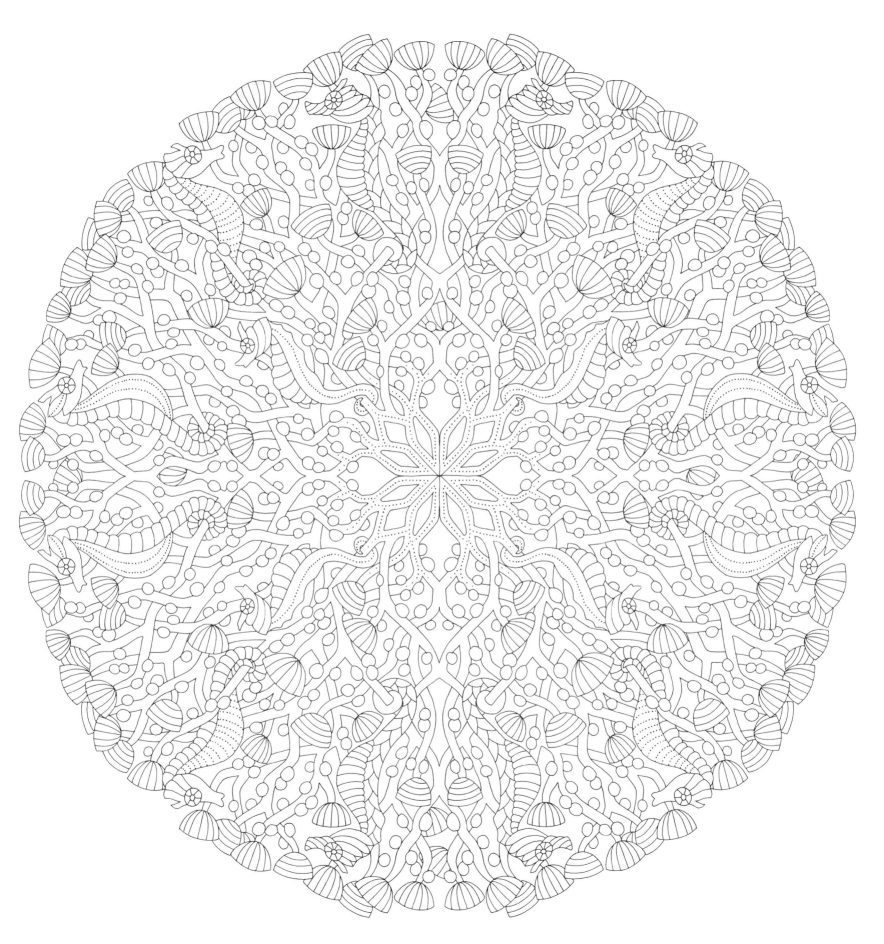

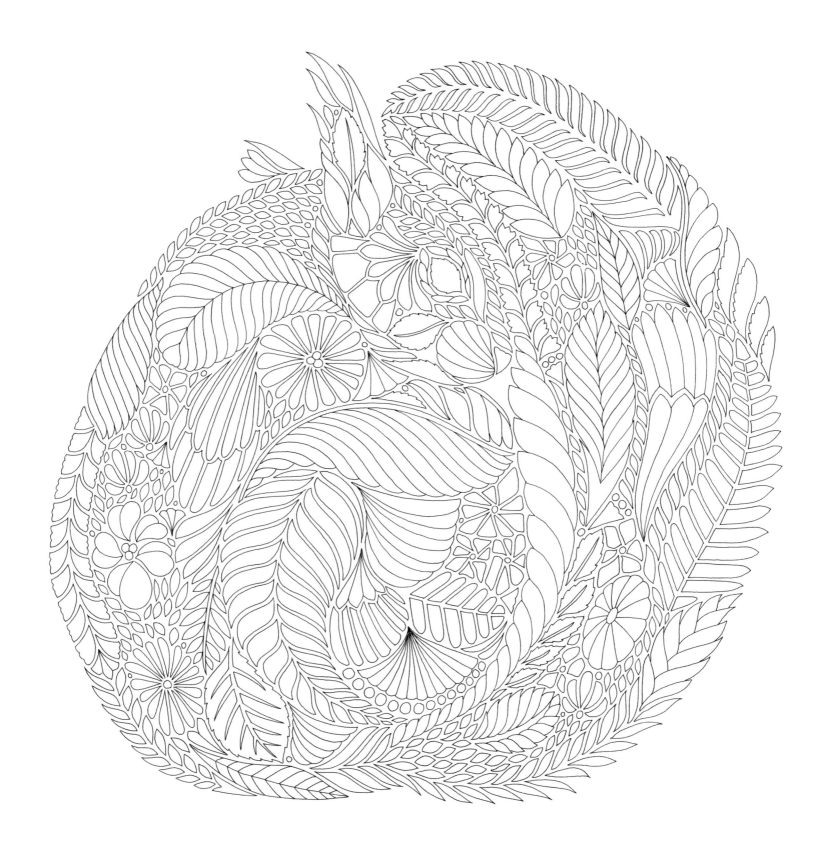

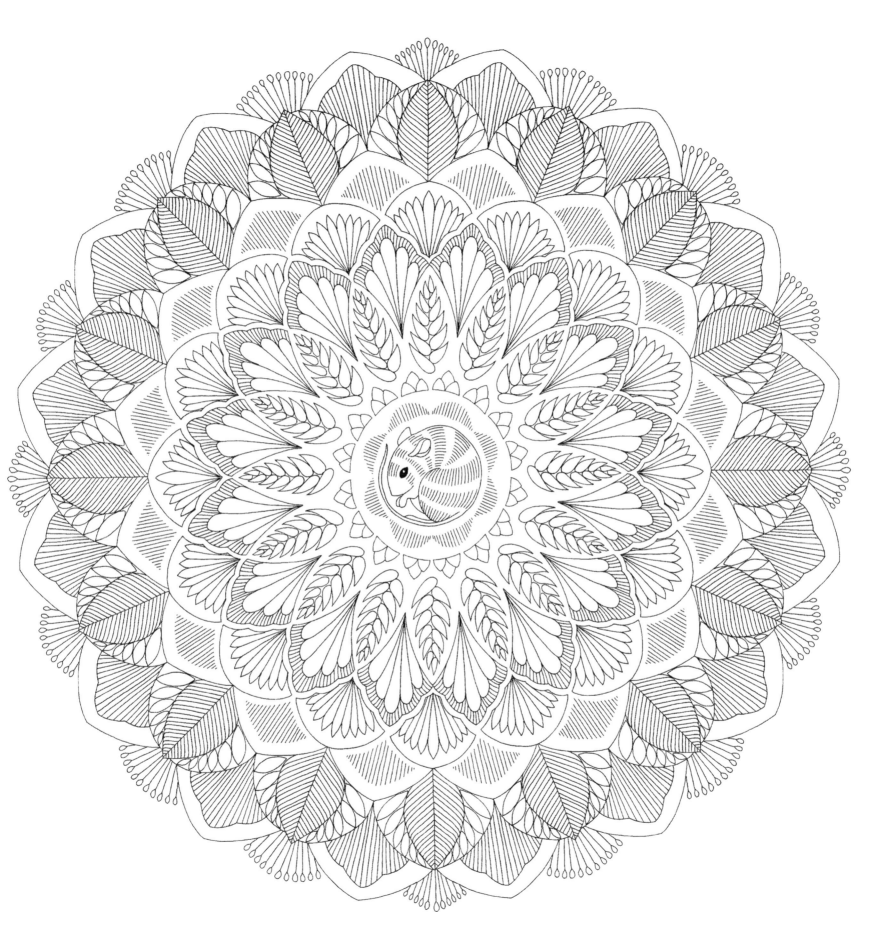

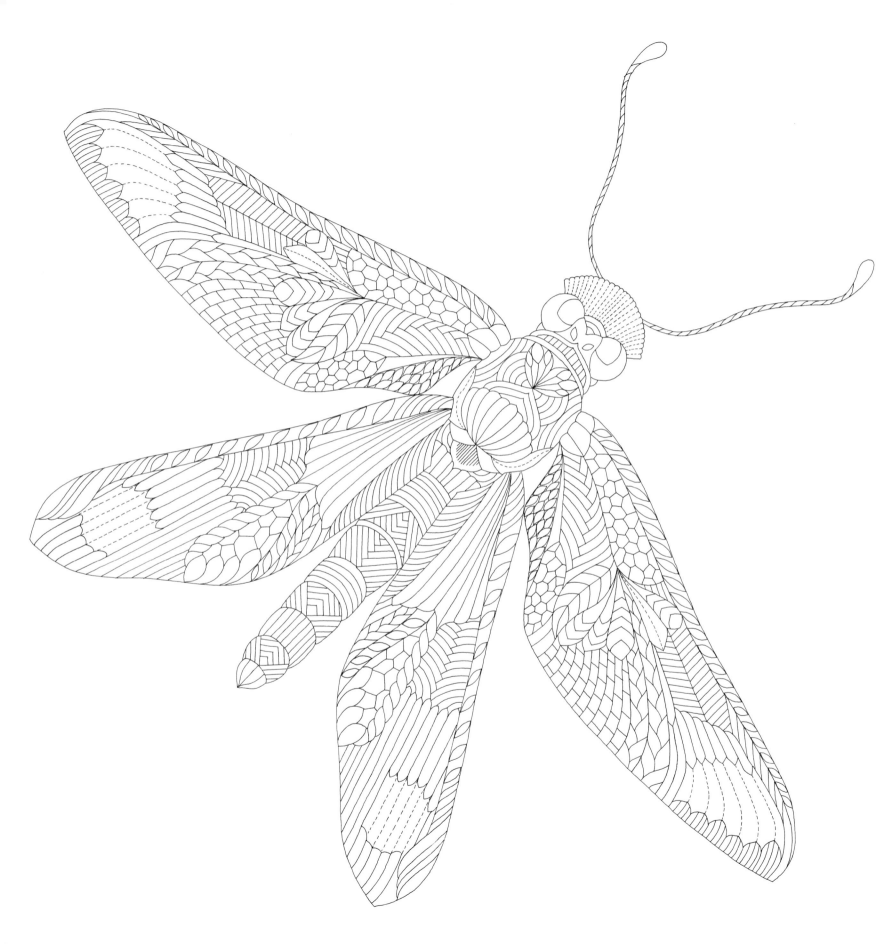

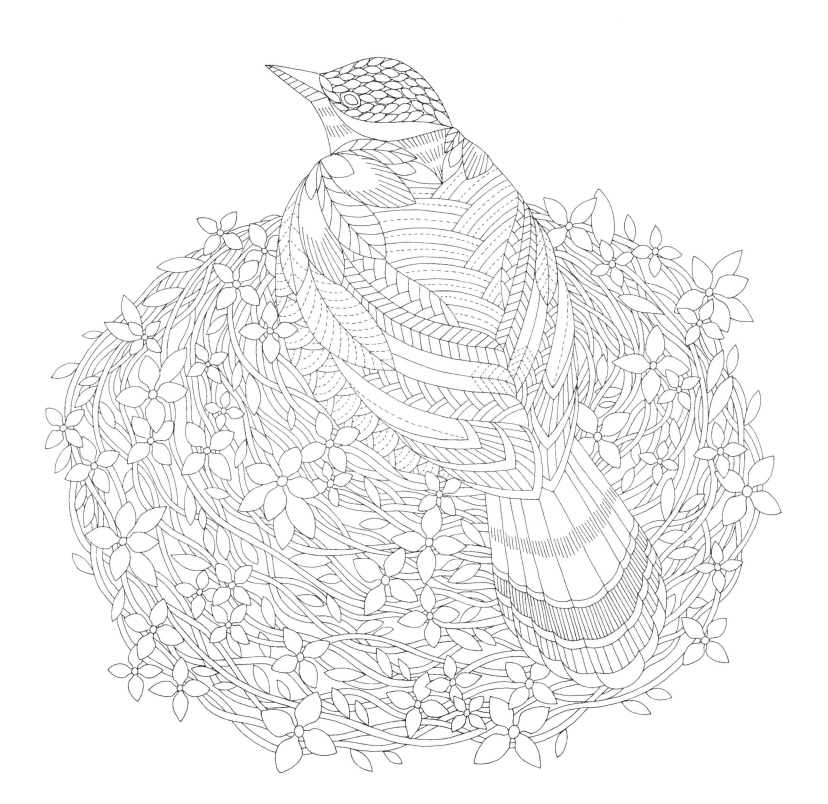

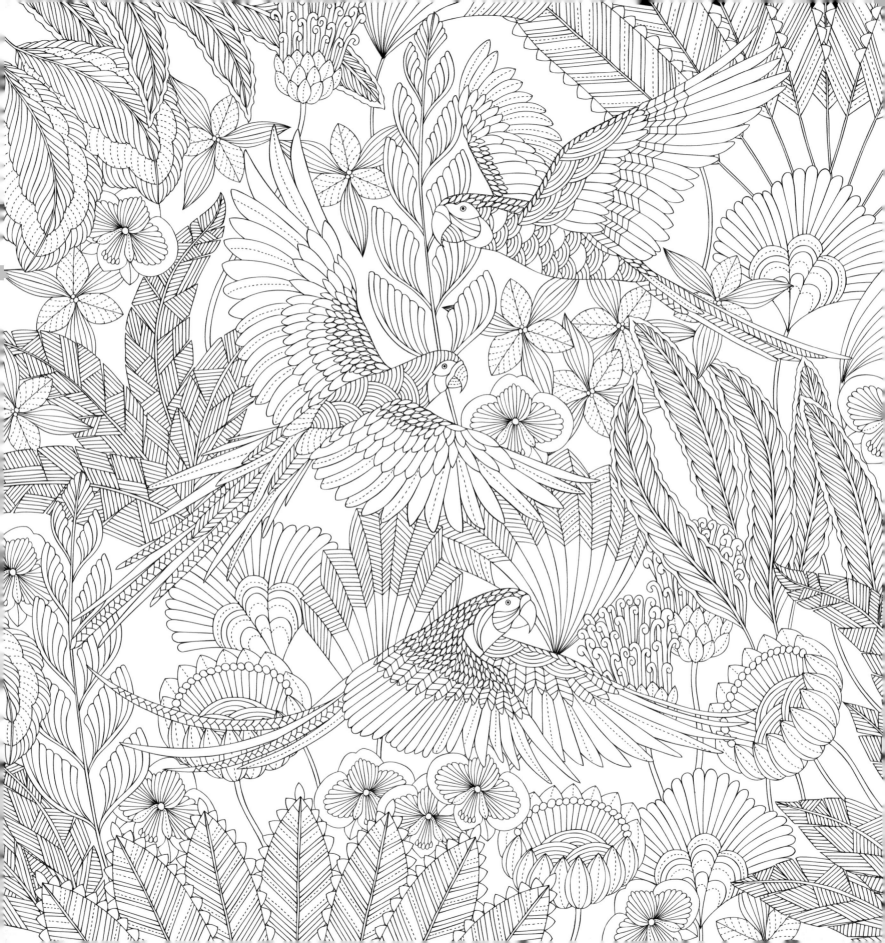

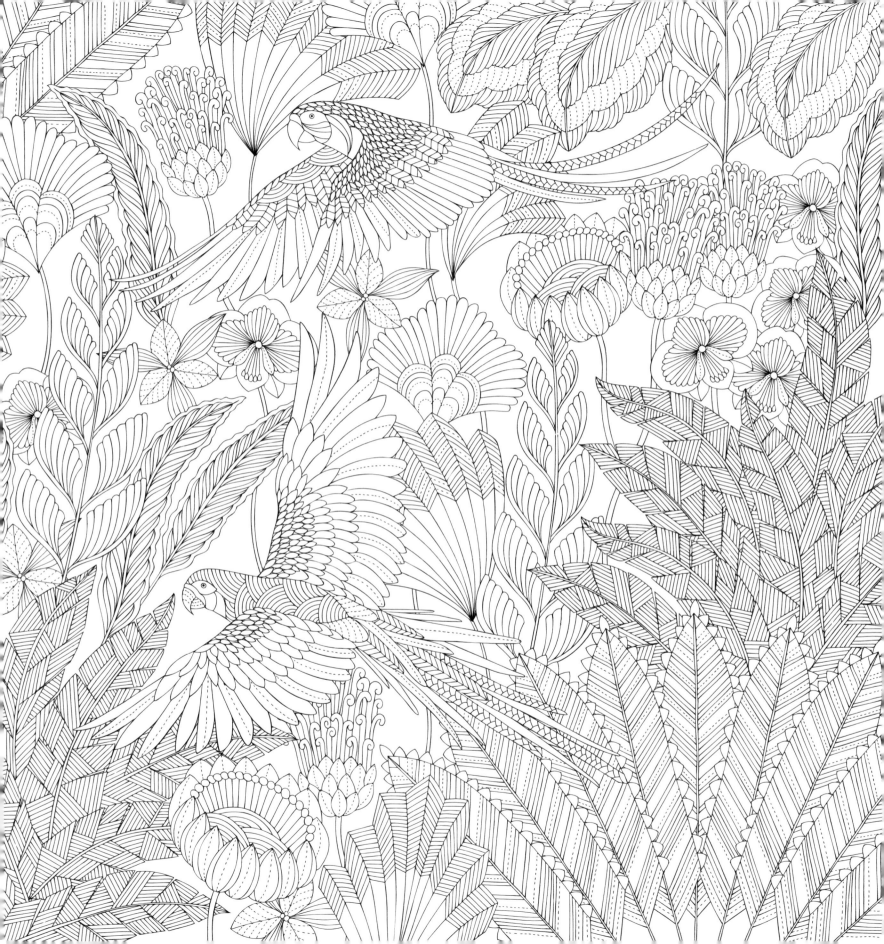

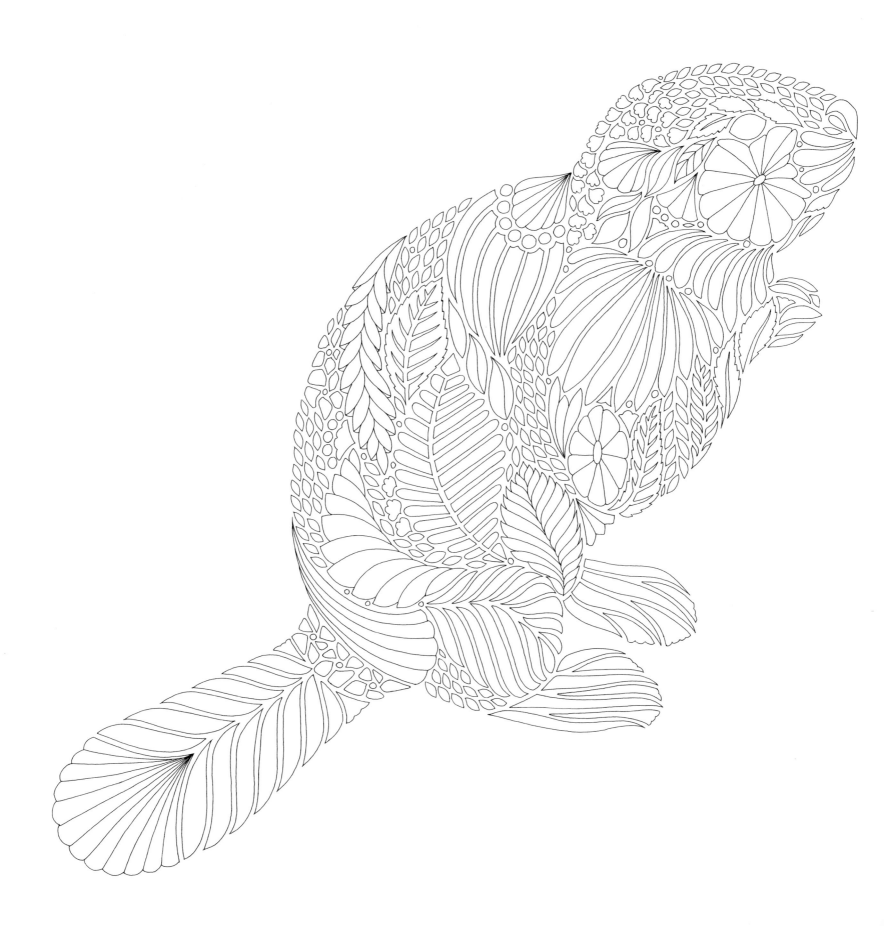

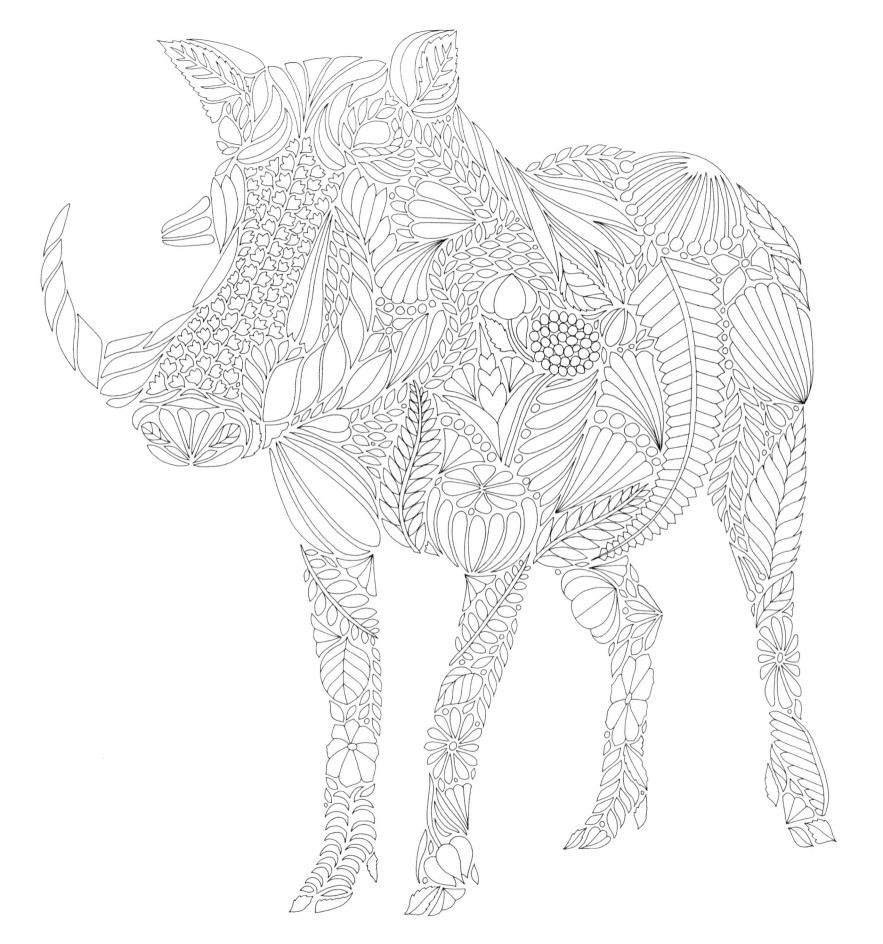

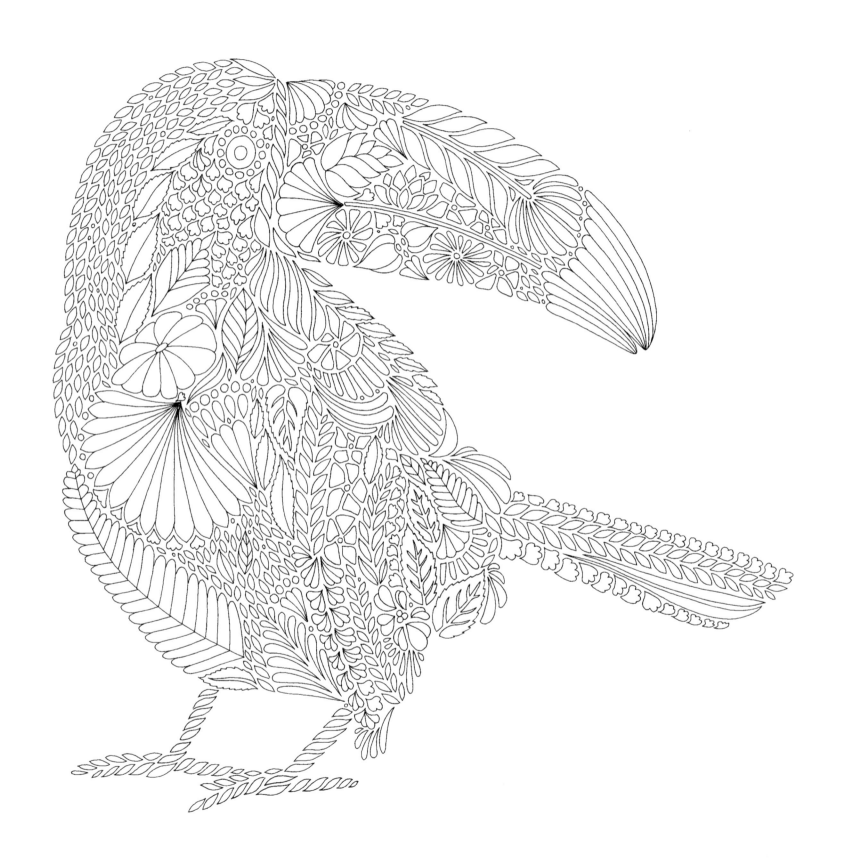

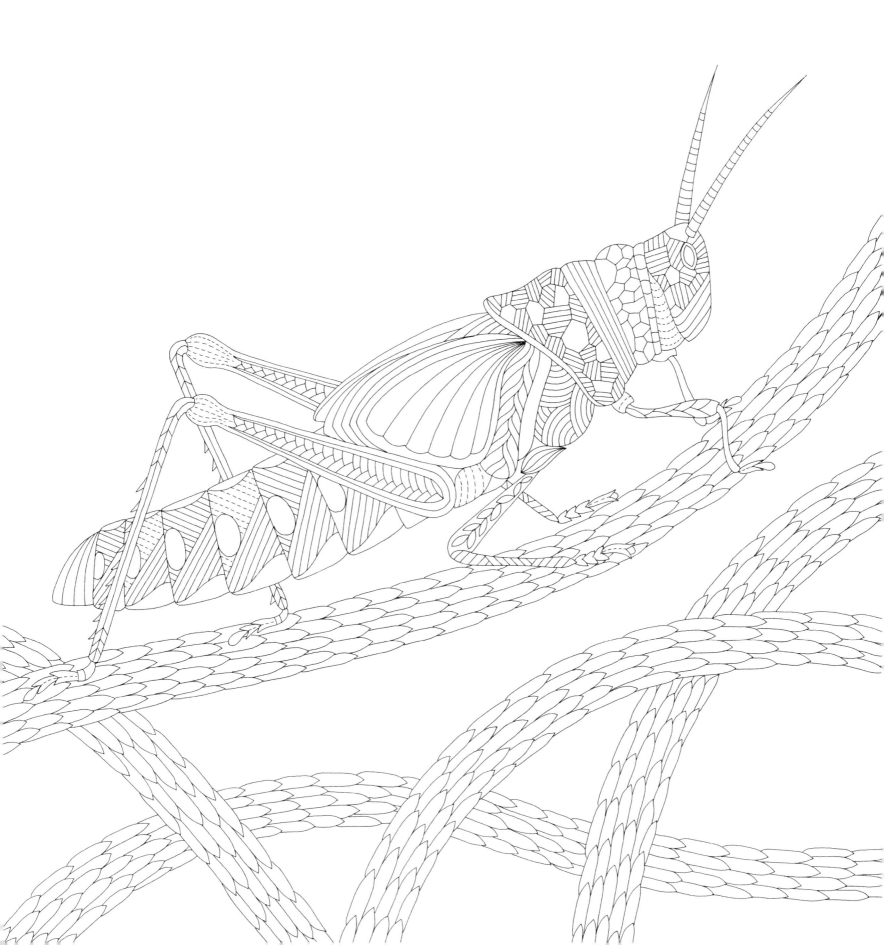

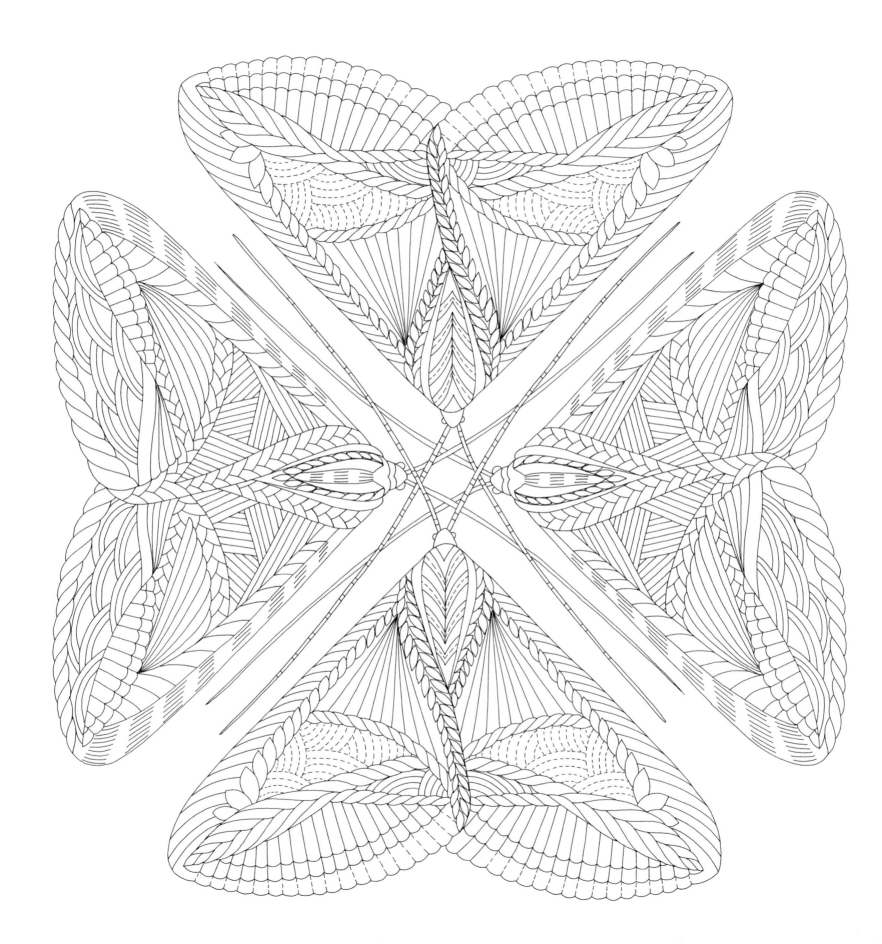

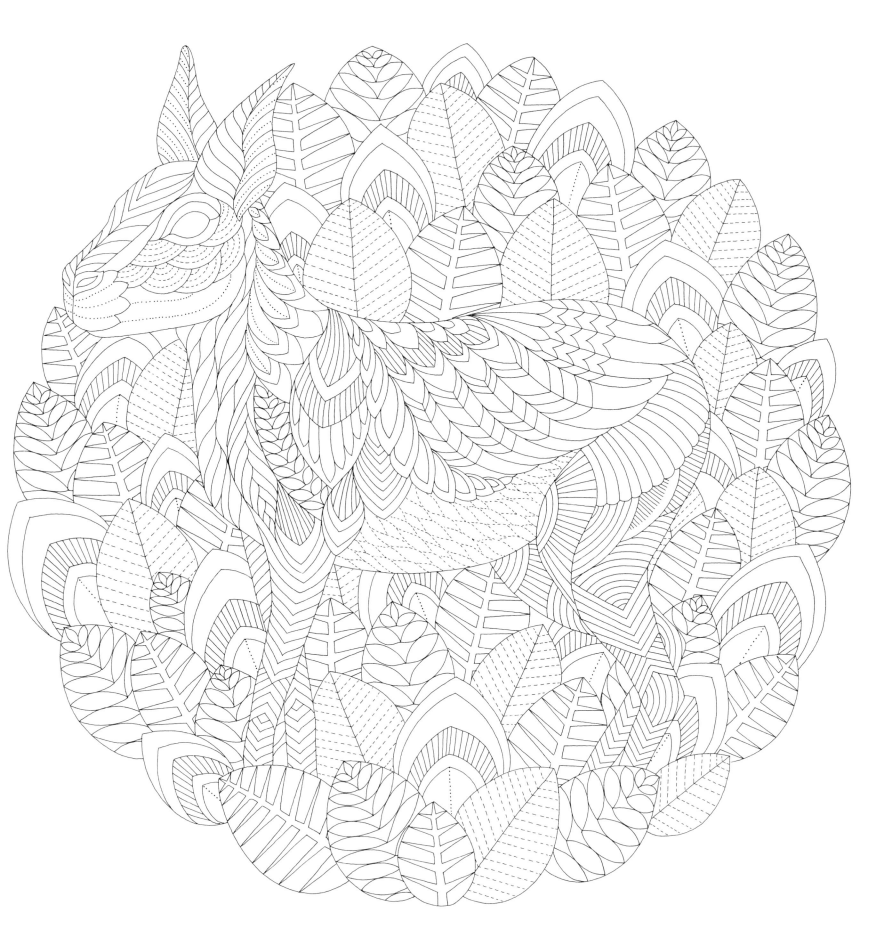

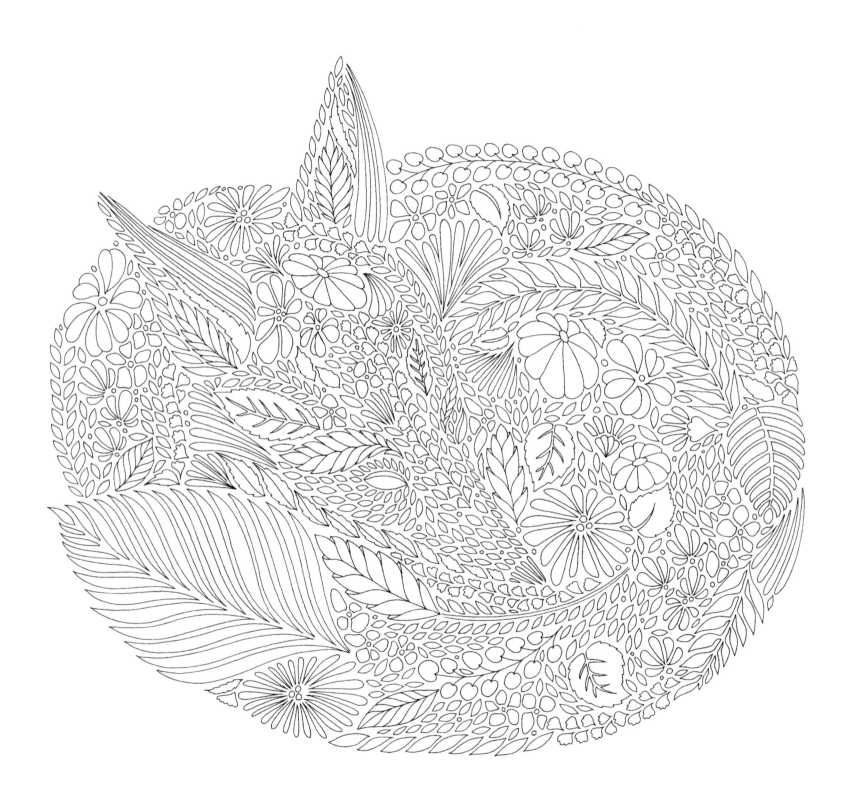

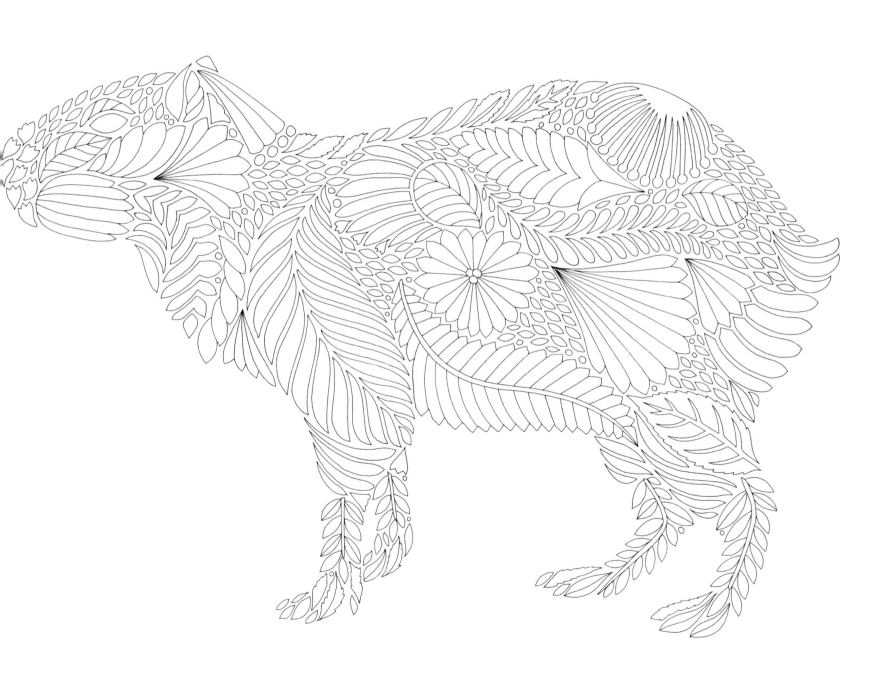

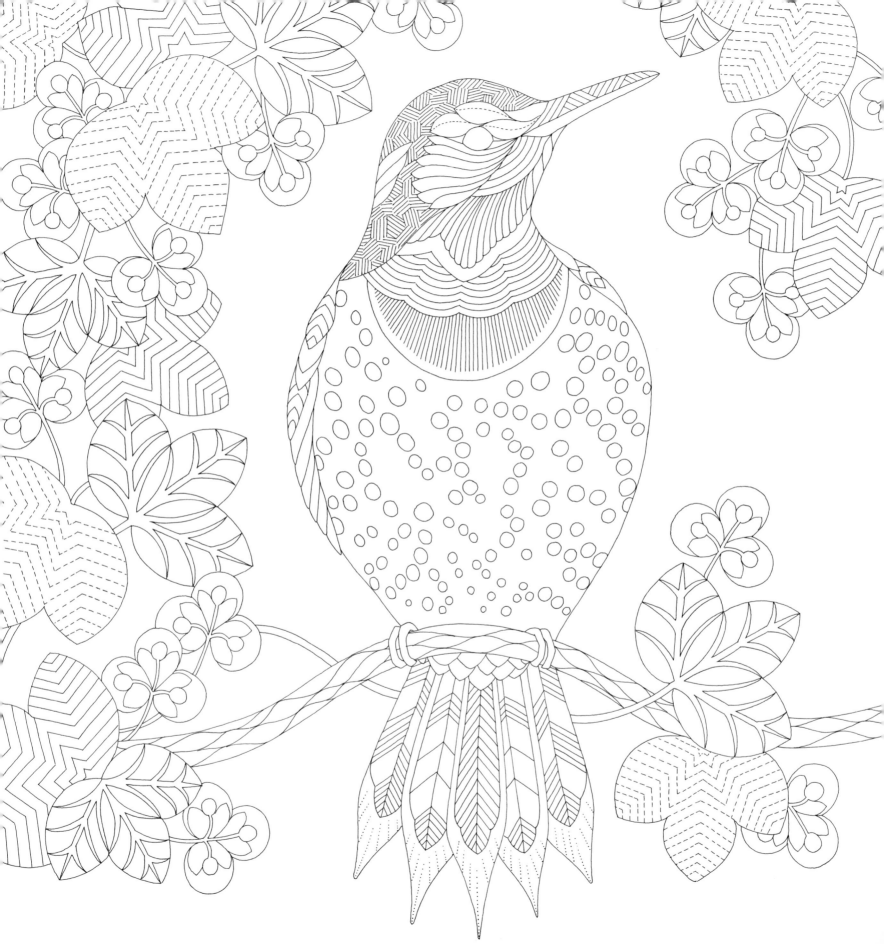

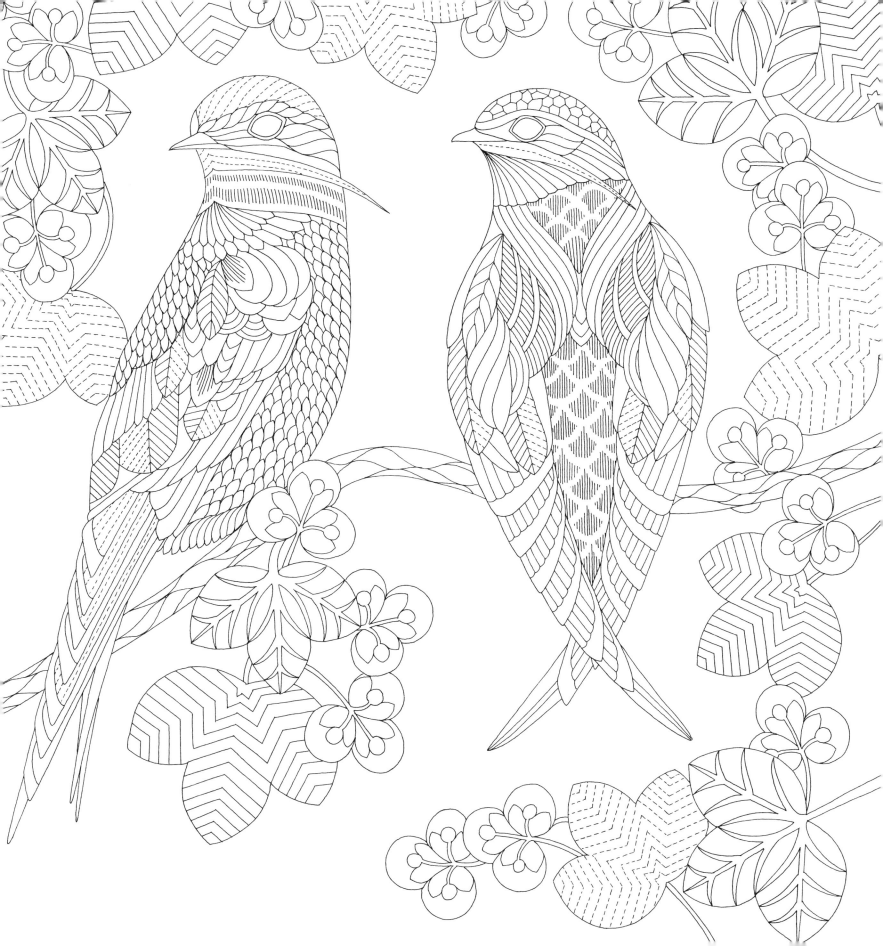

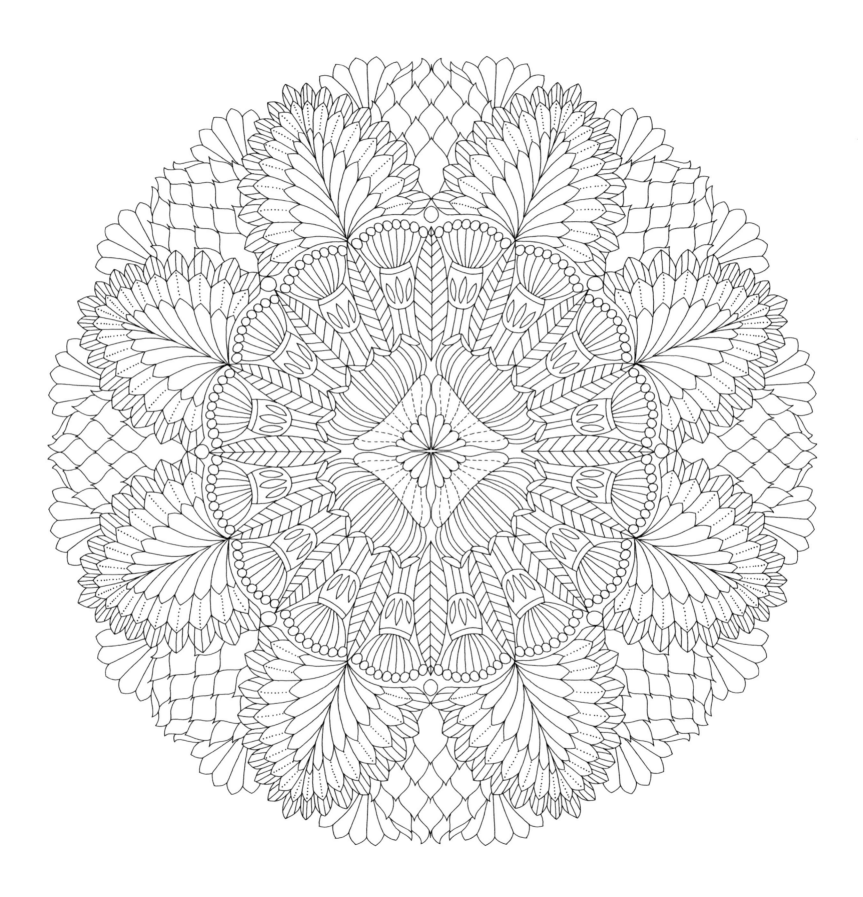

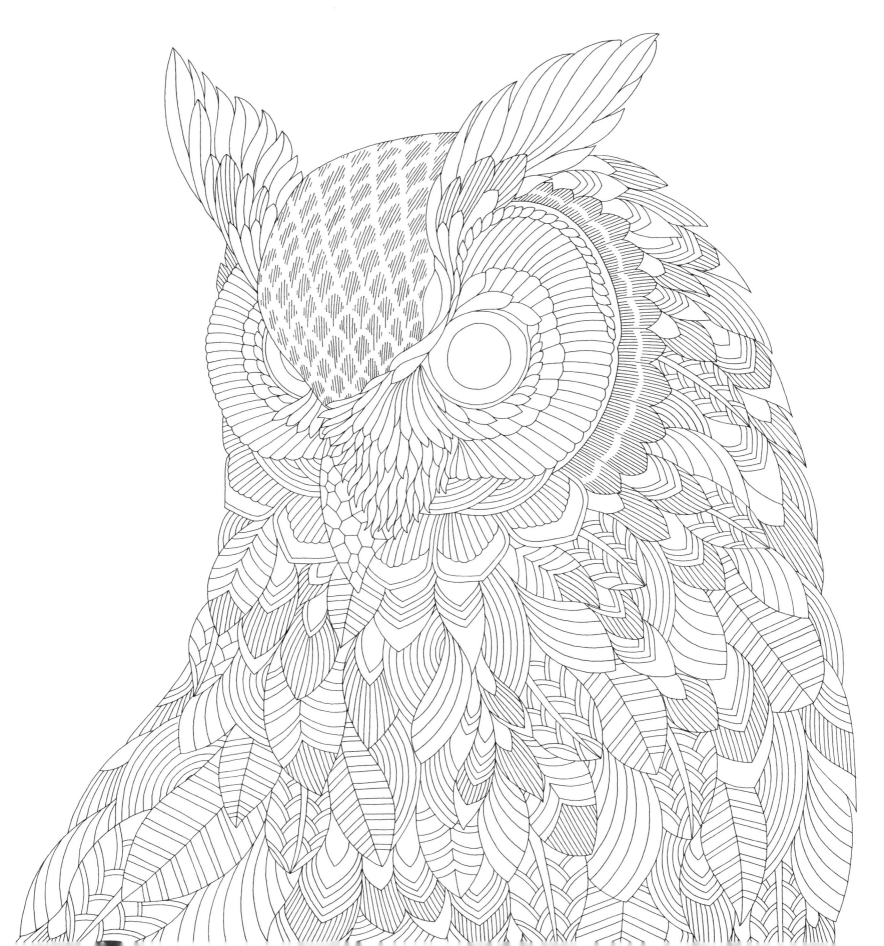

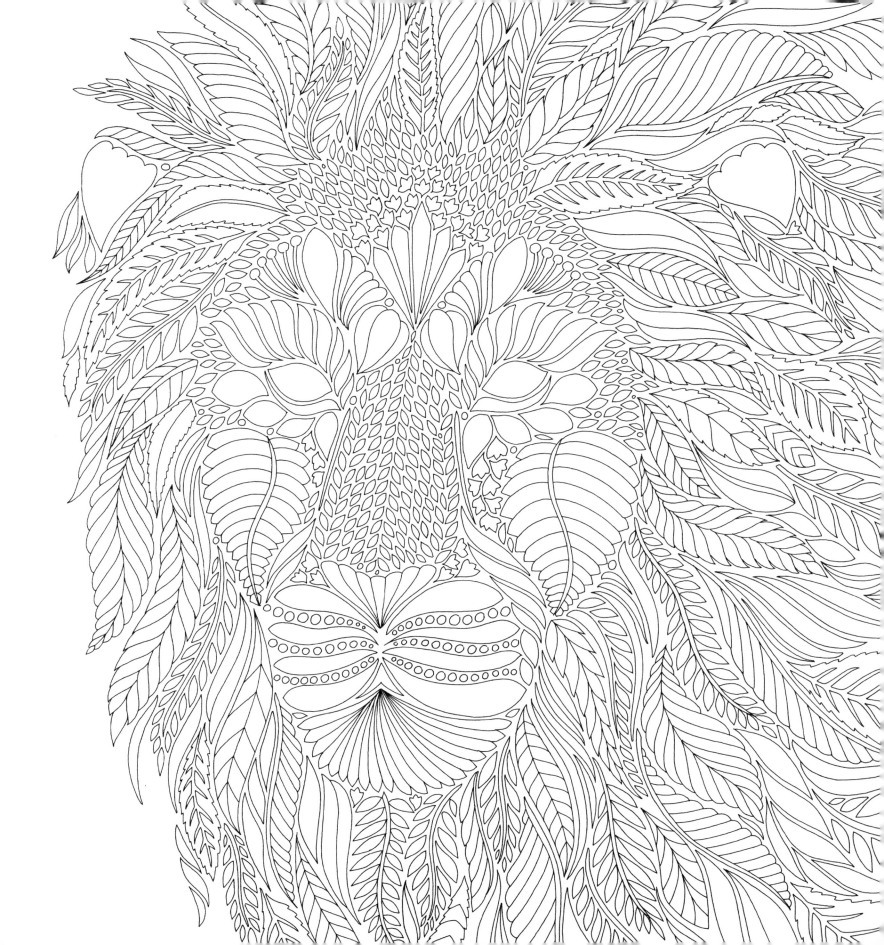

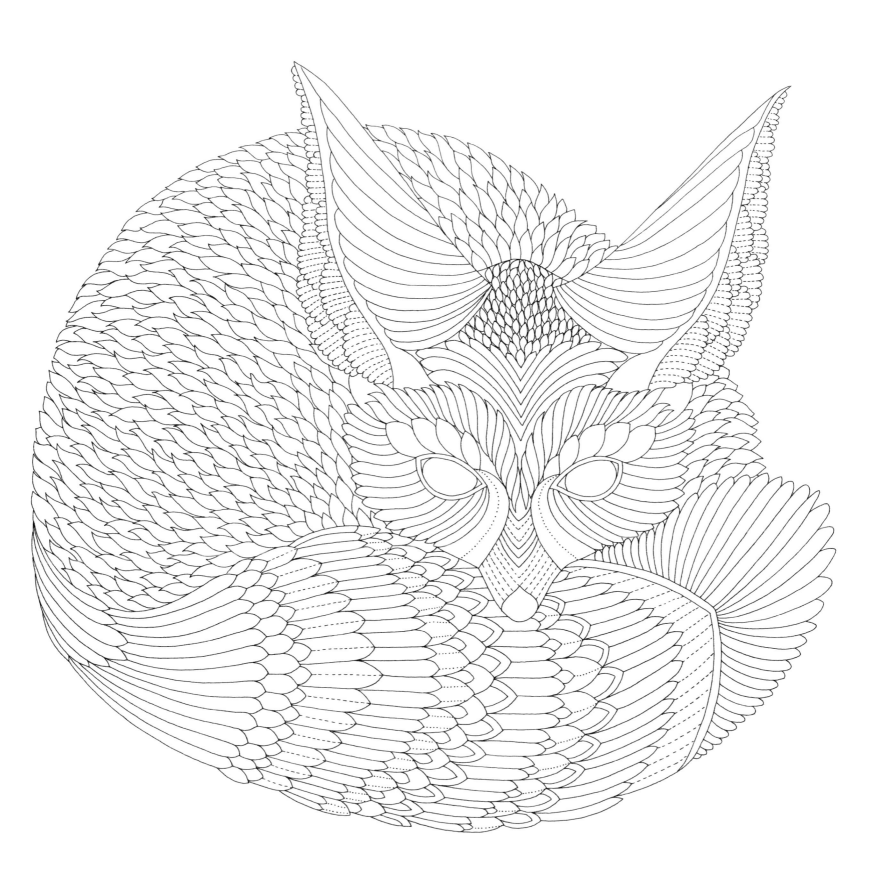

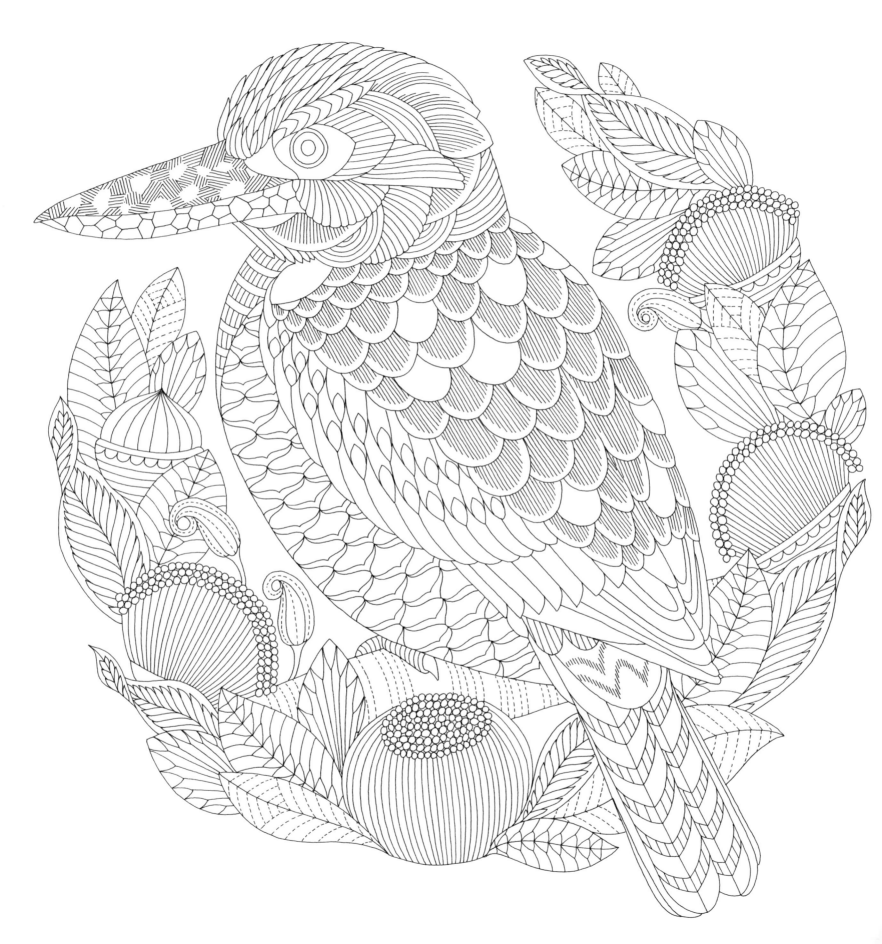

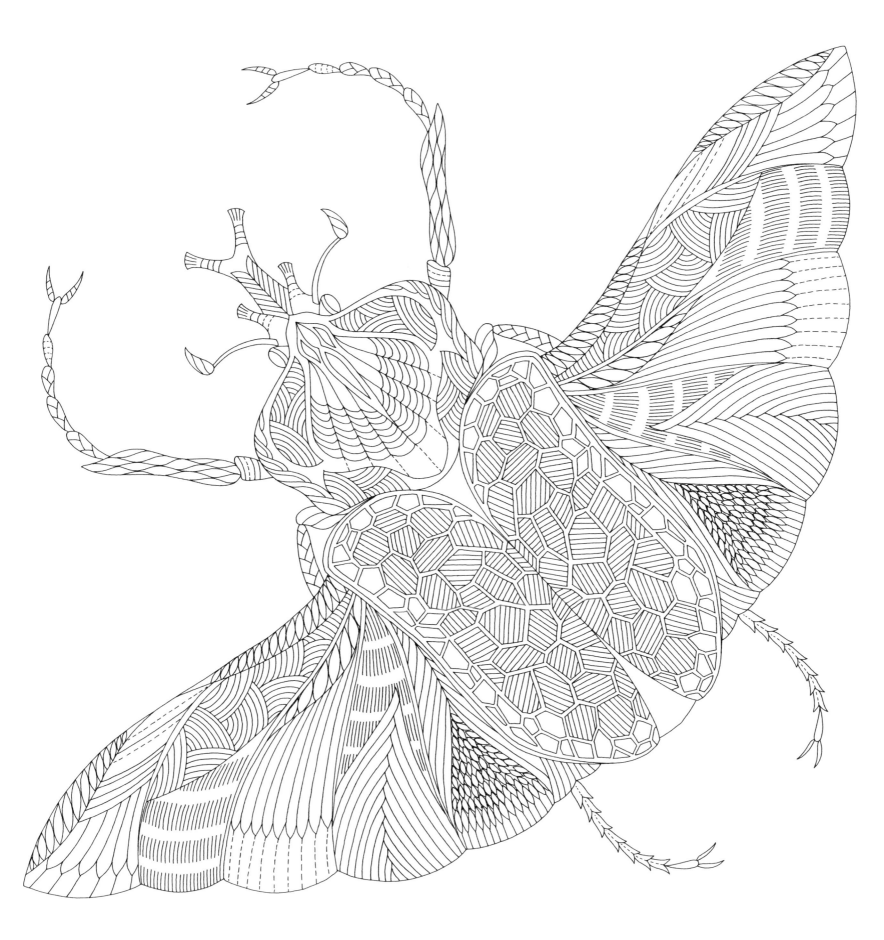

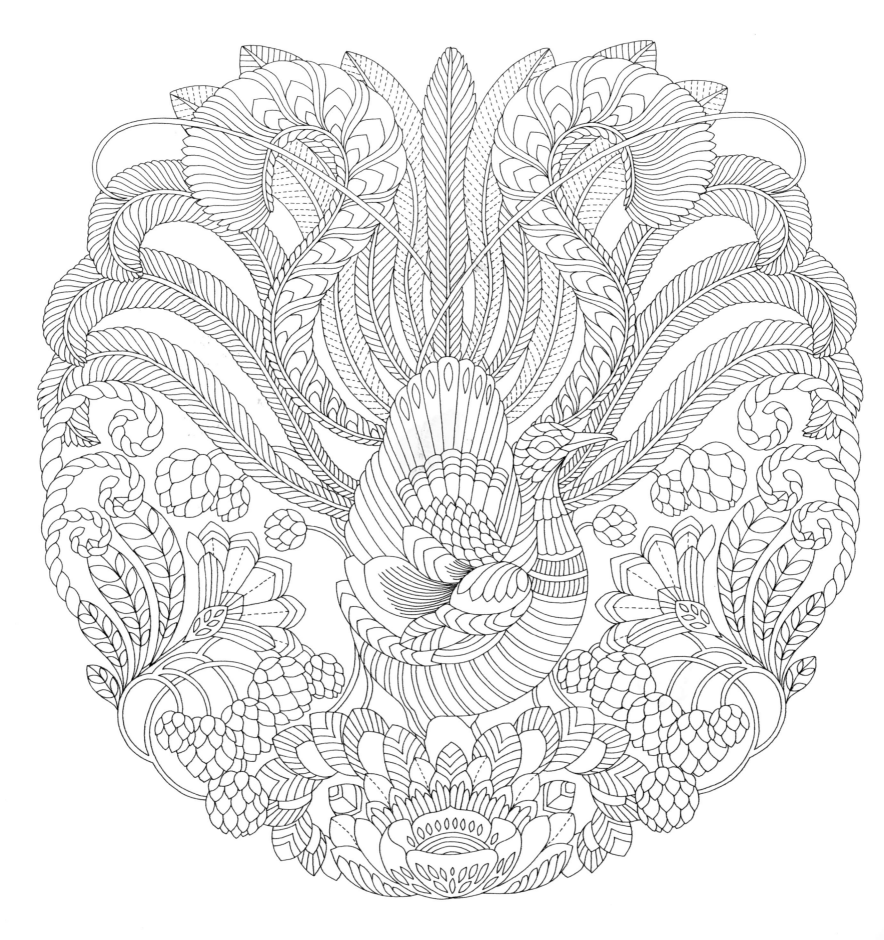

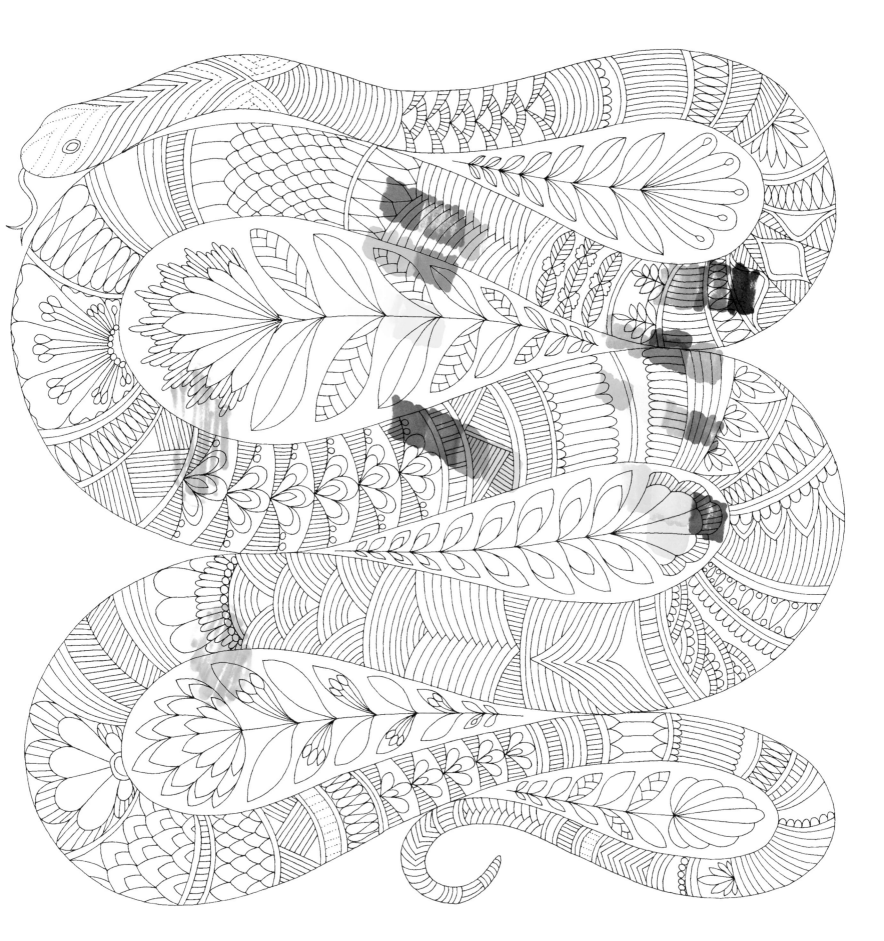

Create your own wildlife wonder here...